SEEING WITNESS

SEEING WITNESS

Visuality and the Ethics of Testimony

Jane Blocker

UNIVERSITY OF MINNESOTA PRESS
Minneapolis • London

An earlier version of chapter 2 was previously published as "Failures of Self-Seeing: James Luna Remembers Dino," *Performing Arts Journal* 67 (January 2001). An earlier version of chapter 3 was previously published as "Binding to Another's Wound: Of Weddings and Witness," in *After Criticism? New Responses to Contemporary Art,* ed. Gavin Butt (London: Blackwell, 2005). An earlier version of chapter 4 was previously published as "A Cemetery of Images: Meditations on the Burial of Photographs," *Visual Resources* 21, no. 2 (June 2005). An earlier version of chapter 6 was previously published as "This Being You Must Create: Transgenic Art and Witnessing the Invisible," *Cultural Studies* 17, no. 2 (March 2003).

Published by the University of Minnesota Press
111 Third Avenue South, Suite 290
Minneapolis, MN 55401-2520
http://www.upress.umn.edu

Library of Congress Cataloging-in-Publication Data

Blocker, Jane.
 Seeing witness : visuality and the ethics of testimony / Jane Blocker.
 p. cm.
 Includes bibliographical references and index.
 ISBN 978-0-8166-5476-5 (hc : alk. paper) — ISBN 978-0-8166-5477-2 (pb : alk. paper)
 1. Subjectivity in art. 2. Reality in art. 3. Visual communication in art. 4. Art, Modern—
21st century. I. Title.
 N8251.S55B55 2009
 701—dc22 2008029070

Printed in the United States of America on acid-free paper

The University of Minnesota is an equal-opportunity educator and employer.

15 14 13 12 11 10 09 10 9 8 7 6 5 4 3 2 1

For my father

CONTENTS

Illustrations

Acknowledgments

In preparing to write these acknowledgments, I realized two things. First, I have been working on the topic of witness for a very long time; and second, I owe a great debt to a huge number of people and institutions who invited me to give talks or publish articles and gave me excellent advice and criticism.

Chapter 2 began way back in 1999 when the amazing Della Pollock invited me to speak on a panel at the National Communication Association Conference, where I gave a paper on James Luna. Chapter 3 began as a paper I gave at the Thirtieth International Congress of the Historians of Art in London in 2000; later Gavin Butt graciously invited me to publish it in his anthology *After Criticism*. Gavin is a kind and insightful editor and offered useful ideas for its revision. Chapter 4 got its start in 2003 when Amy Lyford and Carol Payne invited me to give a paper for their panel at the College Art Association conference; that paper was subsequently published, thanks to their conscientious efforts, in *Visual Resources*. Chapter 6 first appeared (again thanks to Della) in *Cultural Studies*. I was able to try out ideas for chapter 7 at the Harvard Symposium on American Art in 2004, thanks to a generous invitation by Gwendolyn DuBois Shaw and Jennifer Roberts. And chapter 1 came about when Nancy Spector and Jennifer Blessing invited me to participate in an unforgettable conference at the Guggenheim in 2005. I am enormously grateful for all of these remarkable opportunities and intelligent interlocutors.

I must also thank the two readers of my book manuscript (Amelia Jones and an anonymous reader), who offered excellent suggestions for its improvement. In addition, I sincerely thank Cecilia Aldarondo, Anna Chisholm, Lauren Deland, Kenny Fountain, Melissa Geppert, Sam Johnson, Emily Kubic, and Sarah Loyd, students in my graduate seminar "Theories of Witness." They are all enormously talented, and their work on this topic was deeply inspiring. I especially appreciate Kenny's willingness to read my writing and comment so usefully on it. I also inflicted this work in various stages on my doctoral students Tiffany Johnson Bidler and Andrea Nelson, both of whom influenced my thinking in important ways (Tiffany with regard to legitimacy and theology; Andrea with regard to photography): I am grateful. I owe a great debt to Marisol Alvarez, who

endured a tedious discussion with me about the philosophy of love and helped me under-
stand that concept more fully. I am indebted to Yoshi Mizobuchi for his translation help,
particularly because, as a research chemist, he has more important things to do than talk
to me about performance art. I owe a big hug and many thanks to Adair Rounthwaite for
helping me with the index.

I am most grateful to the many artists and their representatives who helped me
research and prepare this book: Kim Waldman at AP Photos, Iñigo Manglano-Ovalle,
James Luna, Erica Pajerowski at Sean Kelly Gallery, Yoko Takatani, Michelle Reyes at
The Felix Gonzalez-Torres Foundation, Stanley Greenberg, Ross McElwee, Alfredo Jaar,
Michael Schulman at Magnum Photos, Eduardo Kac, and Ann Hamilton.

My profound thanks to my editor, Richard Morrison, and the staff of the University
of Minnesota Press. I value Richard both as a friend and as a talented collaborator.

Recently I was complaining to my mother about how busy I am, and her only
response was "Poor Roger!"—referring to my husband, Roger Lindsay. She knows very
well how fully burdened Roger is by my work and how much I owe him for his support,
his willingness to be my first and most careful reader, and for putting up with me all these
twenty years.

Introduction Imagery Specialists

On February 5, 2003, Secretary of State Colin Powell testified before the United Nations Security Council, laying the groundwork with satellite photographs of chemical weapons facilities for the U.S.–led invasion of Iraq. About the satellite images, Powell explained:

> The photos I am about to show you are sometimes hard for the average person to interpret, hard for me. The painstaking work of photo analysis takes experts with years and years of experience, poring for hours and hours over light tables. But as I show you these images, I will try to capture and explain what they mean, what they indicate to our imagery specialists.[1]

In the years since the U.S.–led coalition launched its war in Iraq, the Bush administration's justification for the war, as well as Powell's somewhat self-deprecating contribution to that justification, has been thoroughly analyzed and critiqued. Powell himself said in 2005 that he regretted his testimony, claiming that he had been misinformed.[2] What interests me about it now, besides its intriguing though presumably unintentional mimicry of the visual analysis common in art history, is the way in which he discussed the images, how he marshaled them toward a discursive battle over the rights of witness, and how those images became part of a strategy to authorize one kind of witness over another.

A dominant theme of Powell's testimony on that day in February was that the witness who is invisible, omniscient, and disembodied is more trustworthy than the witness who is visible, with finite knowledge and human limitations. The photographs he showed, it must be noted, were taken from an anonymous, godlike camera, not located in any particular country, but floating in orbit around the earth at a distance from which seemingly the whole of the earth could be taken in. Such images, whether taken by satellites or surveillance aircraft, have become a staple of intelligence testimony in the United States, from the Cuban Missile Crisis and the Vietnam War to the first Gulf War. These photographs, according to Powell, precisely because they are unauthored, require the interpretation of "imagery specialists." As one such specialist, though I am quite certain not the type Powell

had in mind, I would like to bring my "years and years of experience" to the analysis of these pictures.

They are, first and foremost, black-and-white photographs, which, irrespective of what they depict, connote the authority and validity of the documentary. That they are taken by an orbiting machine with a magisterial view of the planet rather than by a human being who may have some vested interest in their interpretation adds considerably to their supposed neutrality, objectivity, and truth value. What is more, they are difficult to interpret and require the skills of imagery specialists (a cadre of disembodied and invisible authorities), which suggests that the images contain hidden secrets to which only a privileged few have access. In short, it is as though these pictures were taken by God.

The other evidence Powell brought to the United Nations—surveillance audiotape and the testimony of eyewitnesses who were, out of fear for their lives, kept anonymous—shared many qualities with the photographs. This evidence was similarly presented

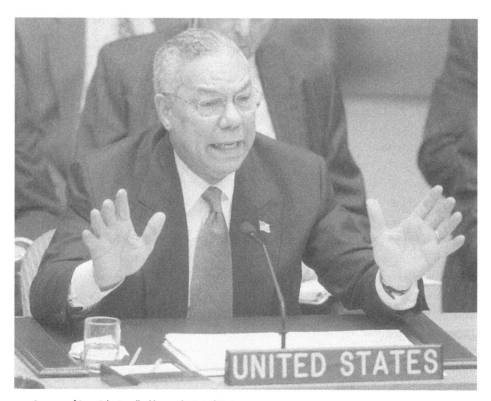

Secretary of State Colin Powell addresses the United Nations Security Council, Wednesday, February 5, 2003, at U.N. headquarters. AP Photo/Elise Amendola.

without authorship, as though it had been heard and recorded by self-activating machines, as though it had been gathered by an invisible force.

The invisibility in which these sources are shrouded is of key importance, because Powell situated the testimony given by the satellite, by the tape recorder, and by the anonymous absent witnesses in opposition to the inspectors sent to Iraq by the United Nations and the International Atomic Energy Agency. Again Powell directs attention to the surveillance photographs:

> Here, you see 15 munitions bunkers in yellow and red outlines. The four that are in red squares represent active chemical munitions bunkers. How do I know that? How can I say that? Let me give you a closer look. Look at the image on the left. On the left is a close-up of one of the four chemical bunkers. The two arrows indicate the presence of sure signs that the bunkers are storing chemical munitions. The arrow at the top that says "security" points to a facility that is the signature item for this kind of bunker. Inside the facility are special guards and special equipment to monitor any leakage that might come out of the bunker. The truck you also see is a signature item. It's a decontamination vehicle in case something goes wrong.[3]

The pictures to which Powell refers are self-interpreting. They come equipped with brightly colored arrows and informational text. They are so explicit, apparently, that the former secretary of state even claims to know what is beneath the surfaces they depict. Somehow he can see the special guards and special equipment inside the facility. What they do not show is the person or entity that took them. They do not show the subject of this gaze, which we are supposed to find credible and with which we are asked to identify.

Consider the strategic potency of that invisible position relative to the seeming vulnerability of the visible witness. Powell compares these photographs with ones taken later that show the same sites having been cleaned up, the "sure signs" of deception having been removed.

> Now look at the picture on the right. You are now looking at two of those sanitized bunkers. The signature vehicles are gone, the tents are gone, it's been cleaned up, and it was done on the 22nd of December, as the U.N. inspection team is arriving, and you can see the inspection vehicles arriving in the lower portion of the picture on the right. The bunkers are clean when the inspectors get there. They found nothing.[4]

Powell presents a remarkably cinematic interpretation of these images. Not only do they show that the Iraqis diabolically "sanitized" weapons sites in advance of U.N. inspectors, but also they somehow capture the inspectors themselves just at that moment when they arrive on the scene too late. We in the audience know what has happened; we are privy to the villains' deception, but the inspectors are not. They are quite literally clueless. Throughout Powell's testimony, the weapons inspectors are portrayed as well-meaning

but easily deceived witnesses who see nothing, their tragic failure seen and recorded by the anonymous camera in the sky. So the inspectors are illegitimate witnesses; their acts of seeing are visible. "From our sources," Powell remarks gravely, "we know that inspectors are under constant surveillance by an army of Iraqi intelligence operatives."[5] The cameras, by contrast, are witnesses whose acts of seeing are accorded greater authority precisely because they cannot themselves be seen. It is to that authority that Powell defers when he says that the pictures are hard even for him to understand; it is that authority to which Powell stands in subservience when he says that he will try to capture and explain the pictures' meaning.

The image of Colin Powell seated before the Security Council and pointing to these photographs is one that I have carried in my mind as I wrote this book. It concretizes for me issues with which I am concerned in these pages. To put it succinctly, I believe that Powell did not originate the strategy of legitimizing the invisible witness, but that the figure of that witness pervades contemporary culture. I also believe that invisibility is an extremely powerful force in the competing truth claims made not only in contemporary U.S. and European political discourse but also in the academy. As a rhetorical trope in its most extreme form, it is capable of justifying unilateral warfare, but it has many more insidious quotidian functions.

I have long been concerned about the subject position of that witness and the privileges such a position can claim. I wish to argue that the godlike invisibility of this witness lends it a legitimacy and authority that allow it to control in alarming ways what we understand "the real" to be. Certainly that claim will not seem revolutionary given the now famous assertion made by a Bush administration aide to journalist Ron Suskind: "We're an empire now, and when we act, we create our own reality."[6]

As Suskind's articles and books have shown, the reality that this administration is intent on creating is one informed by "faith-based" as opposed to "reality-based" thinking. Suskind's concern is not even that this faith-based approach to analyzing information and establishing policy is specifically religious in nature, though of course that is also true, but that it turns a cold shoulder to empirical evidence, embracing instead intuition, divine revelation, and a predetermined view of the world. Again, though this view worries me greatly, the purpose of my book is not to dissect the Bush White House or even to discuss its specific policies. Rather, I see this administration as symptomatic of a larger discourse, painted with religious overtones, which surrounds the question of witness and which, as a result of its invisibility and its piety, empowers certain kinds of testimony and creates certain realities. I should make clear that these religious overtones are not found solely in the testimony given by avowedly religious witnesses, but they also sometimes tint the assertions of those who preach objectivity, reality, and empiricism.

In addition to its attendant theologies, I have also marveled at the ways in which witnessing—whether it is studied by scholars or invoked by generals making a case for war—is very often talked about in terms of pictures and their interpretations. The irony

that Powell acted at the United Nations very much like an art historian, showing images and pointing out their salient features, is not at all lost on me. While journalists and political analysts are far more capable than I of analyzing domestic and foreign policy, it takes an "imagery specialist" to understand the ways in which witnessing is an act of representation, of picturing, an act that is staged in the aesthetic domain of the visible and the invisible. As such a specialist, I must be aware of the ways in which my own witnessing is capable of the same errors, the same lack of introspection, the same colonization of reality.

Rather than seeing the theological and the aesthetic as two distinct strands of witnessing, I would argue that they are (as was the case with Powell's testimony) routinely intertwined. The discourse of representation, specifically of picturing, is itself imbued with quasi-religious claims about faith and the loss of faith, truth and moral corruption, origins and fundamental beliefs. For example, two important studies on witnessing, one that comes from the field of philosophy and the other from the field of psychoanalysis, tell the same story about a dramatic image contained in the mind of an eyewitness to the Holocaust. Psychoanalyst Dori Laub tells, and Kelly Oliver repeats, the story of a panel of historians interviewing survivors for the Video Archive for Holocaust Testimonies, at Yale University.[7] Laub depicts the witness as a "woman in her late sixties" who "was slight, self-effacing, almost talking in whispers, mostly to herself":

> She was relating her memories as an eyewitness of the Auschwitz uprising; a sudden intensity, passion and color were infused into the narrative. She was fully there. "All of sudden," she said, "we saw four chimneys going up in flames, exploding. The flames shot into the sky, people were running. It was unbelievable." There was silence in the room, a fixed silence against which the woman's words reverberated loudly, as though carrying along an echo of the jubilant sounds exploding from behind barbed wires, a stampede of people breaking loose, screams, shots, battle cries, explosions. It was no longer the deadly timelessness of Auschwitz. A dazzling, brilliant moment from the past swept through the frozen stillness of the muted, grave-like landscape with dashing meteoric speed, exploding it into a shower of sights and sounds.[8]

In Laub's hands, this story takes on an ekphrastic quality. He describes the survivor's act of witness as a work of art, as though the story's details were those of a painting or photograph: there are the four chimneys in flames; barbed wire; a crowd of people; a dazzling, brilliant moment from the past; a gravelike landscape; a shower of sights.

What is intriguing about this image for our purposes is that, while its veracity is called into question from the point of view of history, both Oliver and Laub attempt to defend it from the point of view of representation and even, in Laub's case, aesthetics. Moreover, each side invokes different theological principles (the single truth, on one hand, and faith, on the other) to support its claims. The historians to whom it is described claim that the image has lost faith with the truth of what actually happened, that "the number

of chimneys was misrepresented. Historically, only one chimney was blown up, not all four."[9] Not only that, but the historians, who are dedicated to objectivity and pure origins, who act as invisible witnesses to historical events, also question the motivations of the survivor while reserving for themselves a more pious neutrality: "'Don't you see,' one historian passionately exclaimed, 'that the woman's eyewitness account of the uprising that took place at Auschwitz is hopelessly misleading in its incompleteness? She had no idea what was going on. She ascribes importance to an attempt that, historically, made no difference.'"[10] The image painted by this witness is, to the historian's mind, inaccurate, unrealistic, and wanting in detail. As an image, we might say, it lacks the documentary accuracy of the photographic. Moreover, it is ignorant; in an overly dramatic, one might say biased, way, it represents events that were of no consequence. And so we move subtly from a factual judgment about the veracity of an image (it is misleading) to a moral judgment about the subject who testifies (she had no idea).

Both Laub and Oliver use this story to examine the problem of representation, a problem of the representation's mediation, of its unfaithfulness to fact. Both conclude that despite its errors, the image of the four chimneys on fire testifies to something beyond facts, something to which literal depiction can never accurately swear. Laub takes an aesthetic and moral position when he writes:

> She was testifying not simply to empirical historical facts, but to the very secret of survival and of resistance to extermination. . . . She saw four chimneys blowing up in Auschwitz: she saw, in other words, the unimaginable taking place right in front of her own eyes. And she came to testify to the unbelievability, precisely, of what she had eyewitnessed—this bursting open of the frame of Auschwitz. The historians' testifying to the fact that only one chimney was blown up in Auschwitz, as well as to the fact of the betrayal of the Polish underground, does not break the frame. The woman's testimony, on the other hand, is breaking the frame of the concentration camp by and through her very testimony: she is breaking out of Auschwitz even by her very talking. She had come, indeed, to testify, not to the empirical number of the chimneys, but to resistance, to the affirmation of survival, to the breakage of the frame of death.[11]

As if debating the merits of photography versus painting, Laub argues insistently for representation that breaks the frame, that feels more than it knows, that abjures empiricism and, with it, Courbet's famous realist dictum that in order to paint an angel he must first manage to see one. Laub's aesthetic, if you will, seeks out and places faith in the unseen, the angel of representation, so that "secrets," the "unimaginable," and the "unbelievable" may be revealed. He argues in favor of a form of abstraction and repetition in which one chimney miraculously becomes four.

Similarly, Oliver, in quoting this story from Laub and Felman's book, questions empiricism's enslavement to what is already known, to what conforms to received

knowledge. She urges instead forms of representation that, from the point of view of aesthetics, might be called "antirealist" in nature, focusing her ethics on representation "beyond recognition."[12] About this woman's testimony she asks, "What are the effective and affective differences between listening for what we already know and recognize in her testimony and listening for what we don't know, for what is beyond recognition?"[13] For Oliver, what is being represented in this victim's testimony is not a visually verifiable truth; it is not the chimneys but rather the victim's own subjectivity, her capacity to speak to, address, another, who in turn has the ethical obligation to respond. The Holocaust survivor's story, the vivid picture she creates of the uprising, is in these terms not a picture of the exterior world. It is, rather, a picture of her own humanity, her own subjectivity lost in the trauma she experienced and regained in the very process of verbally creating a picture of that trauma. In this way Oliver expresses faith in the act of witnessing, the *doing* of representation, not necessarily in terms of visual depiction but in the sense that in the act of representation itself, of testifying, "meaning is possible."[14] In these terms, the Holocaust witness's testimony is judged to be valuable, faithful to a truth, though, like God, not an immediately visible one.

From a methodological standpoint, I can see the merit in both of these approaches: the historians' need to correct factual errors; the psychoanalyst's need to accept the distortion of an event as a means to engender knowledge of it productively. In the present context, however, my concern is not with determining whose version of events is truer but rather with the way in which each witness (the Holocaust survivor, the historian, the psychoanalyst, the philosopher), by virtue of his or her perceived authority, is positioned relative to truth. Although both Laub and Oliver write in defense of the survivor, as against the criticism of the historians, like the historians, they do so from the point of view of academic (or, in Laub's case, medical) expertise. One might say that they position themselves as image specialists, and thus, in both cases, the survivor herself is subordinated to their judgment. Moreover, these authorities debate her testimony using a rhetoric of faith in invisible and presumably lost origins: for the historians, the "actual events"; and for the psychoanalyst, the repressed trauma as it infects and distorts the patient's selfhood.

Given the political stakes of witnessing (of the sworn testimony's production of reality), the moral stakes at work in interpreting acts of witness, and the artistic stakes of representation, how then should we examine and occupy the domain of witness? As is the case with Laub, Oliver, and the historians, the vast majority of scholarship on the topic of witness (along with the related issues of trauma, memory, testimony, and representation), in a variety of fields including Holocaust and trauma studies, psychoanalysis, philosophy, history, English, and journalism, focuses, as one might expect, on the question of *how* to bear witness. How can one put the Jewish genocide into words? How can one represent the devastation and trauma of war, natural disaster, or starvation? In *Seeing Witness* I ask a different question from a different perspective. Rather than "how," I want to know "who."

I seek to understand the witness as a privileged subject position, and rather than thinking primarily in terms of linguistic representation and narrative testimony, I contemplate witness in relation to the politics of the visual.

When it comes to the question of representation, as Lisa Saltzman and Eric Rosenberg note, "Ironically, much of the recent literature on trauma we consider foundational chooses to pursue the cultural and theoretical configuration of the issue in the domain of language as opposed to the visual."[15] They have in mind such seminal texts as Felman and Laub's *Testimony* (1992), Kelly Oliver's *Witnessing* (2001), Ruth Leys's *Trauma: A Genealogy* (2000), Cathy Caruth's *Unclaimed Experience* (1996), Dominick LaCapra's *Writing History, Writing Trauma* (2001), and Giorgio Agamben's *Remnants of Auschwitz* (1999). While Saltzman and Rosenberg specifically mention the growing literature in trauma studies, I would argue that the same might be said of the literature on witnessing (which often overlaps with that on trauma). Although it might occasionally mention or discuss visual examples, its primary focus tends to be on the linguistic.

This formative, and often theoretical, literature has, however, fostered a great many studies that focus on witness in terms of visual representation. One field that has contributed a great deal to the study of the ethics of witnessing in relation to the visual is photojournalism. Barbie Zelizer's *Remembering to Forget: Holocaust Memory through the Camera's Eye* (1998), John Taylor's *Body Horror: Photojournalism, Catastrophe and War* (1998), and David Levi-Strauss's *Between the Eyes* (2003) all provide extensive analyses of the ways in which media photographs of war, genocide, and disaster shape public understanding of events. Art history—a discipline that is especially suited to analyzing the poetics and politics of the image—has also drawn from the foundations of witness scholarship. There are a great many important books and exhibition catalogs that consider the artist or artwork as witness, texts that focus on artistic depictions of specific historical or traumatic events, such as the Jewish Holocaust or the AIDS epidemic. Douglas Crimp's *Melancholia and Moralism: Essays on AIDS and Queer Politics* (2002) and Dora Apel's *Memory Effects: The Holocaust and the Art of Secondary Witnessing* (2002) are just two important examples. As significant as these texts are, however, they tend to focus on single historical events or traumatic experiences, whereas my work is driven by a concern for the conditions of witnessing itself. Saltzman and Rosenberg's recent book *Trauma and Visuality in Modernity* is, therefore, a bit more closely aligned with my goals. The essays gathered in their book consider trauma (and therefore witnessing) to be an inherent feature of modernity, not only the trauma of specific experiences, such as world wars and genocide, but also of the visual itself. Thus, their book examines the mechanics and ethics of visuality from a variety of perspectives.

In a similar vein, because I believe that Colin Powell's invocation of the invisible witness is so powerful, so dangerous, and so dependent on visual discourses, the purpose of this book is to think about works of art that help us to see the act of witness, to catch sight

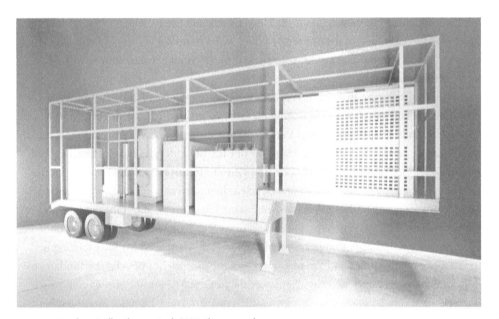

Iñigo Manglano-Ovalle, *Phantom Truck*, 2007. Aluminum and
epoxy paint, 32 feet, 9 inches (10 meters) long x 8 feet,
2 inches (2.5 meters) wide x 13 feet (4 meters) tall. A project
for Documenta 12, Kassel, Germany, 2007. Photograph by
Eli Ping Weinberg. Courtesy of the artist and Max Protetch
Gallery, New York.

of the invisible force on behalf of which Colin Powell testified. As an emblem of that
goal, we might keep in mind Iñigo Manglano-Ovalle's work *Phantom Truck* (2007), which
is an attempt to reveal the visual politics of Powell's testimony. Manglano-Ovalle's work
is, as its title suggests, a representation of a truck, a full-scale replica of one of the mobile
weapons labs that Powell's aerial photographs supposedly documented. Cast in aluminum
and painted grey, the truck appears with its exterior walls removed, allowing the viewer
to see inside, just as Powell claimed to do. But the viewer is estranged from the act of see-
ing because the room in which the truck is displayed is so dark that he cannot be certain
exactly what he sees. In addition, the accuracy of the information presented to the eye
is thrown into question not only because no such trucks were actually found in Iraq but
also because what one sees is only a replica, an aluminum toy modeled on Powell's verbal
descriptions and satellite photographs rather than on an actual vehicle. In this sense, it is
as though a representation, an act of seeing and of testimony, was made real and tangible.
Like Manglano-Ovalle's *Phantom Truck*, the works of art I examine in this book are use-
ful because they try to estrange us from witnessing, to see how seeing takes place. Broadly
speaking, the chapters that follow try to understand the problem of witnessing and

visual culture's inherent connection to it. More specifically, these chapters take up individual works of art made in the last ten or fifteen years that take witness as their subject, artworks that help us think about historical, scientific, technological, religious, and ultimately political testimony.

I want to emphasize that this book is not devoted to describing and attempting to understand specific events deemed worthy of witnessing, of which one might certainly choose thousands. I make no attempt here to catalog even the most recent and most dramatic traumas, neither 9/11 nor the Iraq War nor the bloodshed in Israel, Palestine, and Lebanon. Not the AIDS crisis, Darfur, or Abu Ghraib. In this book I think less about the panorama of events and objects that are looked at in any given instance (the presence or absence of weapons of mass destruction, for example) and more about the actors who look (such as the U.S. government), the technologies they look with, and the forms of power and moral authority that permit their looking and toward which their looking is mobilized. Similarly, although I am nervous about the ascendency of religious fundamentalism in the United States and elsewhere over the last thirty years and the ways in which religious hegemony dominates our understanding of witnessing, I am not interested in analyzing specific religious practices or beliefs. Rather, *Seeing Witness* repeatedly points to the precepts that all fundamentalisms inherently share: the unwavering certitude about one's knowledge of truth; the positioning of oneself as that truth's authoritative witness; the tactical shift from judging the truth of another's account to judging the legitimacy and worth of the other.

By examining the work of a range of contemporary artists—Marina Abramović, James Luna, Felix Gonzalez-Torres, Ross McElwee, Alfredo Jaar, Gilles Peress, Christine Borland, Eduardo Kac, Ann Hamilton, and Dumb Type—I contemplate in *Seeing Witness* a set of issues that arise within theories of witness. Although it began as a series of discrete essays, the book is drawn together generally by its repeated study of the relation between visibility and invisibility and more specifically by its attention to the ways in which the task of witnessing often succumbs to scopic knowledge, the value given to what can be seen. I also delve into the invisible reaches of memory, that process that is nonetheless dominated by visual representation.

In the first three chapters, I take up the question of history as the site of witnessing and consider the politics of history telling from different perspectives. As a means of laying bare my own investments in the question of witness, I contemplate the work of art history in chapter 1 and try to conceive of an ethical approach to that practice, one based on the philosophical concepts of love and desire. Chapter 2 offers, via an examination of a performance by Native American artist James Luna, an example of how the rights of official witness, the privilege of dominant histories, might be questioned, undermined, and reclaimed by those who are normally not authorized to occupy the position of historian. And in the third chapter I seek, first of all, to understand the ways in which theologically inspired laws prohibiting gay marriage, in addition to their other injustices,

prevent homosexuals from acting as legitimate witnesses to the personal histories of their partners. Second, I posit a queer understanding of history as a way to embrace history's repetitions, obscurities, and subjectivities.

The next section of the book, comprising two chapters, focuses on technologies of seeing and remembering. In chapter 4, I discuss the attempts of two photographers (Alfredo Jaar and Gilles Peress) to bear witness to the genocide in Rwanda and to the ways in which that tragedy was witnessed by the West. I inspect photography's role in acts of witness, the ways in which the witness is conceived, like the camera, to be objective and neutral. In chapter 5, I take a look at how digital technologies were initially conceived as memory devices and the ways in which contemporary digital culture affects how we remember and bear witness to the past.

If, as I'm suggesting, we consider the witness to be in a specific kind of subject position, it is necessary to contemplate the ways in which subjectivity is itself understood. The final section of the book is concerned with new advances in genetics and microbiology and the effects of those advances (and, by implication, of biopower generally) on how we conceive of the subject who witnesses. In chapter 6, I focus on a work by Eduardo Kac, which helps to illuminate how advances in DNA technologies, such as gene splicing and cloning, have challenged cultural beliefs about monstrousness, humanity, and visibility. In the book's final chapter I think about the post–World War II history of genetics and the ways in which Erwin Schrödinger's early characterizations of the gene have fostered a contradictory situation in which human subjectivity is both secured and radically undermined.

The purpose of these investigations includes a consideration of what art has to offer to the ethics of witnessing, how art has addressed such things as the ideology of the legitimate witness, the privilege and hegemonic power of official testimony, the politics of the ideal witness, and the ways in which that witness is modeled after the disembodied, monocular camera. In the book's conclusion, I return again to the issue of religion in order to deconstruct the rhetoric of witness narratives and their interpretations. Such texts are often, like Powell's testimony, patterned after religious stories of the Fall or of redemption, myths of origin, parables of truth and authenticity. Finally, the goal of this book is to witness something of the particular historical moment in which it was written. These essays testify to what life is like in the twenty-first century, a century that has been and will likely continue to be shaped by the racism, homophobia, fundamentalism, and genocide of the previous five hundred years, a century that will be witnessed through the lenses of history, technology, and biopower.

I. History

1. A Promise Always Disappearing
The Ethics of History in Ulay and Abramović's *The Lovers*

My first book was an examination of the work of Cuban-born performance artist Ana Mendieta and the historiography that surrounds her. A significant concern of that project was to consider the ways in which the historian works to locate and fix historical events and actors temporally, geographical, categorically, and ideologically. In this context I asked, "What kind of history is it that does not save?"[1] The question was meant critically as a means to envision a new kind of history writing, one based on performance rather than on the preservation-driven logic of the archive. It was there that I began to think about history as an authorized form of witnessing and about the historian as constituting a privileged subject position. So I engaged in a bit of wordplay using the connotations of the word *save*, which has to do simultaneously with preservation, rescue, and redemption. Now, in the context of the present study, this word reads theologically (as I outlined in the Introduction) to draw an analogy between the evangelical notion of being saved and the historical notion of being preserved. In that sense it no longer reads critically, but piously, expressing a faith in history's redemptive powers. Placed in this context, my question frames problems to which this chapter is addressed, which are, how to rethink the subjectivity of the historian, figured here as redeemer, how to formulate an ethics of history writing, how to uncouple the religious and the historical meanings of witness.

My subsequent work has attempted to do this by viewing performance as a particularly vibrant example of the strange relation between history and its objects. I have, for example, written about the desirous relation that exists between the two, the ways in which the historian not so much redeems or preserves but is slave to his desire for the lost object.[2] That work has led me to participate in a couple of conferences on performance art and its connection to the archive, to history, and to the document. In the spring of 2005, the Guggenheim Museum in New York convened a conference to examine these questions. The impetus for that conference was the planned exhibition, in the fall of 2005, of seven performances by Marina Abramović in which the artist would reperform five performance artworks that had been staged by other artists in the 1960s and '70s.[3]

Abramović's project was meant to elicit discussion about the degree to which performance art, usually thought of as ephemeral, unrepresentable, and ontologically self-obliterating, could be redone in the present. Related to that question are important artistic, historical, and philosophical problems, such as the methods of performance art's documentation and that documentation's faithfulness to the original event; the inherent loss of the original and the historical strategies by which that original is remembered and revived; and the phenomenological experience of performance and the relation between the experience and historical description. It was at this conference that I delivered the following paper, which is included here, in part, to stage my own investments in, and therefore vulnerabilities with regard to, the question of witness.

Philosopher Jean-Luc Nancy, in his essay "Shattered Love," writes: "Love is at once the promise of completion—but a promise always disappearing—and the threat of decomposition, always immanent."[4] Love describes a primary relation, a relation of one to another, what the one seeks and the other pledges. Nancy's description, though, seems to beckon us to think of that relation in terms of performance. The promise always disappearing reads as an explanation of what performance, in love, offers its histories; it is a promise that, as Peggy Phelan has famously written, is both constituted and threatened by performance's ontological disappearance.[5] For history, defined by an awareness of time, an occupation with memory, performance stands as Other, as that which abjures the responsibilities of the past and insists instead on the singular "now" of the utterance. Thus performance, by promising disappearance, ironically offers history its heart's desire, that is, its potential completion in its definitive Other. It thus pledges to history the excitement of the moment, not the past, not memory, but a pulsing Deleuzian repetition. "The theatre of repetition is opposed to the theatre of representation," Deleuze explains,

> just as movement is opposed to the concept and to representation which refers
> it back to the concept. In the theatre of repetition, we experience pure forces,
> dynamic lines in space which act without intermediary upon the spirit, and link
> it directly with nature and history, with a language which speaks before words,
> with gestures which develop before organised bodies, with masks before faces,
> with spectres and phantoms before characters.[6]

Performance art, which opposes the theatre of representation, rejects characters, is dressed in masks that do not stand in for faces, employs gestures that do not stand for other bodies. As such, the promise of love that performance makes to history should be understood in a very particular way: although it involves a pledge of fulfillment, it is not a teleological commitment offering an end outside of love, nor is it an appropriation of the other into the self; it pledges neither identity nor representation. What it offers is a singular enunciation, something like "I love you," in which, as Nancy explains, "nothing happens . . . neither power nor effacement." He continues, "This sentence names nothing

and does nothing."[7] What this means is that love does not name something exterior to itself, nor does it accomplish anything other than itself, which is to say that it exists, like performance, only in the moment of its utterance.

If this is what performance offers lovingly to history, what is it that history offers to performance? Deleuze might suggest that history offers only representation, only the attempt on history's part to "integrate the depth of difference in itself; of allowing representation to conquer the obscure."[8] History is the theatre of representation; it is premised on the organized body, which always exists a priori and to which are assigned words, gestures, masks, and ghostly images. The writing of history is, from this perspective, a mediation that prevents rather than enables our experience of the past. It might be said, then, that what history offers performance is not love exactly but desire presented as love. I have written elsewhere about love and desire and the ways in which art history, with its disembodied intellectualism and what Judith Butler calls philosophical "postures of indifference," can be seen in a desirous relation with its definitive Other, performance, with the latter's thrilling physicality and threatening lack. I have suggested that such professed love and unspoken desire succumb to hegemony, in the form of heteronormativity and sexism, and I have examined the high costs of the discursive deployment of desire masquerading as love.[9] While I remain committed to the task of examining the ideological effects of history, the restrictive, delusional, and colonizing effects of representation, in the end, I'm not willing to give up either history or representation. I am not finished with desire. Rather I want to think about history as a form of representation that does not necessarily always limit difference, that is naturally disposed to repetition, that muddles the distinction between love and desire.

Love and desire are normally seen, from the point of view of philosophy, as mutually exclusive. Nancy, for example, is at pains to distinguish the two. "Desire is not love," he declares. "Desire lacks its object—which is the subject—and lacks it while appropriating it to itself. . . . Desire—I mean that which philosophy has thought as desire: will, appetite, conatus, libido—is foreign to love because it sublates, be it negatively, the logic of fulfillment."[10] To put it more plainly, love seeks fulfillment, that is, knowledge of the self through the other; desire rejects fulfillment and unsuccessfully seeks only knowledge of the other in the name of the self. And this is why, according to Nancy, "desire is unhappiness without end."[11] This, it seems to me, is quite an accurate description of history, which, by virtue of its ontology, is set up for the unhappiness that comes with seeking something from which one is by definition excluded. While love is respectable in the eyes of metaphysics and welcomed into Plato's *Symposium*, desire is philosophy's bastard child, which means that, as Judith Butler argues, even when it is cast out it retains an essential relation to philosophical thought. "Desire," she writes, "has been figured time and again as philosophy's Other. As immediate, arbitrary, purposeless, and animal, desire is that which requires to be gotten beyond; it threatens to undermine the postures of indifference and dispassion which have in various different modalities conditioned philosophical

thinking."[12] Butler thus rejects the strict division between love and desire that philosophy has erected; she is suspicious of any claim that dismisses desire and along with it the body, identificatory practice, and sexuality, not to mention metaphysical hybridity. While desire is normally placed at some distance from philosophy, Butler reminds us that it finds entry in ethics and the philosophy of morals, where it is useful for philosophy's attempt, as she remarks, "to interrogate its own possibilities as *engaged* or practical knowledge."[13] Thus, desire is enormously useful in making history admit its subjectivity, accept its own embodiment. Despite Nancy's rejection of desire in favor of love, his analysis of love carries an extremely similar conception of ethics. He claims that the possibility of thinking love is equivalent to the possibility of thinking "of the life of a community, of a time and space of humanity."[14] More than with what distinctions can be drawn between desire and love, my concern here has to do with the ethics to which each perhaps differently points. I will argue that desire, despite its potentially deleterious effects, and love form the basis of an ethics of performance history, so that when we ask about the investments of the art historian in the lost object of performance, we are really asking an ethical question.

In particular, I want to use this opportunity to think about love and desire as potentially central to a historiographic ethics by taking a look at Marina Abramović and Ulay's 1988 performance *The Lovers* and, more specifically, at Cynthia Carr's remarkable historical account of that performance. This performance, to the degree that it engages the philosophical theme of love, seems ideally suited to my analysis, and, I will argue, Carr's history of it is exemplary of an ethics of art historical love: one that repeats even as it is representing; one in which we experience a crisis directly even as we read the description of crisis; one in which witnessing takes place both from within the event and at a distance from it. In addition, I am drawn to Carr's work because my own history, the one that I am articulating now, seeks both repetition and re-presentation. Just as the Guggenheim's symposium was designed to contemplate the re-presentation of performance, so I want here to think about the re-presentation of history, the repetition in my voice of an account written by someone else.

The Lovers was a performance that was conceived in 1983, when Abramović and Ulay had the idea of walking the length of the Great Wall of China. After five years of planning and negotiating with the Chinese government, they set off walking from opposite ends of the wall: Ulay started in the desert west, and Marina in the east by the sea. There were enormous concessions, changes of plan, and failures that, depending on one's perspective, either threatened the performance or constituted it. The artists were not allowed to travel alone as they had wanted; they did not walk every step of the wall as they had imagined, but were instead driven away from it in jeeps where it traverses sites that are considered sensitive for national security; they were unable to camp outdoors as they had hoped; and, for Marina in particular, the trek involved not so much walking as climbing. Worst of all, despite their original goal to meet at the middle of the wall and be married, a year before their walk began the two had split up, so after nearly three months of walk-

ing there was to be no wedding, just a meeting to say good-bye. As performance works go, this one is somewhat unusual in that, from the outset, the historian and his writing were integral to it rather than something assigned to come after. Historian and critic Thomas McEvilley was with the artists when they conceived of the project in 1983 and was invited to join the couple for periods of their walk in 1988. Indeed his chronicle of the walk is the main essay in the exhibition catalog dedicated to the project. In addition, Cynthia Carr, art critic for the *Village Voice*, was asked to join the walk and write about her experiences of it.

Carr's account is vivid and compelling; its voice changes from that of the historian or critic (descriptive and analytical) to that of the participant (excited, confessional, panicked). She performs both history's desire and performance's falling in love. "Each morning," she recalls,

> Marina had had to climb for two hours just to get to the wall. She would reach it exhausted. Then it would take all day to do twenty kilometers, then another two hours to climb back down. She'd never once camped. She'd descend to find a place in the nearest village or xiang. There she would ask the people to tell her stories about the wall. Not its history, but its legends.[15]

"We set off down the border of Inner Mongolia," Carr continues,

> for this was one of the rare places where the wall still served that function. And at the end of the day, we came upon a network of ruins. I was sure it had been a massive fort. In the field south of the wall, where peasants were weeding on hands and knees, sat two ancient greenish stone lions, and beyond them a walled city. I figured this had been the passage to Mongolia, heavily armed back when the wall was supposedly stopping the hordes. Marina wanted to spend the night in that ancient city, where I could learn the history and she could get a legend. We bounced through the same gate that once saw chariots—I was sure of it. I was overwhelmed by it. The buildings were yellow mud; their windows were oiled paper. Our jeep was the only vehicle there. Dingbian, in comparison, had been the picture of urbanity. . . . [At the xiang] we were able to discover that the village, over 2,100 years old, had been there before the wall was there. But no one knew anything of the ruins. No one knew any legends.[16]

Carr's account is richly layered, contradictory, and complicated. It is a history of the search for history, a history describing the pursuit of legends. It chronicles, with historical objectivity, the artist's travel: it is Marina who climbs and descends the wall; it is Marina who is exhausted. It identifies and records artifacts (the green lions), identifies ruins, draws historical conclusions about their past existence, assigns dates, and is marked by loss: "no one knew anything of the ruins." At the same time, however, Carr describes the historian as performer, as one who sets off, one who bounces through the gate. She not only represents and describes a historical other (i.e., the performance or the performer); she also

repeats by presenting herself as both the subject and the object of her own study: "I was overwhelmed." As a result, her account stages "love" as a paradigmatic relation, one that is cast in terms of difference and identity, of self and other.

Originally conceived as a marriage ceremony, this performance has, not surprisingly, generated historical narratives that read as love stories. The artists, in the exhibition catalog, state romantically: "The function of Lovers in the Concept of Conjunction: The union of heaven and earth in primitive astrobiological religions is a symbol of conjunction, as is also the legendary marriage of the princess with the prince who has rescued her. In conjunction lies the only possibility of supreme peace and rest."[17] Cynthia Carr, too, is compelled to narrate her experience of the performance in terms of love. When she describes the power of Abramović and Ulay's years of collaboration, she says: "At the heart of all the work . . . was their connection and commitment to each other. The artists themselves described their relationship as lovers, brother/sister, husband/wife. . . . In their work together, with their somewhat similar profiles and sometimes similar haircuts, they became the image, at least, of the ideal couple."[18] I would suggest that Carr conceives

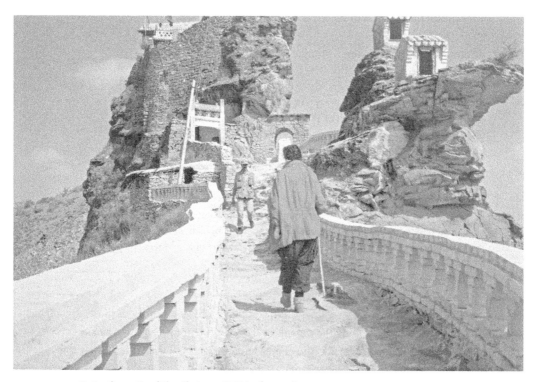

Marina Abramović and Ulay, *The Lovers*, 1988 (performance). Meeting at the Great Wall at Er Lang Shan, Shenmu, in Shaanxi Province, June 27, 1988. Photograph by Da Hai Han and He Xinmao. Reproduced courtesy of Sean Kelly Gallery.

of the artists' works as a display of love not just as a romantic but also as a philosophical ideal. Key to that ideal is what Nancy describes as the breaking or shattering of the self. Love is a relation in which the self seeks the other, not in terms of some teleological fulfillment or in terms of a destination outside the self; rather, that self is *in* love where it experiences a radical break. "The break," Nancy explains, "is a break in [the lover's] self-possession as subject."[19] In her essay, Carr describes a similar kind of shattering as a central goal of *The Lovers*. "They were surrounding themselves with the unfamiliar," she remarks with an air of Hegelianism, "in order to find the unimaginable."[20]

The shattering experience of love characterizes not only Marina and Ulay's sojourn but also Carr's own. She willingly makes her subject position as historian, as official witness, vulnerable and brings it to a productive crisis. "Going off to find the artists on the wall was a trip that I'd saddled with some do-or-die meaning," she writes. "I suppose I thought it would change my life."[21] Of her own experience on the Great Wall, Carr says several times that it was estranging, disorienting, desubjectifying, and overwhelming:

> I began to cry, overwhelmed because I'd come so far, and I don't mean geographically.

> I wouldn't know where I was going, what I'd find there, or (usually) who was taking me.

> Everything familiar was now strange, and I didn't know where I was. Couldn't tell what direction we were going.

And finally:

> I, however, felt a sort of vertigo in the village, an irrational panic I couldn't explain to her. Perhaps I was simply more alien(ated) than I had ever been before. Perhaps when nothing fits a single groove in your memory, you're like a newborn. I would remember this later as a most valued moment.

Carr is, in a way, falling in love with China and with the performance, or rather with the experience of disorientation that they produce. She encounters these paradigmatic others and seems sincerely to believe that they will bring her to herself, that they offer some promise of completion. She experiences the break "in [the subject's] self-possession as a subject." Read metaphorically, as expressions of the experience of history, Carr's statements suggest that the ethics of history (of history as witness) resides first of all in its recognition of itself as performer and second in its necessary acceptance of (dis)orientation, its willingness to operate within the space of alterity, to undermine its own subject position as situated in the present and looking back over what de Certeau has explained is a clearly circumscribed past.[22]

But just as Carr seems to map her location squarely at the center of love, she simultaneously casts herself as an exile who knows only desire. She remarks, "In walking the

Great Wall, crossing mountains and deserts to reach each other, they wished to experience at their meeting 'the apotheosis of romantic love.'"[23] That the historian is placed on the outside of that relation is evident earlier on where she writes: "I suppose the relationship-as-tableau represented some ideal of love and work, of trust and acceptance, that I despair of attaining."[24] Here she seems to look across an invisible border at a region or a time from which she is excluded; she marvels at Marina and Ulay's relationship, their commitment to each other, their love. She is placed in the position of desire, where not only the promise is always disappearing but also fulfillment is denied. That she can occupy both positions simultaneously (that is, the position of a lover, of a performer, who participates in the shattering search for fulfillment and the position of the desirous historian who is separate from the object of her study) is owing to the aporia by which history is itself characterized. To speak of the past is simultaneously to be excluded from it. This is so for history writing in general but is more acutely felt in an art history in which the object of study is not an object at all, in the sense that usually has for the art historian, but an ephemeral action. Cynthia Carr's dramatization of that exclusion makes a play of history's lack of fulfillment, of its limitations in desire, of what goes wrong in it. Her writing thus suggests that an ethical history involves the declaration of its strangeness, both in the sense of being odd and in the sense of estrangement.

That idea most dramatically appears in Carr's account when she describes one night she and Marina were to sleep in a graphite factory. During the night there was a power outage, and, with nothing else to do until the power was restored, the two joined the workers gathered in the factory yard. "A voluble middle-aged man in a white T-shirt made some little speeches . . . about how welcome we were," Carr explains.

> People always talked to her this way, Marina said. It was so hard to get past the platitudes. The workers went on to say that "conditions" weren't so good, then he asked us to please sing. Marina had soon persuaded *him* to sing instead, and in a beautiful tenor he sang bits of local folk songs. I went in for a jacket and returned to find that Marina had assured the group *I* would now sing. A dozen workers watched me expectantly, as Marina suggested I do "Strangers in the Night." Mortified, I gave them my best Sinatra. They only looked baffled and stunned.[25]

Some very interesting things happen in this passage. Carr describes that moment when she is shifted from observer or chronicler to performer, a moment that is repeated several times in her journey. She writes, "We were no longer ourselves, but spectacles of ourselves."[26] In such moments she embodies the repetition to which Deleuze refers. "Repetition is truly that which disguises itself in constituting itself, that which constitutes itself only by disguising itself," he explains. "It is not underneath the masks, but is formed from one mask to another, as though from one distinctive point to another, from one privileged instant to another, with and within the variations. The masks do not hide anything except other masks. There is no first term which is repeated."[27] The masks dis-

played in this account include not only Carr's own mask and that of Frank Sinatra but also the mask of historian and of performer, of the past and of the present. As soon as Carr begins to sing, to perform, she is split between performance and history, the one who acts and the one who remembers, repetition and representation. Her subjectivity is, once again, shattered. It is fitting then that she sings a love song about strangers, for the relation between history and performance needs to be one that accommodates estrangement. Love, which names that relation, needs somehow to resist overcoming difference; it needs to repeat difference, to reenact it without mediating it. For art history, this means inviting repetition within the strange space of representation. For Carr it means writing about, that is, representing, her own estrangement, which is itself a repetition of history's own strangeness. So she writes about singing a love song: "Strangers in the night, exchanging glances / Wond'ring in the night / What were the chances we'd be sharing love / Before the night was through."

2. Peoples of Memory
James Luna and the Production of History

Consider Pierre Nora's claim that today history is replacing memory. Nora, editor of the seven-volume opus on French history *Les lieux de mémoire (Realms of Memory),* claims that history, embodied in the coldly official text, datum, and archive, eradicates memory, which is not embodied because it *is* body, cannot be written because it is lived. Memory's body is, for Nora, "displaced under the pressure of a fundamentally historical sensibility." It "has taken refuge in gestures and habits, in skills passed down by unspoken traditions, in the body's *inherent self-knowledge,* in unstudied reflexes."[1] Because we are products of Western civilization, citizens of capital and industry, audiences of the news media and simulation, agents of change and progress, and participants in Guy Dubord's "society of spectacle," we are estranged from customs and performances of remembering. Driven away by neglect, the "living," "actual," "affective and magical" past has but one haven today among those societies bound to "rituals of tradition"—what Nora calls, "peoples of memory." Real memory, he says, is "social and unviolated, exemplified in but also retained as the secret of so-called primitive or archaic societies."[2]

Nora's thesis uncomfortably rehearses Western historiography's fetishization of the "native" other. It upholds, under the banner of critical theory, the ambivalent discourse of primitivism, the suspicion by whites (presumably peoples of history) that salvation lies in tribal "secrets." I support Nora's questioning of Western culture's reliance on official history and the damaging ideological effects of its mindless reverence for the uninspected category "information." Yet, his firm distinction between history and memory depends on a belief that the former is textual and Western and the latter is experiential and native. How do Nora's claims help justify the development of technologies for reading and writing these lost authentic memories? How do his assertions embolden Nora to make historical claims on memory whose inviolate purity he has himself discursively produced? How does his thesis ultimately endorse the need for historiography, a practice he ostensibly seeks to dismantle? How does his view of native peoples establish his privileged subjectivity as witness?

The ambiguity of Nora's phrase invites a misreading. When he writes "peoples of memory," does he mean those who remember or those who are remembered? And does

not the former depend firmly on the latter? I am concerned here with what balances on the point of that *of*, with the conclusions to which its double meaning leads. Let us consider the damaging effects, on one hand, of claiming that archaic societies are more mnemonically successful than our own and, on the other hand, of presuming that such societies exist pleasantly in memories of our own past. The stakes here are high, because although peoples who remember may be envied by whites, as Vine Deloria points out, native memory, "prehistorical" legend, and mythology have a hard time competing for legitimacy in Western epistemology.[3] What manner of violence is done when memory is tied like a stone to the foot of the native and then tossed into a sea of postmodern cynicism? If, as Nora claims, self-knowing is inherent in the body, a living aspect of memory, then the native body itself stands both as proof of memory's purity as a category and as cause of its elusive nature and incommensurability with authoritative discourse. In that sense, what results from self-knowing cannot be *known* in a theoretical sense, cannot be written, cannot really be expressed.

The results are no less troubling when we consider peoples who are remembered, for to be remembered means inherently to exist only in the past, to succumb to the process of forgetting and blurring, the "misty watercolor memory" of Barbra Streisand's song. When Nora writes of archaic or primitive secrets, he reveals something about the sources of his own memories. Vivian Sobchack writes that, just "as filmgoers have not been able to escape the lessons of historiography, so, on their side (and try as they might), historians have not been able to escape the lessons of the movies and television."[4] Nora seems to be remembering a Hollywood character like Tonto or a literary figure like Queegqueg and mistaking them for real natives. Tonto's crossed arms and stony silence and Queegqueg's mysterious tattoos are signifiers for their enigmatic character and proof that they are not themselves witnesses but that their self-knowledge must be given voice by others. In saying this, I am not arguing that Nora's picture of the native is somehow tainted by the televisual or fictional image, that Tonto cheapens his otherwise legitimate historiography (a claim that Sobchack's essay vigorously questions). Rather, I am suggesting that history, in an intensely mediated environment, often suffers from a confusion: did this really happen or did I just see it on television? Moreover, I think that sometimes the historian is keenly invested in retaining, rather than sorting out, the confusion. It is not "peoples of memory" who animate the historian's text but rather the mysterious native, whom he has, in Joe Roach's words, "imagined into existence as his definitive opposite."[5] I am forced to ask whether our memories as Westerners are peopled by a cast of invented natives whose performances of authenticity and "silent customs" are scripted by our own historical accounts.

Performance artist James Luna deconstructs the phrase "peoples of memory" in his 1996 performance *In My Dreams: A Surreal, Post-Indian, Subterranean Blues Experience*. He toys with white anxieties that native cultural memories are more significant, more spiritual, or more pure than their own. Luna spends a great deal of his time as an artist clowning in the costume of memory and history, throwing a pie in the face of liberal guilt and white

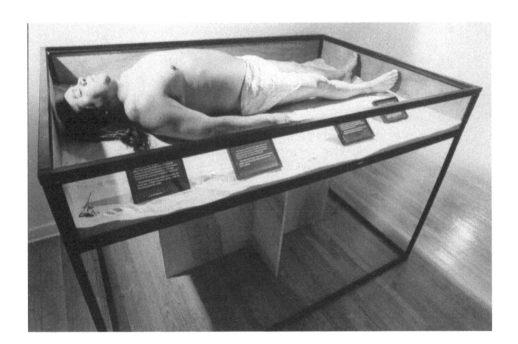

James Luna, *Artifact Piece*, 1987/1990. Performed at the Studio Museum in Harlem as part of *The Decade Show: Frameworks of Identity in the 1980s*. Photograph by Robin Holland. Courtesy of James Luna.

"native envy." He does pratfalls over the question of authenticity, tripping again and again over the problem of the body's "inherent self-knowledge." He also shows that, in the context of dominant culture, being remembered, like being dead, is often a stifling experience. In this chapter, I examine Luna's performance in order to learn his strategies for getting some memories forgotten as well as others restored. These strategies are important because, to the degree that Nora is a self-styled "historian of memory," he is among a burgeoning number of scholars who investigate identity through the past. His suspicion that "we live in an age of rupture" is the contemporary historian's motivation, and it lends urgency to Luna's project because it hints at the desperation with which that historiography is produced.[6] It is in the context of this urgency that I want to show how Luna uses Dean Martin as the visual signifier for white culture's stupefaction, its customs and rituals of forgetting.

James Luna first engaged these issues in his *Artifact Piece*, which he performed in 1987 at the Museum of Man, in Balboa Park, San Diego. As a critical parody of the ethnographic museum, Luna composed a display on the Native American in which he, himself, lay in a museum vitrine clothed only in a towel. Placards that appeared with the display transcribed the various scars by which Luna's body is marked:

Drunk beyond the point of being able to defend himself, he was jumped by people from another reservation. After being knocked down, he was kicked in the face and upper body. Saved by an old man, he awoke with a swollen face covered with dried blood. Thereafter, he made it a point not to be as trusting among relatives and other Indians.

The burns on the fore and upper arm were sustained during days of excessive drinking. Having passed out on a campground table, trying to walk, he fell into a campfire. Not until several days later, when the drinking ceased, was the seriousness and pain of the burn realized.

Having been married less than two years, the sharing of emotional scars from alcoholic family backgrounds (was) cause for fears of giving, communicating, and mistrust. Skin callous *[sic]* on ring finger remains, along with assorted painful and happy memories.[7]

By transcribing these scarified signs and pretending to decode their meanings, Luna objectifies the script that is etched in his skin. The contusion, the burn, the callus in this case function, like Queegqueg's tattoos and Tonto's folded arms, as signifiers for mysteriousness, wildness, the body's "self-knowledge."

In this performance, Luna engages the problem of alcoholism among Native Americans, a theme that recurs in various ways in his work. The educational texts in this mock museological display are unified by their references to drunkenness, which has both comic and tragic overtones. A few years after this performance, in 1990, Luna addressed the theme again in his work *A.A. Meeting/Art History*. In this piece, the artist is photographed mimicking the Indian's pose in James Earle Fraser's famous sculpture *The End of the Trail*, except that, instead of a pony, Luna straddles a sawhorse, and, instead of a spear, he carries a bottle of liquor. Luna, in the guise of the contemporary Indian warrior, finds his trail blocked by the debilitating effects of substance abuse, his battle for independence lost to chemical dependency.

To see these works solely as tragic commentaries on the troubles that plague Native North America would be a mistake. It is important to recognize that they also investigate historical representations of natives, question how Indians are remembered by whites. For Luna, Fraser's sculpture is part of the same historical imagination, distorted by the desire for poetical authenticity, that produced the film *Dances with Wolves*, which, in his words,

did nothing but glorify all the good stuff. It didn't show any Indians mad, or any Indians upset. It didn't show any Indians cry. It didn't show any Indians fucking up. We're still beautiful, stoic, and pretty. You see the movie and you go out and see a fat, overweight, acne-covered, poor, uneducated person—is that the real Indian you want to see?[8]

The liquor bottle that appears in *A.A. Meeting/Art History* has more than a merely sociological significance, as the work's title suggests. It is not just an artifact of alcoholism; it

James Luna, *End of the Trail*, 1990, from *A.A. Meeting/Art History*, 1990–91. Gelatin silver print, 30 x 39 inches, mixed media installation. Photograph by Richard Lou. Courtesy of James Luna.

is also metaphorical of history's inability to determine whether its memories really happened or are manufactured out of fiction, television, film, and popular art. It is a vivid reminder of history's tendency to pass out and forget the past.

In My Dreams depends on similar jokes to introduce two significant themes that balance uneasily on the question of memory. "Wildness" and "control" are like two white lines marking the boundaries of the highway that appears as one of the performance's central images. James Luna rides, sometimes erratically, between these lines.

One component of the performance is a ritual of examination that functions as an eating ritual, a solemn purification and blessing of food. In this scene, Luna enters the stage wearing a sleeveless white T-shirt and black pants. He sits down at a small table and begins arranging the empty plastic food containers that are set there. First Luna takes the lid off a Styrofoam cup and pours in a packet of artificial sweetener, the contents of which sound like fine sand against the empty cup. He then pretends to smell the coffee and stir it. He pantomimes a sip, shrugs as though to say "Why the hell not?"

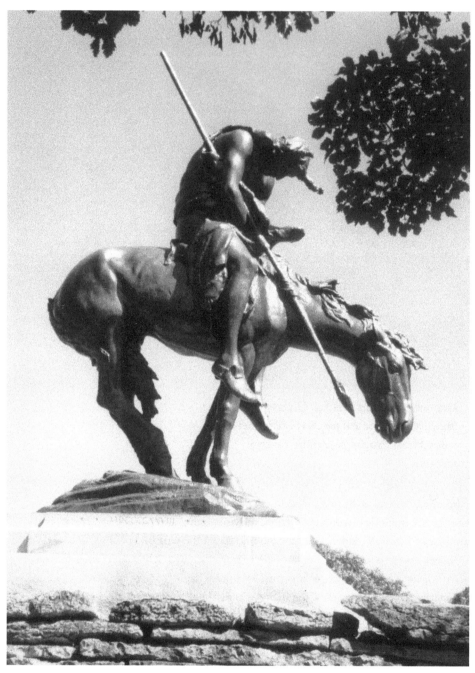

James Earle Fraser, *The End of the Trail*, 1894. Bronze, 134 inches in height. Photograph courtesy of the City Clerk's Office, Waupun, Wisconsin.

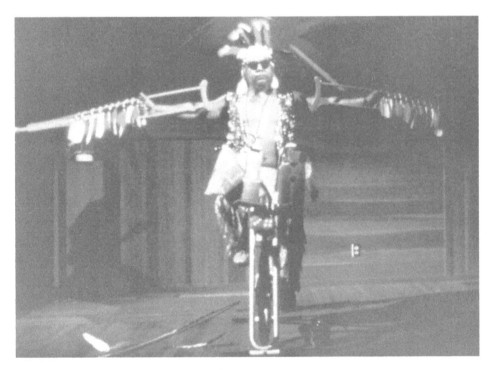

James Luna, *In My Dreams*, 1997. Performed in Saskatoon,
Saskatchewan, Canada. Photograph by Bradlee LaRocque.
Courtesy of James Luna.

and adds another package of sweetener, inducing a few people in the audience to laugh
uncomfortably. Then he opens a clear plastic box with raised divisions forming com-
partments (the kind of box in which a deli sandwich or salad might be served). Into one
compartment he squeezes a flatulent packet of catsup, the contents of which appear like
a dollop of bright red paint. Into an adjoining compartment he empties a packet of mus-
tard, thus adding a bright yellow to his palette. Luna then opens a small packet of salt and
sprinkles it over the whole container, shrugs, and adds more. More people laugh. He fin-
ishes by sprinkling a packet of pepper. He pantomimes taking a taste of the invisible food
smothered in real, artificial flavorings.

 Before he proceeds to "eat," however, Luna takes out a small black case with a zip-
per, opens it, and removes an object resembling a calculator, which the audience soon
discovers is his glucometer. He places it on the table, then opens a light blue plastic tooth-
brush holder and takes out a small plastic container about the size of a medicine bottle.
He opens the top, takes out a strip, and places it in the meter. He then pricks his finger,
squeezes blood from it onto the strip, and sucks off the salty excess. The audience waits
while he silently watches the meter count backward from 45. He returns the strip bottle
to the toothbrush holder and removes from it a syringe and a small bottle of insulin. He

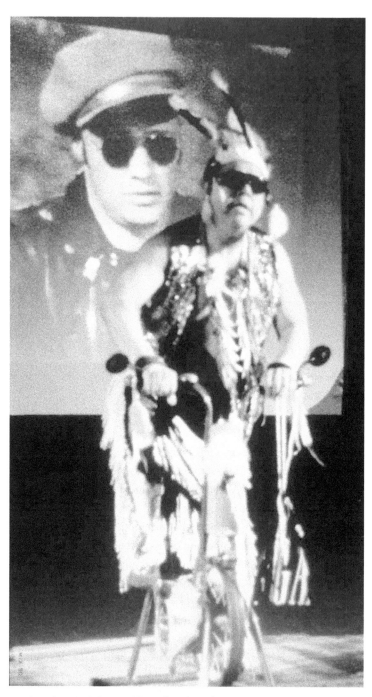

James Luna, *In My Dreams*, 1997. Performed in Saskatoon,
Saskatchewan, Canada. Photograph by Bradlee LaRocque.
Courtesy of James Luna.

draws up several units, lifts up his T-shirt and injects himself in the abdomen. He then recaps the needle and puts the insulin and syringe back in their case. He picks up the plastic utensils as though to eat, and the lights black out bringing the scene to an end.

In this scene, Luna engages diabetes similarly to the way he did alcoholism in his previous works; that is, he treats it both as an artifact of the dysfunction of Indian culture and as a metaphor for the dangers of white historiography. The former idea is the most obvious, because, like alcoholism, diabetes has achieved epidemic proportions among Native Americans in the United States, Canada, and Mexico. On the La Jolla Indian Reservation, where Luna lives, some 42 percent of the population are diabetic. Luna's project has long been to show the present reality of Indians, to demonstrate native appropriation of white culture, and to document his community's persistent survival despite its occupation by outsiders.

In this scene, Luna seems to invoke Foucault's claim that in the culture of discipline, the body becomes an object "perpetually offered for examination."[9] The examination is essential to the rhetoric of diabetes care, which is based on control. Since the disease is incurable, the goal is simply to control it, to force the body against its will to work "normally," and it is the glucometer that polices the boundaries of normativity. To be out of control means to be unconstrained by rules or consequences, to be irrational, unreasonable, unpredictable. The test, to the degree that it both produces and polices the boundaries of the "normal," is a tool of history's representational authority, the source of its claims to truth, to universality. The glucometer is an artifact that testifies to contemporary culture's devotion to technology and simulated knowledge. "Everywhere," Baudrillard insists, "the test functions as a fundamental form of control," and this is because in it "the answer is called forth by the question."[10]

Because he is diabetic, James Luna must accept what Baudrillard calls the "manipulative truth" of the test.[11] It is possible to read his performance of this ritual examination as an engagement with the question of "manipulative truths" of various kinds. In this scene, the injection Luna takes reads as an inoculation against simulated food, mass produced and excessively packaged condiments. Luna's silent performance mimes the gestures of traditional thanksgiving blessings, but in a context where food is a symbol of white colonization of Native America.

In the era of what he calls the "McIndian," in which one can order sweat lodges, dream catchers, shaman lessons, ceremonial drums, and an endless array of turquoise jewelry from mail-order catalogs, Indian culture is packaged as spiritual fast food for white consumers. But as much as Indian-ness is consumed by whites, whiteness is consumed by Indians. The television, popular music, alcohol, fast food, commercial food additives, and consumption-promoting packaging associated with dominant white culture are a central part of the Indian way of life. The consumption of whiteness is toxic, however; it devitalizes the native population with alcoholism, hypertension, and diabetes, which in turn ironically invite still further intersections with white culture in the form of its

political, scientific, and technological response. What can the glucometer mean to Luna as a surveillance device? How is its power exercised on him? To what end does he publicly perform the ritual of examination?

The glucometer writes Luna's identity as a contradiction between wildness and control, savagery and civilization. He is wild because he is an Indian and prone to diabetes and alcoholism, unemployment, and the loss of traditions—diseases of consumption that threateningly point to capitalism's extreme conclusions. He is controlled because he is subject to repeated examination by a device that stands for white ingenuity and authority. Such stereotypes essentialize Indian identity as either "savage or civilized, descended from pastoral shepherds or warlike plunderers."[12]

Luna uses a mock ritual to confront the two versions of white memory: repudiation and desire. He disturbs the happy image of the "peoples of memory" by showing whites what it can mean to "be remembered," what white identity looks like from the point of view of its own representation in television, film, history, and popular culture. Luna fabricates this performance of whiteness out of ambivalent memories of McDonald's, the Lone Ranger, and Jean Jacques Rousseau, a whiteness that manifests itself in anxieties over the loss of spirituality, meaningful tradition, authenticity, and nature and an unquestioned faith in science, technology, and progress. The performance exposes how Anglo and Indian identities are each produced, as Scott Michaelsen writes, "within sight of the other, with reference to a site for the other."[13] Luna refers to those whites who envy what they perceive as the native's "better memories," gentle, prehistorical memories of meaningful ceremony, as a tribe of Wannabes. He disillusions their fantasy by showing just what native memory now includes: the remembrance of whiteness remembering nativeness.

Luna's goals with respect to constructions of identity can be seen more clearly if we consider other sequences from the performance *In My Dreams*. It is set on a small stage with a white screen at the back. A white stationary bicycle is positioned at center stage, facing downstage toward the audience. The handlebars of the bike are elaborately decorated with red, white, and blue feathers, a small white basket, and a dream catcher. Directly in front of the bicycle is a circular electric fan, which is also decorated with red, white, and blue feathers. Behind the bicycle on a small ledge beneath the slide screen, a pair of small crutches is placed, the wooden framework of which is decorated with simple curvilinear black lines. The same red, white, and blue feathers are affixed along one side of each crutch with eye hooks.

The overture for the performance consists of a medley of popular songs by Jefferson Airplane ("Plastic, Fantastic Lover"), Cheryl Lynn ("Got to Be Real"), Rick James ("Give It to Me Baby"), Junior Brown ("Surf Medley"), Dean Martin ("Return to Me"), and a monologue by Jack Kerouac on the Beat Generation. The music is accompanied by slides projected onto a large white screen, including documentary black-and-white photographs of Native Americans posed in groups, performing dances, and so forth, and images of

Luna from previous performances. The lights fade, and a song called "Only in Dreaming" is broadcast; the slide show continues, this time with an image of Dean Martin from an early record cover.

Luna steps from behind a door at stage left dressed ridiculously in a cheap costume-like headdress with a flashing orange light in the center, a brightly colored sequined vest, black pants, and red athletic shoes. From his waistband hangs a white hotel towel positioned as a breech cloth, the embossed name "Hampton Inn" clearly legible. He carries a long stick with a pointed spearhead at one end.

He climbs aboard the bicycle, and a video on a continuous loop is projected behind him, which at first shows the pavement rushing by from the vantage point of the back of a car. The clip of the rushing pavement is intercut with a scene from *The Wild One*, in which a pack of motorcyclists dressed in black leather approaches the viewer and grows to fill the screen. The motorcyclists seem to be roaring past Luna, who continuously pumps the pedals on his bicycle. Another clip shows Dennis Hopper and Peter Fonda from *Easy Rider*, riding motorcycles across the screen from left to right, perpendicular to the direction of Luna's trip. While the three clips keep rolling in sequence, Luna first pedals his bicycle slowly, then displays his "spear" and does "tricks," such as balancing on one pedal while extending his other leg behind him. He stoically motions the audience for applause. He sits down again and resumes his pedaling, reaches into the basket, draws out a pack of cigarettes, and lights one. Then he takes out a can of beer and pops it open. After taking a drink he returns it to the basket to the sound of nervous laughter from the audience. With the projected images of the road speeding away behind him and the fan blowing the feathers on both the handlebars and his headdress, one has the sense that Luna is riding along slowly and silently as if in a dream.

Suddenly a change occurs in the repeating loop of the video. For the first time, we see the scene in *Easy Rider* in which two "rednecks" in a pickup truck pull up alongside Dennis Hopper, riding his motorcycle. The film's sound track is not broadcast, so the two men engage in silent dialogue with Hopper, who turns cooly to them and "flips them off." The man in the passenger side of the truck takes out a shotgun and points it at Hopper. The audience watches Hopper get knocked from his motorcycle by a bullet. Luna rides steadily throughout this scene and then, looking upward, flips off some unseen interlocutor. The video cuts off; he dismounts his bike and goes out the side door.

Luna's use of *The Wild One* and *Easy Rider* in this performance is significant, because both films depict wildness, cool failure, and rebellion as forms of cultural resistance. *Easy Rider* especially associates wildness with freedom, with a return to the land and to self-sufficiency. The entire plot of that film is based on the pursuit of freedom. The cross-country motorcycle trip that forms the film's structuring device begins when the main character, Wyatt (Peter Fonda), throws his wristwatch into the road, symbolically rejecting the preoccupations of work and economic ambition. Along the journey he and his partner, Billy (Dennis Hopper), experience various alternative lifestyles, from a hippie

commune to Mardi Gras. In one scene Wyatt says to a rancher who has come to his assistance, "It's not every man that can live off the land. You can do your own thing in your own time. You should be proud." The focus on wildness is sharpened by Steppenwolf's song "Born to Be Wild," which forms the sound track for Wyatt and Billy's cross-country trek. Freedom here is associated with wildness in the sense of pastoralism, unrestrained growth, and living off the land.

The motorcycle is the perfect symbol of individualism and rebellion. In both this film and *The Wild One* the riders are perceived as threatening. Yet Wyatt and Billy in *Easy Rider* are completely misunderstood. It is not they who threaten, but the lower-class, racist whites who ultimately murder them. On the contrary, the life they seek is the romanticized bucolic life of the native. The native's lifestyle is positioned as the most peaceful, pure, and enviable. The film, released in 1969, had a strong impact on its young viewers but had special significance for Luna and his college-age friends, for whom it resonated with the American Indian movement and a validation of Indian identity.

The Wild One serves as the violent counterpoint to the pacifism of *Easy Rider;* its characters are the "warlike plunderers" to *Easy Rider*'s "pastoral shepherds." With Johnny (Marlon Brando) as their leader, these motorcyclists travel in a pack, a threatening group formed in solidarity to create meaningless havoc. In this context Marlon Brando's character takes on a cool cynicism and nonchalant anger so that the film's most famous scene—the one in which someone asks, "Hey Johnny, what are you rebellin' against?" and he answers, "What have you got?"—is its most disturbing. This is just blind rage. Like *Easy Rider,* the film's plot involves the unjust persecution of the misunderstood hero. When the gang occupies the small town of Bleeker, threatening its citizens, especially the sheriff's daughter, the men in the town, whose masculinity has been intimidated by the gang's behavior, form a lynch mob. Through a misunderstanding over the death of one of Bleeker's elderly residents, they pursue and finally imprison Johnny. In its final scenes, *The Wild One* toys with the questions of truth, justice, and mob violence, and ultimately Johnny is saved by the honest testimony of an eyewitness.

While the native sits at the heart of the freedom fantasies in these films, Luna shows here, as he did with the food ritual, that wildness and control are interchangeable operations. He reveals the ways in which the native is tamed by colonizing forces. His stationary bike is literally going nowhere. It is a "girl's" bike in contrast to the rugged masculinity of the motorcyclists' roaring machines. He wears a cheap costume with a fake loin cloth and a headdress that doubles as a reflector, against which Hopper's blue jeans and Brando's leather take on a rugged authenticity. In his basket he carries no secrets, no tribal artifacts, only beer and cigarettes. Unlike the pervasive use of marijuana in *Easy Rider,* which shows the characters' assimilation of an enriching spiritual practice associated with Indians, Luna's contraband marks him ironically as "white trash"; it reads as low-class and self-destructive. When he dismounts to perform his Eagle Dance, he does so not with

traditionally decorated wings but with crutches that symbolize the limitations placed on his flight, which is no longer a tribal ritual but entertainment packaged for white tourists.

Peter Fonda wears a jacket with a red, white, and blue flag, meant to suggest an America made out of adventure and a quest for the authentic, which is offered in response to bourgeois conservatism. In contrast to Fonda's jacket, the red, white, and blue feathers that decorate Luna's bike and crutches suggest a commodified version of the native, the sell-out to America, Incorporated. Unlike the horrifying instant in which Hopper is stopped by the bullet, Luna's conflict is measured more slowly and less dramatically by an incremental accommodation of the influences of dominant white culture. His gesture of resistance seems less brash, less cocky, and ultimately inauthentic in regard to the common stereotype of the wise and stoic Indian.

In My Dreams is more than a lament on the state of native culture, however. It employs effective strategies whereby history is remembered and memory is historicized. This move may be seen most dramatically in Luna's enactment of horse tricks on his bicycle. By balancing on one leg and extending his other behind him, his arms outstretched, Luna seems at first to parody Indian horse tricks performed at rodeos and Wild West shows for white tourists. His performance is complicated, however, by the fact that Dennis Hopper, as Billy in *Easy Rider*, performs the exact same moves on his motorcycle. What does it mean that Luna is performing Dennis Hopper performing Billy performing Indian horse tricks? "Like performance," Joe Roach writes, "memory operates as both quotation and invention, an improvisation on borrowed themes, with claims on the future as well as the past."[14] This seemingly infinite regress of quotation complicates native memory to show that it does not spring solely from pure origins in venerable ancestors but is constructed in part out of its own representations in popular culture, out of what it inherits and redresses from whiteness.

In the performance's last scene, Luna reenters the stage holding a wooden rattle and stands momentarily in front of a slide of Dean Martin projected onto the screen. The slide shows an aged Martin in black and white with the caption "Dec. 25, 1995, Dino Dead." Luna then launches into a monologue about where he was and what happened on the tragic day when Dean Martin died:

> I awoke Christmas Day and turned on the radio to listen to NPR. The first news that I heard was that Dino had died. I thought I was dreaming. We were listening to him last night while we were gassing. We like Dino on the La Jolla Reservation—we like a good song; we like a good story; we like sad music. You see it's not just about Dino, but the times that he brings to mind when we hear music like that. When Willie was in the service in Germany he had all of Dino's records. When I first started going to bars I would hear him. When his TV show was big, though I didn't watch it, I was in college, and all the politics were going on, and so forth. The good times are now, though. We don't think about

the future in La Jolla; we live for now, 'cause I think that what we know is that we are in heaven; this is our heaven and we'll get our hell later. We don't think about our health like we should; we don't think about ourselves like we should. We think about getting through the week of work and what this next weekend will bring. So when I heard Dino had died, it reminded me what a fucked up life I have sometimes and that when he went he took some of the good times with him.

At this point Luna says, "Fuck it, let's dance for Dino." The lights come up, and Luna holds the rattle upright and shakes it as he jogs around the stage to George Clinton's "Atomic Dog." He proceeds to the audience and chooses three people to dance with him. He leads them to the stage, jogging and shaking the rattle. They dance around the stage until Luna directs them back to their seats. He ends the dance, and the lights go out except for the slide of Dino.

What is most obviously unexpected about this last scene is the way in which Dean Martin—pop singer and comedy actor, Jerry Lewis's partner and member of the Rat Pack—functions as a conduit for native memory. In another performance of this piece, Luna explains that "it isn't about Dino, but about the memories he conjures up. The music helps us remember. He did something for us." It is as though Martin's music formed the sound track for Luna's college memories of the American Indian movement. In November 1969, when Martin's show was seen every week on NBC, a group of more than six hundred Native Americans representing more than fifty tribes occupied the former island prison of Alcatraz, in San Francisco Bay. The occupation continued for a year and a half before the Indians were forcibly removed by federal officers. Four years later, in 1973, on the site of the 1890 massacre at Pine Ridge Reservation, several hundred Oglala Sioux claimed the village of Wounded Knee as a liberated territory in order to protest the unemployment, welfare, alcoholism, and suicide that were the pervasive results of U.S. Bureau of Indian Affairs's management of Indian lands. Martin's show was still on the air but was canceled the next year, in 1974.

That Martin could figure as the backdrop for this political struggle is confirmed not only by his popularity in the 1960s and '70s but also by his role as professional drunk. Here was a celebrity whose comic "bit" in this period was playing the stereotypical alcoholic—burping, weaving, losing track of his routines, slurring the punch line. In his obituary, Associated Press reporter Annie Shooman describes Martin as "highball swilling" and claims that he once had a license plate reading DRUNKY.[15] These facts resonate with one of the other scenes in *In My Dreams,* in which Luna tells a story about a sailor who gets drunk at an annual fiesta. He explains that on the reservation the Indians joke, "Drink and be somebody!" In other versions of this piece, Luna, an alcoholic, explains how his memories of Martin coincide with the period when he "first started drinking."

Luna's performance can be amplified by artist Dan Graham's essay on Dean Martin and what Graham claims was Martin's cynical subversion of the television medium.

James Luna, *Take a Picture with a Real Indian*, 1991. Life-sized
figures, black-and-white photographs mounted on foam core.
Photograph by Sheldon Collins. Courtesy of James Luna.

Graham analyzes Martin's TV show performances—his "stumbling style" of comic
delivery, his purposeful misreadings of cue cards, and his calculated performances of
inebriation—to suggest that Martin overacted his signature role in order to expose the
gap between his real and televisual identities. Graham claims that Martin's performance
of drunkenness is not taken for reality by television viewers. Rather, he suggests, Martin
purposefully performs the standard "bit" that audiences have come to expect so as to dis-
tance himself cynically from it at the same time. The stupor he enacts is thus a metaphor
for the stupor induced by watching television itself, for the feeling that the somniferous
medium of television deadens thought, disorients, and depresses.[16]

By embodying the alcoholic and performing drunkenness to the point of cliché, Mar-
tin takes a risk as a celebrity. The character he plays is contained by the self-referential
nature of the joke; that is, sobriety is proffered as a true identity and then taken back with
the rapidity of a one-liner: "I drink moderately. In fact, I keep a case of Old Moderately
in my dressing room." His act depends on teasing the viewer, pretending to be sincere,
and then revealing the punch line. Like a striptease, Martin's performance pretends to
unclothe him, to unveil his true self, but in the end only offers an image of what everyone
watching always already knows. In the end, Dino is worthy of Luna's dance, because, as a
professional drunk, Dino *cannot* remember and thus becomes the celebrity mascot for the
white man's customs of forgetting.[17]

We have said that the contemporary historian is impelled by the profoundly disorient-
ing effects of globalization to shore up destabilized identities (national, ethnic, or racial)
through their remains in collective memory. To the degree that identity politics are the
wages of this historiographic practice, "being remembered" for Indians often means
to dress the stage set on which dominant culture's past is performed, of which Luna's

project *Take a Picture with a Real Indian* is a vivid example. In this 1991 work, gallery visitors chose from a selection of life-sized photographs of Luna, dressed in various costumes, with which to have their souvenir pictures taken. About this work Luna states, "I saw some Indian selling his red ass to sell jewelry, and I was ashamed but knew what he was doing—he was working. I've worked too. When this opportunity came to do a statement on tourism, I thought of the Navajo and how as Indians we have all been on the tourist line."[18]

Luna's project seeks to expose the pure theatricality of the living history museum, infotainment, the historical theme park, the waxworks diorama, and the brown highway markers that map the tourist experience of history. To accomplish this, he overacts the part and runs history's shtick into the ground. Like Martin's ubiquitous tuxedo, Luna's headdress, beads, and sequins tease the audience that, in the language of the tabloids, wants to know what the Indian is "really like." With his lively eulogy of Martin, Luna remembers instead of being remembered, a rare reversal of the sentimental histories to which Tonto, Queequeg, the Indian at the end of the trail, and Kevin Costner lend their celebrity.

3. Binding to Another's Wound
Felix Gonzalez-Torres and Ross McElwee on Weddings

History is hysterical: it is constituted only if we consider it, only if we look at it—and in order to look at it, we must be excluded from it. As a living soul, I am the very contrary of History, I am what belies it, destroys it for the sake of my own history (impossible for me to believe in "witnesses"; impossible, at least, to be one; Michelet was able to write virtually nothing about his own time).

—ROLAND BARTHES, *Camera Lucida*

My parents were married in 1954. Their friends made a home movie of the wedding that shows a funny scene outside the church where my great-aunt Josephine clowns for the camera. The film, in those juicy Super 8 colors, stutteringly pans the guests milling about in front of the church steps and then focuses in on Jo, who first waves exuberantly, then impishly presents her camera to take a picture of the amateur moviemakers. These dueling lenses trained on each other always get a laugh, not only because we remember Jo was funny and childlike, but also because we recognize the irony of the film camera being documented by the photograph, the dizzying *mise en abyme* of looking at someone looking at someone looking, of witnessing witness. The wedding, as the site of such surplus witness, is the concern of this chapter.

My interest in the wedding has to do, first of all, with its legal and political effects. As a legal ceremony, it demands the authority of juridical witness and confers the authority of official testimony. I take it for granted that, in its most basic terms, the wedding is a performative; it is a unique, unrepeatable event composed of an authoritative act of naming, a speech act of considerable ideological force. It is what Judith Butler calls the "heterosexual ceremonial" and is therefore an occasion of power, of seeing (the elaborate display of normative sexuality), and of blindness (that sexuality which the ceremony obscures but on which it nevertheless depends). More specifically, I see the wedding as an inauguration of witness and an induction into history. A politics is at work in granting witness to the wedding, an endowed privilege, to which not all attendees have equal access.

In addition to its very real and material effects, I am also concerned with the wedding as a metaphor for coupling and binding, for the union of the one who experiences and the one who remembers, for the event and its witnessing. The wedding is an excessively historicized event, one that demands, but seems nonetheless to escape, documentation. It stands as an elaborate ceremony of memory, but is at the same time an event whose dispersal is rehearsed in photographs and films from which the witness is by definition excluded. It is an event that, although not usually (or at least not intentionally) traumatic or psychologically wounding, is constituted by the splitting that characterizes the witnessing of trauma. Because the witness is split, divided between events that occurred but that he cannot speak or images that are clearly rendered and yet remain hidden, the act of testifying requires separate yet intimate subjectivities. Testimony is spoken in two voices, voices that utter a private knowledge. Lest we be distracted by the sentimentality and cozy domesticity associated with the marriage ceremony, we need to keep in mind the very serious stakes of that intimacy. Giorgio Agamben alludes to the intimacy of witnessing when he writes that testimony is "a process that involves at least two subjects: the first, the survivor, who can speak but who has nothing interesting to say; and the second, who 'has seen the Gorgon,' who 'has touched bottom,' and therefore has much to say but cannot speak."[1] He later concludes that witnesses are the remnants of trauma (for him it is Auschwitz; for someone else it might be AIDS); they "are neither the dead nor the survivors, neither the drowned nor the saved. They are what remains between them."[2] I want to understand the wedding in these terms as a ritual devoted to what remains between two people.

Like the movie of my parents' wedding, my own seeing here is doubled by and split between these two concerns. In this chapter I look at the way the wedding authorizes witnesses, whereby the witness is a legal and political category, the exclusion from which is a disgraceful form of inequality that must be questioned. But I also look at the wedding as a demonstration of history's hysteria, of the aporia of witness, of the traumatic practice of looking at another's looking, wherein witness is impossible. As a meditation on history, my work here is ultimately a consideration of what it means to be a historian, an official witness. That task consists, I will claim, in stereoscopic seeing and double telling. It consists, to use Cathy Caruth's phrase, in binding to another's wound. And so we begin by tying the knot.

The first knot we must tie pulls tight on the wedding and the performative. Just one year after my parents were married, in 1955, J. L. Austin set about defining the performative. Both products of the postwar culture, my parents' wedding and Austin's book, in their own ways, present the wedding as an unremarkable event. While my parent's own wedding was no doubt a uniquely important event in their lives, for them, weddings as a practice were simply what people did after the war, a sign that things were, as Warren G. Harding put it some years earlier, "returning to normalcy." For Austin, a wedding is such a common, "normal" ritual that it goes unremarked as a basic example used to illustrate

his linguistic philosophy. Austin said that the performative was a type of utterance "in which to *say* something is to *do* something."[3] His famous examples include such utterances as "I do" or "I pronounce you . . ." at a marriage ceremony. In each case the saying of the thing and the doing of the thing are the same; in each case words do not simply describe or report: they act. He explains: "When I say, before the registrar or altar, &c., 'I do,' I am not reporting on a marriage: I am indulging in it. What are we to call a sentence or an utterance of this type? I propose to call it a *performative sentence* or a performative utterance, or, for short, 'a performative.'"[4]

For Austin, however, the ability of such utterances to act is contingent on both their content and the qualifications and intentions of their speakers. He writes: "The uttering of the words is, indeed, usually a or even *the*, leading incident in the performance of the act . . . but it is far from being usually, even if it is ever, the *sole* thing necessary if the act is to be deemed to have been performed. . . . For (Christian) marrying, it is essential that I should not be already married with a wife living, sane and undivorced, and so on."[5] One cannot performatively produce marriage, then, if one is not authorized to do so or if the bride and groom are ineligible, or indeed, one presumes, if the participants are of the same gender. Such hitches Austin describes as "unhappy" or refers to as "infelicities," and it is these that occupy the vast majority of his book on the subject. So while his intention seems at first to define a particular class of utterances, he soon becomes embroiled in the more profound task of defining the limits of authority.

It is his role as an arbiter of authority rather than simply of the categories of speech that makes Austin (or more accurately the cultural presumptions he invokes) vulnerable to critique. His infelicities and the power involved in defining them and enforcing their exclusions have prompted Judith Butler to write, "The centrality of the marriage ceremony in J. L. Austin's examples of performativity suggests that the heterosexualization of the social bond is the paradigmatic form for those speech acts which bring about what they name."[6] Butler thus awakens us (if we are not awake already) to the heterosexual presumption that authorizes the performative and to the solemn weight of what is at stake in questions of performativity: the power to name or to participate in self-naming; the power to authorize publicly a private bond; the power to legalize particular forms of sexuality; the power to define what constitutes a family; the power to cite and draw from the legitimizing force of conventional authority; and the power to summon witnesses. The wedding, in short, occasions power. To the extent that these forms of power accrue to heterosexuality, how can we, to paraphrase Butler, use the performative "to undo the presumptive force of the heterosexual ceremonial"?[7] And how can we understand better how private performatives such as the wedding tie the knot with public ones, with legal, political, and social privilege? Moreover, where can we locate the intersection of public and private as it relates to witness; where, in other words, does a catastrophic social trauma, such as the Jewish Holocaust or the AIDS crisis, cross with the private experiences of those whom such events affect?

Neither Butler nor Austin really consider the wedding ceremony in detail; Austin focuses only on the locutionary force of "I do" and Butler on the citational power of "I now pronounce you." But the wedding offers a variety of performatives that complicate these flashier climactic utterances and have implications other than those that are commonly registered. I will therefore highlight a different part of that "heterosexual ceremonial," the part that authorizes witnesses. That the wedding is defined by witness seems clear enough, but witness has two aspects of its own that I'm interested in; one is seeing, and the other is history—two passages through which the queer finds entry.

"Marriage," write Eve Sedgwick and Andrew Parker, "exists in and for the eyes of others."[8] But, as Carol Mavor has pointed out, the eyes are not the reliable devices they once were conceived to be. She writes in her book on Clementina Hawarden's photography:

> Our eyes and the stereoscope do not operate under the rules of Renaissance perspective: despite our attempts to understand vision otherwise, they disregard the classical observer in favor of binocular disparity. As [Jonathan] Crary observes, to the extent that looking through the stereoscope is extremely "planar," . . . it is also *strange* rather than, as convention would suggest, *realistic.* "Strange" is the first definition that *The Oxford English Dictionary* gives the word "queer." The stereoscope emphasizes the body's own doubleness, the queerness of seeing.[9]

The act of seeing, Mavor tells us, is characterized by disparity, strangeness, and doubling. Seeing, witnessing, does not approach the real; rather, it estranges reality, opens the space of difference. Certainly the sensations one experiences in the stereoscope have only grown more acute in the context of contemporary mechanisms of witness. Our eyes are doubled not only by the photograph but also by the video camera and the digital image in virtual space. Perspective can no longer be thought of as drawn together at a single point or even at two points, but expands outward infinitely in both time and space. Our claims on the real grow more awkward, less sure. Even the time of seeing is disorientingly compressed, attenuated, and repeated.

Like two eyes that are the same and yet different, history (a licensed form of witness) is itself a kind of double vision (for Barthes, a form of hysteria). It strangely keeps one eye on the present and another on the past. Like seeing, history is estranged from the real; as Cathy Caruth says, the real event "can be grasped only in the very inaccessibility of its occurrence."[10] It is this fact that causes Barthes to remark that he finds it impossible to believe in witnesses. Theorists of witness argue differently (more usefully) that the inaccessibility of events is the very nature of witness. Caruth, for example, claims that events as they occur are unknowable and can be approached only by a departure in time and a latent return, a forgetting in order to remember. This necessarily results in repetition, so that "an impossible and necessary double telling . . . constitutes . . . historical witness."[11] By and by we will see that history's impossible and necessary telling, its

inherent repetitions of the same, its enactments in the present of events from the past, represent precisely that queering of the social bond for which Butler calls.

The second knot we must tie binds together wedding and witness. For Austin the role of the witness is an important part of safeguarding the purely performative, because he sees the witness not as hysteric but as authority. "It is worthy of note," he writes,

> that in the American law of evidence, a report of what someone else said is admitted as evidence if what he said is an utterance of our performative kind: because this is regarded as a report not so much of something he *said*, as which it would be hear-say and not admissible as evidence, but rather as something he *did*, an action of his. This coincides very well with our initial feelings about performatives.[12]

The one who witnesses a performative utterance—seeing the priest saying "I now pronounce you," the judge saying "I hereby sentence you"—is witness to an act with legal ramifications. What is more, he or she is allowed to speak or write about such an act as a matter of evidence. This indicates that these utterances, in addition to the performative force of marrying or sentencing, which they contain, also have the power to inaugurate, to authorize witnesses. That is, such performative statements instantaneously alter not only the status of the bride and groom or criminal but also the status of those watching the proceedings. By operating in this way, performatives work in the realm of history: they initiate the witness as historian. The wedding functions as a performative induction into history.

Sedgwick and Parker simultaneously ratify and systematically question the role of witness in the wedding ceremony when they write:

> It is the constitution of a community of witness that makes the marriage; the silence of witness (we don't speak now, we forever hold our peace) that permits it; the bare, negative, potent but undiscretionary speech act of our physical presence—maybe even *especially* the presence of those people whom the institution of marriage defines itself by excluding—that ratifies and recruits the legitimacy of its privilege.[13]

What they describe is that process whereby certain types of attendees of the ceremony will be initiated into history (those who are willing to testify to the sole legitimacy of the heterosexual bond), and other types (those whose identities are erased by this particular performative) are asked to keep silent. Indeed, in one stroke these silent witnesses are necessary for and excluded from history. Thus, in addition to the exclusion of particular forms of sexuality, of particular participants, and particular names, something else is lost in the heterosexualization of the performative, that is, the right to serve as witness to another. Parker and Sedgwick abjure the wedding's demand for witness when they write that "any queer who's struggled to articulate to friends or family why we love them, but

just *don't want to be at their wedding*, knows it from the inside, the dynamic of compulsory witness that the marriage ceremony invokes."[14] But here, as before, they are referring only to the audience's limited role as witness to the spectacular heterosexuality of the wedding event. While I would agree that the marriage ceremony is defined by a paradigm of witness, I want to locate it a little differently. The audience that witnesses a wedding authorizes the marrying couple to be witnesses for each other—to witness each other's traumas, to tell each other's past, to speak for the other's desires in both personal and legal matters. Here is one of those places where public and private forms of witness cross, where the historical, social, and political implications of an intimate relationship between two people are made visible. Taking those implications seriously, understanding the gravity of this kind of witnessing, is extremely important. We get a glimpse of this in the testimony of a Holocaust survivor, a woman named Helen who was separated from her husband during the war but was reunited with him after the liberation of the concentration camps:

> The man I married and the man he was after the war were not the same person. And I'm sure I was not the same person either... but somehow we had a need for each other because, he knew who I was; *he was the only person who knew.* . . . He knew who I was, and I knew who he was. . . . And we're here, we're here to tell you the story.[15]

This survivor explains that, in order to bear witness, to "tell the story," someone must know who she is; this intimate relationship in which her husband can speak with the authority of "knowing" is essential. Their testimony about the enormous historical event of the Holocaust begins with and is authorized by the intimacy of two.

In this context we can see the huge and serious implications of what it means to be excluded from the wedding, the marriage, as the authorization of witness. The current political movement to expand the definition of marriage in the United States in part addresses itself to these implications. It is to this form of witness that the legalization of civil unions in Vermont in 2000 and the Supreme Court ruling in Massachusetts in 2003 addressed themselves. The Vermont law authorized same-sex couples to assume the legal rights of the next of kin, including guardianship and medical decision making, hospital visitation, and control of the partner's body at death. Felix Gonzalez-Torres's 1991 work *Untitled (Perfect Lovers)* offers us a way of seeing this particular form of witness and its implications. The piece consists of two white institutional clocks, hung side by side, set to the same time. The performative that weds these lovers is "unhappy" in Austin's terms. The two cannot be "wedded" officially, because their love defies the heterosexual ceremonial; it involves not gender difference but gender sameness—the clocks are identical. Yet they silently trouble the prohibition against same-sex marriage; they are wedded in the sense that they are bound to each other's mortality, to telling each other's story. Each is a repetition of the other's time; each one measures the winding down of the other. Such

is, according to Nancy Spector, Gonzalez-Torres's definition of marriage. She writes, in his ideal world,

> people do not endure alone; they survive in pairs, as part of loving couples who age together, no longer in danger of premature separation caused by incurable and inexplicable disease. Here, bodily fulfillment refers to being in love, to existing in a state of togetherness, to constituting a community of two.[16]

I see the "lovers" in Gonzalez-Torres's work as more than single individuals; I see them as the very potential to establish the community of two through which history, both necessary and impossible, gets told.

This is addressed in other works, such as the *Bloodwork* series, in which Gonzalez-Torres attempts to bear witness to the trauma of his lover Ross Laycock's illness and death from AIDS and, at the same time, to witness the witnessing that medicine is granted. In two carefully drawn and painted panels, the artist attempts to show what AIDS means to those whose real lives are obscured behind either cold medical data or sensational photographs of emaciated faces; those whose bodies behave incomprehensibly, traitorously because of their illness; those about whom science speaks with authority but whose desires it is incapable of representing; those whose histories will be used against them. Each panel consists of a grid on which is drawn a red line that either descends from the upper left corner to the lower right or ascends from the lower left corner to the upper right, as though tracking dramatic statistical and thus physical declines and improvements.

These blood tests are a bitter parody of the ones the bride and groom take in order to obtain a marriage license. In both cases the tests bespeak public anxiety over, and consequent attempts to police, the private mingling of blood. But each, in distinctly different ways, helps to authorize and invalidate witness, to legitimize and bastardize certain versions of the past. As Simon Watney writes:

> We may thus detect a significant slippage at work between the field of "scientific" medical photography, which identifies symptoms, and a wider form of what might be described as moralised seeing, according to which AIDS is a signifier of powerful non-medical meanings. AIDS thus becomes also a *crisis of memory*. For when the deaths of our loved ones are casually dismissed as "self-inflicted," it is the most fundamental level of our most intense experience of life and of love that is effectively denied.[17]

Gonzalez-Torres disillusions our belief in the necessity of medical witness, showing it to be false, in the end incapable of seeing what it supposes to know. Instead he insists on the value of witnessing's impossibility, the authoritative truth that lies precisely in his inability to show the trauma by which he is engulfed and silenced.

These precepts embolden Gonzalez-Torres to claim the rights of witness, albeit of a different sort, not only to Ross's and his own traumas, but to history itself. In an untitled

billboard he made in 1989, the artist provides an unconventional time line that reads: "People With AIDS Coalition 1985 Police Harassment 1969 Oscar Wilde 1895 Supreme Court 1986 Harvey Milk 1977 March on Washington 1987 Stonewall Rebellion 1969." This is history through the eyes of a witness who, it is normally presumed, "will not speak now, will forever hold his peace." Moreover, by daring to be a queer witness, he shows how history itself is queer, how it is made not of single comprehensible events and their representations but of different versions of the same, of repetitions and doublings. The police harassment of gays in New York in 1969 repeats the harassment of Oscar Wilde in 1895.[18] The criminalization of homosexuality in 1895 is repeated in the Supreme Court's *Bowers v. Hardwick* decision of 1986. In reading this time line, we experience 1969 twice:

Felix Gonzalez-Torres, *Untitled (Perfect Lovers)*, 1991. Wall clocks and paint on wall. Overall dimensions vary with installation. Clocks: 14 x 28 x 2¾ inches overall. Two parts: 14 inches diameter each. Photograph by Peter Muscato. Copyright The Felix Gonzalez-Torres Foundation. Courtesy of Andrea Rosen Gallery, New York.

Felix Gonzalez-Torres, *Untitled (Bloodworks)*, 1989. Graphite, colored pencil, and tempera on paper, 12¼ x 19½ inches overall. Two parts: 12¼ x 9 inches each. Photograph by Peter Muscato. Copyright The Felix Gonzalez-Torres Foundation. Courtesy of Andrea Rosen Gallery, New York.

once through harassment, a second time through rioting. With this abbreviated history, Gonzalez-Torres reminds us of the queerness of seeing, the traumatic failure to understand events in the first instance and the historical repetitions that result from that failure.

The third knot we must tie is braided of questions posed by acts of witness. This knot is called trauma. If both history and seeing are estranged from the real, if they are strangely blurred and doubled, how can one speak effectively of real experience? How can one bind events to their telling? How can we couple the one who experiences history and the one who witnesses it?

First of all, we must reconcile ourselves to the traumatic quality of witness. I don't mean this in the sense that most scholars do when they write on witnessing. That scholarship tends to privilege and sometimes fetishize trauma rather than considering more banal forms of experience. For me, witnessing is traumatic simply because to be a witness means by definition to stand outside events, even those quotidian events we experience directly. Let me try to clarify this. From the point of view of psychoanalysis, events are described as traumatic in two ways. First, from an objective standpoint, they are specific

Felix Gonzalez-Torres, *Untitled,* 1989. Billboard. Dimensions
vary with installation. Copyright The Felix Gonzalez-Torres
Foundation. Courtesy of Andrea Rosen Gallery, New York.
Photograph copyright Stanley Greenberg.

kinds of experiences (e.g., war, rape, murder, starvation, death) that have traumatizing characteristics: they are violent, they involve extreme emotional or physical loss, they are dramatic or sudden. Second, from a psychological standpoint, such events, regardless of the actual form they originally took, cause a breakdown in the subject's capacity to experience, know, narrate, and work through them. In this regard, Ruth Leys claims that "from the beginning trauma was understood as an experience that immersed the victim in the traumatic scene so profoundly that it precluded the kind of specular distance necessary for cognitive knowledge of what had happened."[19] Here Leys explains that trauma (regardless of the type of experience that caused it) means not being able to gain distance on an event, the distance necessary in order to assume a subject position relative to it and to organize that event into a witness narrative. The irony is that gaining distance is not in itself a solution, because to be distanced means to have one's subjectivity split: there are the self that experiences the event and the self that separates herself from it and reports on it. That splitting of ourselves is itself traumatic (or hysterical, as Barthes describes it), because it means, according to Cathy Caruth, that what happens is "unavailable." For these scholars, trauma is a kind of psychic wound that takes place suddenly, incomprehensibly. It is never understood *as* it is being experienced but only through leaving the event and latently returning, a compulsive repetition. So the antidote to painful proximity is *both* the gaining of "specular distance" *and* the return to the place of the original event.

In this sense, I would argue, most any act of historical witnessing has a component of trauma, because such acts produce a splitting of the subject, a continual movement away from and back toward the event, a movement that is a consequence of subjectivity itself. For example, Gonzalez-Torres experiences the brutality of being a gay man in a heterosexist society and so must split himself into the one who screams back at the Christian Coalition in a gay rights parade and the one who sees his own experience distantly, sees it within what Carl George describes as "a long history of struggle against misunderstanding and aggression."[20] To compose his billboard history, then, Gonzalez-Torres must occupy a traumatic subjectivity.

"Trauma," Caruth writes, "seems to be much more than a pathology, or the simple illness of a wounded psyche: it is always the story of a wound that cries out, that addresses us in the attempt to tell us of a reality or truth that is not otherwise available."[21] It is possible to look at this claim skeptically, as Ruth Leys does, because it tends to delegitimate the testimony of the one who experiences trauma and to locate a more authentic form of testimony in the wound itself. (The wound speaks where the victim cannot.)[22] While Caruth's metaphor is troubling from the perspective of psychoanalytic treatment, it is useful from the perspective of history. As I've said, history is definitively traumatized, separated in time and space from that about which it claims to testify. But to be excluded from history, to be denied a voice, to be uncoupled from the one who knows "who I am," is far worse. It is to be without a recognizable selfhood. History begins with the moment

of listening to that cry, the moment in which, as Caruth says, "we are implicated in each other's traumas."[23]

So the second thing we must keep in mind is that history, as Caruth warns, cannot be thought of as "straightforwardly referential (that is, no longer based on simple models of experience and reference)." History is, therefore, the thing we do in place of "immediate understanding."[24] In the absence of reference, Caruth's definition of history involves what she calls a "double telling," which is "the oscillation between a *crisis of death* and the correlative *crisis of life:* between the story of the unbearable nature of an event and the story of the unbearable nature of its survival."[25] This may involve, as it did for Gonzalez-Torres, the literal crisis of another's death compounded by one's own survival or, as is more often the case, the kind of crisis that Barthes describes: "As a living soul, I am the very contrary of History."[26] In either case, it produces, in Agamben's words, "the unprecedented shame of the survivors in the face of the drowned."[27]

Let us tie one last knot, a knot that weds history and dispersal. I want to use some of Gonzalez-Torres's work along with one of Ross McElwee's documentaries, one he made in 1993, called *Time Indefinite,* to think about the implications of wedding as history, to consider the special occasion that history is. *Time Indefinite* is a film that not only documents weddings but also self-reflexively considers questions specific to historical practice: the nature of documentation, the accumulation of archives, and the trauma of death. It thinks obsessively about what we do in place of immediate understanding. The first and last shot of the film is one taken from a pier off the coast of North Carolina, which captures McElwee's own shadow and that of the camera perched on his shoulder, as they are cast on the sand below.[28] In this brief footage, McElwee makes the viewer keenly aware that she is watching a film about filming. Like the photograph that my aunt Jo took of the movie camera, the shadow on the beach records the act and the image of witness.

Time Indefinite starts with a wedding. The film begins at the annual family reunion, where McElwee gathers his relatives on the deck of their seaside cottage to announce that he and his filmmaking partner, Marilyn Levine, are going to get married. He sets off to make a film specifically about the process of marriage but more generally about family. He films himself and his fiancée getting their marriage license and their blood tests, Marilyn's gynecological examination, the premarriage drinks with his friends, the caterers and florists setting up for the wedding, and Marilyn getting dressed. A few months later, he records Marilyn announcing to her parents that she is pregnant. All the while he muses about life and death and about the family as a device for measuring time.

At a certain point McElwee loses control of this "documentary"; his attempts to direct the events in the narrative about his family are thwarted by his wife's miscarriage, his grandmother's death, and the sudden death of his father, all of which take place within a two-week period. He says of that time: "That winter seemed interminable, and I found myself profoundly missing my father, my grandmother, and the child that Marilyn and I would have had. It was as if the two generations before me and the one that was to

come after me had, without warning, suddenly vanished." Most of the rest of the film is taken up with McElwee searching for answers about his father's death. He travels back to North Carolina and Florida to talk to his sister DeDe and his brother Tom, to stay in his father's empty house, to talk to his father's housekeeper, Lucille, and to his old friend Charleen.

McElwee sets up a homology between history and wedding early in the film in a scene at a bachelor party, where his friends share their experiences of marriage and weddings. They warn him about his own wedding set to take place the next day, that it will resist his attempts both to experience the event and to remember it. One friend tells him, "You won't get a chance to eat a single piece of food. You will see everyone you know and love in your life but you won't remember having seen them, even though they're there because you invited them. You won't have a chance to talk to anyone you know. It will cost you a fortune, and you'll always have the pictures to look back on." When McElwee asks if his friend ever looks at his own wedding pictures, he replies, "Many times. There are moments I don't even remember experiencing, but I have the pictures to prove it."

The wedding not only satisfies the definition of the performative, but because of its inherent latency, it also satisfies a significant part of trauma. While theorists of trauma and witness concern themselves with more cataclysmic forms of trauma (the death of a child, the bombing of Hiroshima, the Holocaust), their definitions often include the idea that it, in Caruth's words, "is not locatable in the simple violent or original event in an individual's past, but rather in the way that its very unassimilated nature—the way it was precisely *not known* in the first instance—returns to haunt the survivor later on."[29] Because I am interested in using trauma to understand more fully the nature of witness, that unassimilated nature is precisely what concerns me here. The wedding, while not usually violent, is almost always seen as an "original" event. It thus can stand for all those special occasions that haunt us because we have forgotten them, significant events about whose fleeting nature we worry and for which we bring out our cameras. Such occasions are marked with ceremony and are memorialized precisely because they are private events that have very public, social implications. Photographs or home movies become, in this sense, proof that such events actually took place. They are the vehicle by which we return to and reexperience the trauma of our own obliviousness to events we did not understand, the impossibility of our witness. And yet, as McElwee's film demonstrates, such historical documentation is itself subject to dissolution and loss.

McElwee's method might first appear to be the opposite of Gonzalez-Torres's famous experiments with dispersal, his stacks of candies or printed images free for the taking. McElwee attempts, through a highly subjective form of cinéma vérité, to collect and hold on to filmic evidence for as much of his life as possible. So ubiquitous is the camera perched on his shoulder that his father calls him "the big eye." McElwee explains that the need for documentation runs in his family. In a voice-over, synchronized with clips from a home movie of his own baptism, McElwee says:

Maybe I picked up the filming habit from my uncles. During the years I was growing up it seemed like either Uncle Fred or Uncle Nate filmed nearly everything we did. . . . Maybe this exposure to cameras has had some subliminal effect on me, made me want to do it when I got older.

McElwee's compulsion to record, however, causes problems. "It was becoming more and more difficult," he complains, "for me to film my own life and live my own life at the same time." And about the tragic deaths he has endured, McElwee confesses:

I've ended up with a lot of anger—anger at the fact that my mother and brother and father are gone. But it's completely useless; there's absolutely nothing to vent it on. And I think this is connected in some way to why I keep filming away just like Uncle Nate and Uncle Fred, adding more footage to the family archives.

McElwee has learned the harsh and unrelenting and arbitrary nature of death. It is this lesson, combined with his fear of losing still other loved ones, that compels him to record. However, filming conventionally significant events such as weddings or birthdays is not enough; his appetite for evidence is insatiable. He films blind dates, his brother shaving, his wife brushing her teeth, his father performing surgery, clouds from airplane windows, his father's housekeeper ironing clothes, friends and relatives cooking, himself talking on the telephone, and on and on. But of his attempts to document death he asks, "What good does the proof do me?" Indeed, *Time Indefinite* ends up affirming memory as loss.

In this film, McElwee's own wedding (and his filmed documentation of it) becomes the starting point for a narrative return to the trauma of death. It is as though, in the wedding ceremony, both bride and groom are initiated as witnesses to each other's sudden and inexplicable experiences of loss and mourning, to each other's fragile mortality. They are paired one to another "through the very possibility and surprise of listening to another's wound."[30] In the film, McElwee's own marriage is mirrored by that of his friend Charleen, whose role as witness to her partner is even more dramatic. Charleen's estranged husband, Jim, committed suicide by immolating himself inside the house they had shared. She is charged with the care of a fragile archive, her husband Jim's ashes. They are tied up in a plastic storage bag, which she fondles mournfully to feel the feather-soft dust of incinerated flesh along with the fragments of sharpened bones. Charleen is a historian of Jim's life, a latent witness to his trauma. Even as she touches this delicate souvenir and narrates the story of his suicide, the irreducible bones poke though the bag and turn it into a sieve through which his remains are slowly lost. The paradoxical nature of the archive, its simultaneous obliteration and preservation of the past, mirrors the work of history, the way it forgets in order to remember.

Just as Charleen is Jim's historian, so Gonzalez-Torres becomes the archivist of his dead partner. Like Jim, Gonzalez-Torres's lover was cremated, his ashes preserved in one

Ross McElwee, *Time Indefinite*, 1993. Color, 117 minutes.
Distributed by First Run Features, New York. Film still courtesy
of Ross McElwee.

hundred plastic bags, which the artist left wherever he traveled.[31] But unlike Charleen
and Jim, Felix and Ross cannot assume the rights of mourning, cannot assume to speak
on each other's behalf. As Simon Watney writes, "In these circumstances we often feel
that we owe one another 'a terrible loyalty,' to borrow from Tennyson. Without marriage
and its attendant rituals and institutions, gay men's most intimate and important relation-
ships are frequently misunderstood and undervalued by heterosexuals, who simply cannot
understand what one is actually saying when one tells them that a 'friend' is sick or a
'friend' has died."[32] In October 1992 ACT-UP staged a protest, an Ashes Action, at the
White House (then occupied by George Bush Senior), in which eleven people, followed
by some eight thousand supporters, marched from the Capitol, carrying plastic bags con-
taining the ashes of their loved ones who had died of AIDS. Reaching the White House,
these eleven witnesses tossed the ashes onto the lawn. This action involved a strategy of
dispersal, the letting go of cherished remainders, in order to claim the rights of memory
and witness. As David Feinberg, a participant in the protest, explains, "We were going to
shower the White House lawn with the ashes of our loved ones."[33] Following this action,
he reports, the protesters engaged in a public and politically charged act of witness; they
"gather[ed] in the park behind the White House for a public speak-out.... David [Robin-
son] talks about [his lover] Warren. He cries."[34]

A similar strategy is at work in another of Felix Gonzalez-Torres's installations. His *Untitled (Loverboys)* (1991) is a pile of white-and-blue swirled candies, the size and weight of which is meant to match the combined weights of the artist and his lover. The pile serves as a double portrait of sorts, one that yields itself to the interventions of the audience, who are invited to take a piece of the candy for their own. Nancy Spector writes, "In its excessive generosity—its willingness to give itself away to any admiring beholder—the sculpture risks the danger of total dissipation."[35] Of this work, the artist explains, "I was losing the most important thing in my life—Ross, with whom I had the first real home, ever. So why not punish myself even more so that, in a way, the pain would be less? This is how I started letting the work go. Letting it just disappear."[36]

It is in this engagement with disappearance and dispersal that I see myself seeing, that I become aware of being an art historical witness. I remember the morning of January 12, 1996, in which I entered my office to find a piece of paper someone had

Felix Gonzalez-Torres, *Untitled (Lover Boys)*, 1991. Blue-and-white candies individually wrapped in cellophane, endless supply. Overall dimensions vary with installation. Ideal weight: 161 kg (355 pounds). Copyright The Felix Gonzalez-Torres Foundation. Courtesy of Andrea Rosen Gallery, New York.

shoved under the door. It was a photocopy of Felix Gonzalez-Torres's obituary that had appeared the day before in the *New York Times*. It struck me that the photocopied newspaper page I had picked up off the floor was rather like Gonzalez-Torres's own endlessly reproduced images, piled on various gallery and museum floors and free for the taking. The dispersal of the obituary is, like the dispersal of Gonzalez-Torres's other stacks, a dissemination of witness. Of these works he said in an interview,

> The first stacks I made were some of the date pieces. Around 1989 everyone was fighting for wall space. So the floor space was free, the floor space was marginal. . . . and also, to be really honest, it was about being generous to a certain extent. I wanted people to have my work. . . . In a way this "letting go" of the work, this refusal to make a static form, a monolithic sculpture, in favor of a disappearing, changing, unstable, and fragile form was an attempt on my part to rehearse my fears of having Ross disappear day by day right *in front of my eyes.*[37]

Allowing viewers to take the sheets from the stacks, the candy from the piles, let Gonzalez-Torres witness his own witnessing of Ross's death, which took place traumatically right in front of his eyes.

Susan Tallman, writing about the stacks, remarks, "With each removal it moves out from the concise block into the broad, dilute space of the edition, spread over a hundred walls, drawers, refrigerators (what do people do with these things when they get them home?), and there assumes a life both linked to the original sculpture and independent of it."[38] In my office I keep both the photocopy of the *Times* obituary and one of those offset prints, *Untitled* (1991), which I got from the Walker Art Center.[39] The black-and-white print shows the gently rippling surface of water, as though the paper had been cut out of the middle of a pond. The dark image, with no horizon line, no objects depicted, no human presence, seems mournful to me. This work of art which, is not really an artwork, displayed in a museum but taken out of the museum, is a reminder to me of history's necessary and impossible work. These artifacts, which are both gifts and burdens, are "linked to and independent of" the history they materialize. They rehearse for me my fears of what disappears from history—what drains out like water, what sifts out like ashes—right in front of my eyes. The ashes of Gonzalez-Torres's own life may be caressed in his self-portrait, revised for the last time in 1995:

> Red Canoe 1987 Watercolors 1964 Paris 1985 Supreme Court 1986 Blue Lake 1986 Our Own Apartment 1976 Rosa 1977 Guáimaro 1957 New York City 1979 Pebbles and Biko 1985 Ross 1983 Civil Rights Act 1964 Mariel Boatlift 1980 White Shirt 1984 Julie 1987 An Easy Death 1991 CNN 1980 Black Monday 1987 Berlin Wall 1989 Great Society 1964 Venice 1985 Wawanaisa Lake 1987 U.N. 1945 Mother 1986 Myriam 1990 VCR 1978 Dad 1991 Bay of Pigs 1961 D-Day 1944 Interferon 1989 Jeff 1978 Silver Ocean

1990 H-Bomb 1954 The World I Knew Is Gone 1991 Bruno and Mary 1991
Madrid 1971 MTV 1981 Rafael 1992 May 1968 Andrea 1990 Twenty-fourth
Street 1993 LA 1990 Placebo 1991 George Nelson Clocks 1993 A view to
remember 1995.[40]

Here the artist testifies to his life as an intersection where private and public meet; he
bears witness to Ross, as though he were saying, "Somehow we had a need for each other,
because he knew who I was; he was the only person who knew. . . . He knew who I was,
and I knew who he was. . . . And we're here, we're here to tell you the story." The story
that Gonzalez-Torres tells is not only about his love for Ross or about private events in
their lives, such as their trip to Wawanaisa Lake, but also about the AIDS epidemic, in
which forty-eight million people have now died. And between these things, between the

Felix Gonzalez-Torres, *Untitled,* 1991. Offset print on paper,
endless copies, 45¼ x 38½ x 7 inches at ideal height.
Installation view at Luhring Augustine Hetzler, Los Angeles,
1991. Photograph by James Franklin. Copyright The Felix
Gonzalez-Torres Foundation. Courtesy of Andrea Rosen Gallery,
New York.

Still of the wedding of Ross McElwee's parents, from his *Time Indefinite*, 1993. Color, 117 minutes. Distributed by First Run Features, New York. Film still courtesy of Ross McElwee.

public and the private, the global and the personal, details, memories, and images fall like ashes.

It is difficult to straighten neatly the threads and knots I have tangled and pulled at here. So let's entangle them a bit more by looking at one last wedding photo. McElwee's documentaries are known for his unique style of cinéma vérité and for his intercutting of home movie clips, traditional documentary footage, and bits of videotape. In *Time Indefinite* he does this repeatedly, in one instance incorporating home movie footage of his parents' wedding. As we watch the grainy Super 8 images flicker by and listen to the sound of the home movie passing crudely over the sprockets of the projector, McElwee says:

> So this reel of film has been lying around for forty years. I bet that my parents never even had time to look at it. Life was probably too hectic. Right after the wedding, my father went back to medical school, and my mother was working as a secretary. And then four kids were born in quick succession, so we moved from an apartment to a house. And my father was gone every day and most nights working at the hospital, and he saw patient after patient, year after year, and year after year my mother cooked and cared for the kids. And there were birthday parties and Boy Scouts and basketball games and graduations. And it

was a forty-year blur of events and images, and then suddenly it's all over. And there was never time for anyone to look at the wedding footage until now.

In this way *Time Indefinite* engages in stereoscopic seeing and double telling. It uses McElwee's own wedding as a repetition of his parents' wedding. It uses filming as a repetition of his family's filming of home movies. It attempts to witness the process of witness: the lens that watches history rattle by. And if it repeats the doubling that history does, it also repeats the strangeness of seeing, of not seeing fast enough. In the end, the film is witness to the "forty-year blur of events and images." It consists, to quote Caruth once more, "not in seeing but in handing over the seeing it does not and cannot contain to another (and another future)."[41] And so now too shall I.

II. Technology

4. A Cemetery of Images
Photography and Witness in the Work of
Gilles Peress and Alfredo Jaar

Thirteen months after the 1994 genocide in Rwanda, journalist Philip Gourevitch visited the church at Nyarubuye where some one hundred Tutsis had sought refuge, only to be hacked to death by Hutus. This church had become a rotting memorial; the Tutsis did not bury their dead at Nyarubuye or at many other such sites, but left them untouched as a testament to the atrocities that had taken place there. When Gourevitch gazed upon these putrefying corpses, he remarked, "The dead looked like *pictures* of the dead."[1] Because the bodies seemed unreal in spite of his knowledge of the slaughter and his belief in the accounts he had already heard and read, he explains, the genocide was "still strangely unimaginable. I mean one still had to imagine it."[2]

These statements, tinged with incomprehension, bring us squarely to the entangled questions that I seek to ponder in this chapter, for what Gourevitch describes is the troublesome role of photographs in acts of witness. That role begins with the process whereby an eyewitness, because he does not recognize and cannot comprehend the horror at which he is looking, is forced to try to imagine it, that is, by definition to "form a mental image of something not present to the senses."[3] But he must engage in imagining *even as* the material facts of atrocity are present to him, *even as* he is in fact seeing them. To be a witness, then, means simultaneously to see and to imagine, but from Gourevitch's description we learn that imagining is not a free and boundless form of creative work but rather is disciplined by the rules and habits of photographs, their discursive formation. These rules involve the habits not only of depiction and of viewing depictions but also of imagining oneself relative to what is depicted. In addition to having to imagine the atrocity, then, Gourevitch must also struggle to imagine his own witnessing of it, to see himself seeing.[4] In one passage, he explains that he was escorted on his visit to Nyarubuye by Sergeant Francis of the Rwandese Patriotic Army. About Sergeant Francis, Gourevitch writes, "His English had the punctilious clip of military drill, and after he told me what I was looking at I looked instead at my feet. The rusty head of a hatchet lay beside them in the dirt."[5] In the presence of this Tutsi officer, Gourevitch is made to imagine himself seeing; when he cannot, he looks away.

The private conflict he endured that day—a conflict about the unburied dead and their burial in remembered photographs, a conflict about how one imagines one's own witnessing—is one version of a larger problem that lay at the center of a public debate in postgenocide Rwanda. The terms of that debate are sketched in a conversation Gourevitch had with Alexandre Castanias, a monitor for the U.N. Human Rights mission and an eyewitness to a similar massacre at the Kibeho church in Gikongoro:

> The talk about Kibeho had started when Alexandre asked me if I had been to the church at Nyarubuye, to see the memorial there of the unburied dead from the genocide. I hadn't yet, and although when I did go I didn't regret it, I gave Alexandre what I thought—and still think—was a good argument against such places. I said that I was resistant to the very idea of leaving bodies like that, forever in their state of violation—on display as monuments to the crime against them, and to the armies that had stopped the killing, as much as to the lives they had lost. Such places contradicted the spirit of the popular Rwandan T-shirt: "Genocide. Bury the dead, not the truth." I thought that was a good slogan, and I doubted the necessity of seeing the victims in order fully to confront the crime. The aesthetic assault of the macabre creates excitement and emotion, but does the spectacle really serve our understanding of the wrong? Judging from my own response to cruel images and to what I had seen in the hospital ward of Kibeho wounded, I wondered whether people aren't wired to resist assimilating too much horror. Even as we look at atrocity, we find ways to regard it as unreal. And the more we look, the more we become inured to—not informed by—what we are seeing. I said these things, and Alexandre said, "I totally disagree. I experienced Kibeho as a movie. It *was* unreal. Only afterward, looking at my photographs—then it became real."[6]

Here Gourevitch and Castanias take up opposing positions in an ongoing debate about the discursive habits of documentary photographs, their perversely spectacular nature on one hand and their intense realism on the other.[7] Gourevitch adds his voice to what has already been said about the patterns of "cruel images," the role played by photojournalism in ideology formation, its share in the commodification of human tragedy, its dependence on spectacle, its function as an instrument for policing knowledge, and its "aesthetic assault" or pornographic mise-en-scène. Castanias lends his voice to what has also been said about the urgent necessity of such images, about the crucial role played by photojournalism in democracy, its capacity to testify to uncomfortable or impermissible truths, its "reality," and its necessary function as historical witness. What is perhaps less discussed but potentially more productive, especially with regard to Rwanda, is the question of the photograph's role in either contributing to or undermining our capacity to imagine our own witnessing.

I am interested particularly in how the West imagined itself as witness to the Rwandan genocide. A great deal has been written about the West's misperception and mischaracterization of these events: the United States, Belgium, Great Britain, and France

looked at the killings that began on April 6, 1994, and described them as acts of "ancient tribal conflict," as a "civil war" between the Hutu government and the Rwandan Patriotic Front, and as "the struggle of two rival ethnic groups." All these claims were grossly inaccurate. The so-called ancient conflict was a by-product of European colonization and the European's favoring of the lighter-skinned Tutsis, whom they considered more suitable for leadership. Thus, white Europeans appointed Tutsis to positions of privilege within Rwanda, despite their minority status. This, in turn, caused nearly a century of resentment by the majority Hutu. Moreover, it was not in any way a civil war, which would suggest that the conflict involved two armed sides locked in mutual combat. Instead it was largely a massacre of innocent and unarmed people, a despicable act of ethnic cleansing.[8] In addition to these mischaracterizations in the media, officials in the Clinton administration were forbidden to describe the atrocities as genocide; they could say only that "acts of genocide may have occurred."[9] It was only in October 1994 that the Commission of Experts, set up by the U.N. Security Council to investigate the killings, officially described the slaughter of more than eight hundred thousand Tutsis as genocide, invoking, for the first time since its inception, the Genocide Convention of 1948. Western politicians, foreign policy analysts, governments, United Nations officials, and journalists acted as false witnesses to the tragedy in Rwanda, misrepresenting what they saw there. That shameful action was made possible by the particular way in which the West imagined itself (and continues to imagine itself) as witness to human conflict. Because of its wealth, its technologies of surveillance, its ubiquitous media, its free press, its Christian heritage, and its military power, when the West imagines its own witnessing, it conceives of that witnessing in terms that are both photographic and godlike: as itself unseen, as omniscient, disembodied, and disinterested. Colin Powell's presentation of U.S. surveillance photos from Iraq at the United Nations in 2003 is only one recent example. The West sees, according to this mythology, impartially and from a distance, the way a camera sees. And yet, the one thing a camera cannot see is itself. In the blindness of that technology of witness, a world of cruelty and failed foreign policy lies.

The task of questioning the West's ponderous conception of its own witnessing is enormous; its urgency is great. I'd like to spend the rest of this chapter looking at the photographic strategies employed by Chilean-born artist Alfredo Jaar and French photojournalist Gilles Peress to question the West's habit of imagining witness in photographic terms. In particular, I will consider Jaar's *Real Pictures*, which consists of photographs he took of Rwanda in 1994. Alongside Jaar's work, I will look at some photos that Peress took, especially one of a discarded and battered photo album, part of the detritus of the massacres. The purpose of this comparison is to contemplate how these gestures of self-conscious burial complicate our habits of picturing and therefore imagining witness.

For four years Alfredo Jaar worked on The Rwanda Project, in which he sought to represent the genocide, or, more accurately, to represent its unrepresentability. His project is ultimately a meditation on the nature and limits of the journalistic or documentary

photograph. He has said of this project, "The camera never manages to record what your eyes see, or what you feel at that moment. The camera always creates a new reality. I have always been concerned with the disjunction between experience and what can be recorded photographically. In the case of Rwanda, the disjunction was enormous and the tragedy unrepresentable."[10] Jaar was and is outraged by the world's complete indifference to the carnage in Rwanda, where nearly a million people were killed in a little over three months. That indifference came in spite of newspaper reports and gruesome photographs, such as the disturbingly graphic images taken by photojournalists, including Gilles Peress. In response to the camera's simultaneous ubiquity and inefficacy, Jaar has tried to

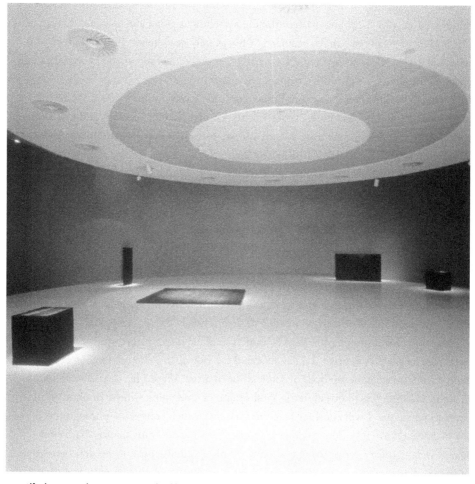

Alfredo Jaar, *Real Pictures*, 1995. Archival boxes, black linen, silk-screened text, Cibachrome prints, variable dimensions. Photograph courtesy of Alfredo Jaar.

develop strategies to place photographic knowledge at the center of his inquiry: he has veiled images or shown them disappearing; he has reduplicated some images hundreds of times, even a million times; he has blown them up and backlit them in photo boxes or miniaturized them in slides that must be looked at through a loupe.

Significantly, as part of his Rwanda Project, Jaar's installation called *Real Pictures* was composed of his Rwandan photographs, which he "buried" in black linen storage boxes and stacked in piles. There are eight different configurations of these boxes, each containing from 18 to 120 identical photographs from different sites that Jaar visited in Rwanda and Zaire. The top of each box is silk-screened with a text in white letters that describes the duplicated image encased within it. Most interpreters of *Real Pictures* see it as funereal, as an elegy to the image and to the power it has lost to a world of simulation and spectacle. Critic David Hartt, for example, writes, "Jaar is aware that to merely show us images of the carnage and destruction is exploitive, and worse, a pointless mimicry of the news media."[11] Jaar thus withholds these images from the media "stream." David Levi-Strauss, in his discussion of the project, similarly critiques the media, saying, "The way the politics of images are organized has changed, and this has acted to erode their power and effectiveness. There has always been something about 'real pictures' of real violence that undercuts their political effect, and separates them from experience."[12] He goes on to conclude that Jaar's work "transform[s] photojournalism through aesthetic means, by reworking the mise en scène."[13] Analyses such as those of Hartt and Levi-Strauss suggest that the value of *Real Pictures* lies in its ability to disrupt the habits of the pictures that dominate our capacity to imagine horror. Certainly that is Jaar's own stated goal, made clear by his inscription of the following statement by the Catalan poet Vincenç Altaió at the entrance to *Real Pictures:* "Images have an advanced religion; they bury history."[14]

In addition to the prevailing view that the project is a "tomb for the media," however, I would argue that it has another important effect, which is that it undermines our capacity to imagine our own witness in photographic terms.[15] The connection between the two, our habits of depicting trauma and our habits of picturing ourselves as witnesses to trauma, is expressed by John Taylor in his book on photojournalism. "The faithfulness of the photograph as trace, index or evidence," he writes, "though compromised by its use, puts onlookers in the privileged position of standing in the place of the actual, earlier eyewitness. This combination of realism and distance from the objects in view allows watchers to indulge in voyeurism. It also fixes viewers in an act of looking and seeing which, according to Jameson, is not only rapt but also mindless."[16] Westerners looking at media images of the Rwandan genocide become the voyeurs that Taylor describes. We become viewers who can neither see nor imagine seeing our own viewing; we engage in a looking-from-a-distance that is unaware of itself, that is mindless. Not only was the documenting gaze of the international press corps a central part of the Rwandans' experience of this tragedy, but also that gaze was one defined by its incapacity to see itself. The story

"A Prayer for the Living," written by Nigerian writer Ben Okri about the joint U.S.–U.N. intervention in Somalia in 1993, describes how events there were made to conform to the discursive habits of photographs. But the story can also be seen, more generally, to give voice to Africa's contemporary experiences of the Western media:

> I suppose this is what the white ones cannot understand when they come with their TV cameras and their aid. They expect to see us weeping. Instead they see us staring at them, without begging, and with a bulging placidity in our eyes. Maybe they are secretly horrified that we are not afraid of dying in this way. . . . I sang silently even when a good-hearted white man came into the school building with a television camera and, weeping, recorded the roomful of the dead for the world. . . . I opened my eyes for the last time. I saw the cameras on us all.[17]

Okri explains that the white ones cannot understand what they were sent to witness, because, first of all, it does not conform to preexisting pictures of weeping and starving Africans, and, second, their cameras and their eyes engage in tasks that are blind to their own witness, recording and weeping, respectively.

That Jaar is responding to that problem is evident where he describes the work of documentary photography, emphasizing the important role that incidental details have in the process of witnessing. He explains: "A parallel emerges between these minor elements [in the photograph] and the spectator: both the spectator and the minor details assume the precarious position of witnesses. This strategy offers a commentary on our incapacity to see, on the futility of the gaze that arrives too late."[18] Here the artist likens the spectator to the inanimate objects that find their way into the photographic frame, objects that testify to the photograph's reality but in themselves cannot see. His concern with the possibility of seeing our own seeing is further demonstrated in the texts that are printed on the black boxes in which he buried his Rwandan photographs. For example, the description of the photograph of Ntarama Church reads:

> This photograph shows Benjamin Musisi, 50, crouched low in the doorway of the church amongst scattered bodies spilling out into the daylight. Four hundred Tutsi men, women and children who had come here seeking refuge, were slaughtered during Sunday mass.

> Benjamin looks directly into the camera, as if recording what the camera saw. He asked to be photographed amongst the dead. He wanted to prove to his friends in Kampala, Uganda, that the atrocities were real and that he had seen the aftermath.

In this ekphrasis, it is Musisi's eyes that record what the camera saw. His eyes are devices for seeing the fact that the camera sees. They bear witness to the eyes of the photographer, to the eyes of the West. And the photograph in turn sees that Musisi has seen; it testifies to his witnessing. In reading this text rather than seeing the image it describes, we

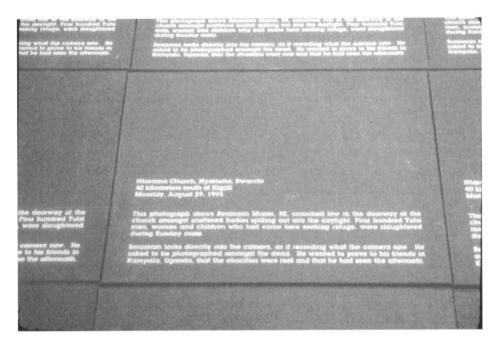

Alfredo Jaar, *Real Pictures* (detail), 1995. Archival boxes, black
linen, silk-screened text, Cibachrome prints, variable dimensions.
Photograph courtesy of Alfredo Jaar.

are put in the position of having to imagine, that task so central to witnessing. In Jaar's
work the ritual burying of the photograph acts to blind us, and in our blindness we imag-
ine ourselves as witnesses.

Gilles Peress's burial is of a somewhat different sort, but it has similar effects. Peress,
a Magnum photographer who has worked in Northern Ireland, Turkey, Rwanda, Bosnia,
and Iran, has produced a photo book about the Rwandan genocide called *The Silence*. The
book, which reproduces his black-and-white photographs without commentary, is divided
into sections called "The Sin" (which includes images of Tutsis killed in or displaced
by the genocide in Rukara, Nyamata, Nyarubuye, and Mayangi), "Purgatory" (which
includes images of Hutus living in refugee camps in Zaire and Tanzania), and "The
Judgement" (which shows Hutus dying of hunger and disease in the refugee camp at
Goma). These sections are framed by two images of the same man. The first is preceded
by the following text: "Rwanda. Kabuga, 27 May 1994. 16h:15. A prisoner, a killer is pre-
sented to us, it is a moment of confusion, of fear, of prepared stories. He has a moment
to himself." The photograph shows the man seated on the ground looking away from the
camera, which frames him from above. The second image, appearing at the end of the
book, is preceded by this text: "Rwanda. Kabuga. 27 May 1994. 16h:18. As I look at him
he looks at me." This photograph, nearly identical to the first, shows the same man in the
same pose from the same camera angle, only this time, the man's eyes are rolled upward

at the photographer. Thus, the religious narrative constructed in the book's pages of sin, purgatory, and judgment, is bracketed by the question of looking.[19] In the first image we voyeuristically look at this killer, who is "presented to us" just as he was to the photojournalists sent there to document the story of the crisis. In the second, at the end of this book of horrifying images, we see him seeing, we imagine our own witnessing, and we are judged through his eyes.

Peress has remarked that his experiences of witnessing indescribable violence have caused in him an "urgency to look at reality. As it is. And more." It is an urgency, he says, "to peel off layers from my eyes, to see."[20] There is one image in *The Silence*, bracketed between its twin images of witnessing, where layers of seeing are peeled away, where seeing is both buried and unearthed. The camera, trained at the ground, produces a sensation of vertigo, a feeling of falling. The object it spies there is an old photo album, its acetate pages torn, splayed out, and peeled away, its remaining photographs stained by water and covered in dirt. Peress's camera records the memorializing function of the photograph, its placement in albums, its implicit narratives (both personal and national) of family and home. It recognizes itself in the photographic frame; it sees itself seeing.

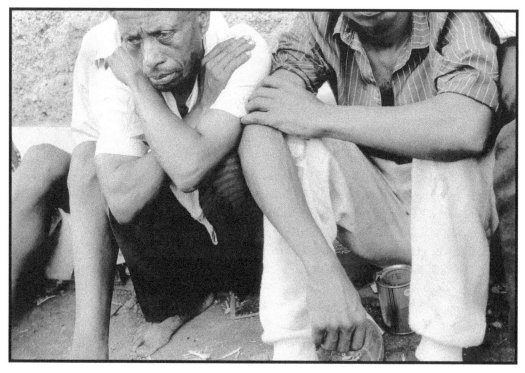

Gilles Peress, *The Silence*, 1994. "Rwanda. Kabuga, 27 May 1994, 16h:15." Photograph courtesy of Magnum Photos.

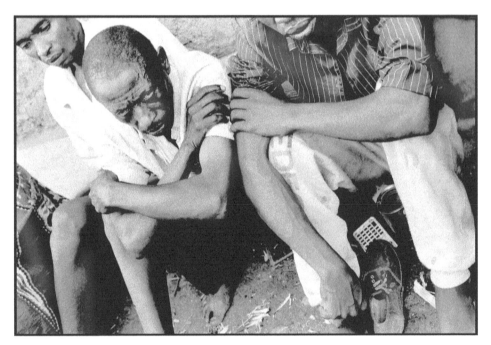

Gilles Peress, *The Silence*, 1994. "Rwanda. Kabuga, 27 May
1994, 16h:18." Photograph courtesy of Magnum Photos.

The image is a mirror in which we witness the photographic model on which we have
based our witnessing.

One can make out four of the photographs in the album's six sleeves. The image on
the upper left shows a dimly lit interior where stands a smiling boy in a striped shirt. The
image on the lower left shows a small house dominated by the large tree in its front yard.
Next to that is a scene from what looks like the same yard, where a little boy stands smil-
ing at the camera. And finally, on the lower right, is another image of two boys in white
shorts standing in front of a house. What is perhaps most startling about these images,
particularly in the context of Peress's disturbingly funereal book, is their depiction of
people who are living, young boys who pose comfortably, who are playing, smiling. These
are images of life as it was lived before the genocide, when normal experience was still a
possibility. But even they are framed by death. The self-reflexive nature of this image—a
photograph of photographs—is made more profound by the barely discernable presence,
in the black dust, of a small hand print that, like the photograph itself, bears an indexical
relation to the absent (and presumably dead) body to which it refers.

In this sense, the album, like the many dead bodies Peress recorded, seems to lie
somewhere between memory and oblivion, between burial and exhumation. The album
itself was left there, out in the sun with the decomposing bodies, as a memorial to the
lost innocence of these children, to the hand that imprinted itself in this dust. But the

A Cemetery of Images

photograph of the album is something different. Like Alfredo Jaar's solemn black boxes, it has the effect of strategically shoveling under, burying, and putting to rest the technologies of witness that, through the camera's gaze, routinely obscure the presence and responsibility of witness itself. Looking at the photograph, we wonder how it was that we came to imagine ourselves as witnesses in these terms, how we used the dispassionate neutrality of the camera as a model for how to look at genocide, how the West conceived of itself as an omniscient god who sees but is not responsible for human slaughter.

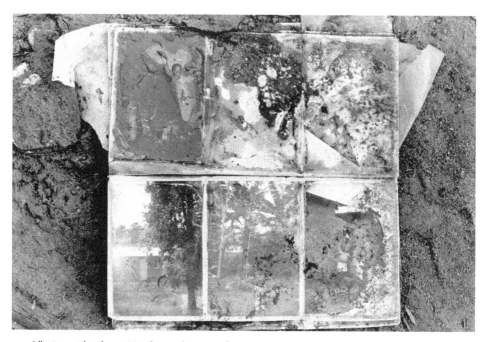

Gilles Peress, *The Silence,* 1994. Photograph courtesy of Magnum Photos.

5. Machine Memory
Digital Witness in Dumb Type's *memorandum*

Who can say what memories were before photography existed?

—SHIRO TAKATANI

[Memory's] new vocation is to record; delegating to the archive the responsibility of remembering, it sheds its signs upon depositing them there, as a snake sheds its skin.

—PIERRE NORA

Unblinking Eye, Perfect Memory

In 1945, Sicilian-born artist Alfred Crimi produced an intriguing pencil drawing for Vannevar Bush's now famous essay "As We May Think," which was first published in *Atlantic Monthly* and then later reprinted in *Life* with Crimi's illustrations. An engineering researcher at MIT during the war, Bush served as director of the Office of Scientific Research and Development, where, according to the editor of *Atlantic Monthly*, he "coordinated the activities of some six thousand leading American scientists in the application of science to warfare."[1] Thus, he played an early and active role in the establishment of contemporary geopolitics, which combines industry, technology, and warfare, as well as contemporary capitalism, which in turn is a product of globalization and instantaneous communications. Strangely, given his central role in developing the military industrial complex, the ostensible purpose of his most famous article is to encourage the use of technology for what he calls "true good" as opposed to "throw[ing] masses of people against one another with cruel weapons."[2] The article introduced Bush's concept of his most famous invention (although it was never realized as he imagined it), the memex, a device that could record, using small cameras, store, using microfilm, and retrieve, using a protocomputer sorting device (similar to an earlier invention he called the Rapid Selector), millions of pages of data.[3] "Consider a future device for individual use," Bush explains, "which is a sort of mechanized private file and library. It needs a name, and, to coin one at random, 'memex' will do. A memex is a device in which an individual

Machine Memory

[61]

stores all his books, records, and communications, and which is mechanized so that it may be consulted with exceeding speed and flexibility. It is an enlarged intimate supplement to his memory."[4] The memex, then, as Bush conceived it, was to be a memory machine.

The first component of the memex was the adaptation of photographic technologies for the collection and storage of data. Bush proposed microfilm, a technology that already existed, as a means to archive in miniature millions of pages of information.[5] In addition to the photographic process involved in microfilm, he imagined a tiny camera strapped to the forehead of, for example, a scientific researcher, a camera that could take thousands of pictures of whatever the researcher was seeing and experiencing. "As the scientist of the future moves about the laboratory or the field," Bush imagines, "every time he looks at something worthy of the record, he trips the shutter and in it goes, without even an audible click."[6] It is this strange device that Crimi's drawing attempts to represent. The image depicts the face of a man whose eyes are focused so intently on something (presumably something that is worthy of the record) that he is almost cross-eyed. The man wears a pair of glasses with a focusing device in the right lens (which we are told in the caption). In addition, he wears a narrow headband strapped to a small camera lens, which protrudes from the middle of his forehead like a prosthetic third eye. Because this image contains so many eyes—the man's two eyes, the two lenses of his glasses, the focusing device, and the cyclopean camera on his forehead—the illustration reads as though it were a depiction

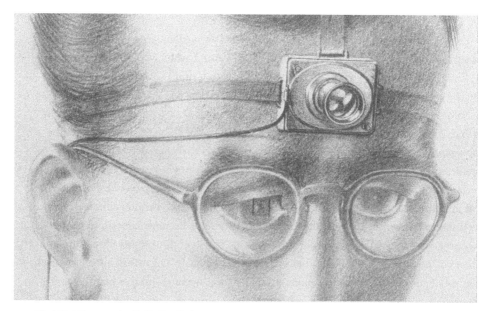

Alfred Crimi, illustration for "As We May Think," 1945.
Permission to reprint granted from the estate of Mary and
Alfred Crimi by Joan Adria D'Amico, executor.

of a superwitness, a viewer who experiences, records, and remembers everything he sees. "In it goes, without even an audible click." The device he uses is an early example of what Paul Virilio describes as "the new industrialization of vision," which eventually would lead to a "kind of mechanized imaginary." This vision is characterized by machines that, often independent of human operators, see and record visual experience, share those records with other machines, and thereby proliferate an image world that functions further and further outside human experience.[7]

Once all the images were gathered in the memex and all the microfilm was produced, a researcher would sit at a desk-sized machine in which all the data were stored in compact form. By pushing a series of buttons, he would then call up information from this mechanized imaginary, in the form of pictures that would be projected onto "slanting translucent viewing screens [that] magnify supermicrofilm filed by code numbers."[8] Unlike traditional library storage systems, however, the memex was designed to be more than simply a compact reference device. Bush imagined a fully interactive machine that would process the researcher's notes, scribbled in longhand, about what he was seeing and reading, by dry photographing (much like today's photocopy machines), coding, and then storing them. Not only could future operators of the memex make comments and annotations about the information already stored; they could also reply to the comments made by previous researchers.

Ironically, the imagined memex, though an analog machine, served as a conceptual template for the later development of personal computers, hypertext, and digital culture generally. Important figures in the early history of computers, such as Ted Nelson and Douglas Englebart, have utilized Bush's concepts in their own seminal writings.[9] Although its means of recording, storing, and retrieving information were entirely mechanical, the memex concretized the concept of a personal information device, one in which data are stored and retrieved through a new organizational system. Rather than using traditional library subject headings for the storage and retrieval of information, a system that dominated methods of information storage in the mid-twentieth century and that Bush considered outmoded and artificial, memex would allow a user to retrieve information as the human mind does: not by categories and subheadings, but by association or trails of thought.[10] This idea had enormous influence on future research into artificial intelligence and attempts to produce machines that think like humans.

The questions thus become: Why were such a device and its subsequent computer progeny thought to be necessary in 1945? What had happened to human memory and the human witness that catalyzed this research? Bush offers this answer:

> [Man] has built a civilization so complex that he needs to mechanize his records more fully if he is to push his experiment to its logical conclusion and not merely become bogged down part way there by overtaxing his limited memory. His excursions may be more enjoyable if he can reacquire the privilege of forgetting

the manifold things he does not need to have immediately at hand, with some assurance that he can find them again if they prove important.[11]

Bush describes a phenomenon on which many experts in his own time and many more since have commented, that is, the growing sense that life is becoming too fast, too complex, too loaded with information and imagery for feeble human memory to retain it. Moreover, because of the sheer volume and indiscriminate nature of what needs to be remembered, man has lost the privilege of forgetting. Since there is no time to prioritize information, to establish hierarchies, to determine what is "worthy of the record," it all goes in. For Bush, the rapidity of contemporary life produces an acute crisis of memory, his description of which retains remarkable currency today:

> There is a growing mountain of research. But there is increased evidence that we are being bogged down today as specialization extends. The investigator is staggered by the findings and conclusions of thousands of other workers— conclusions which he cannot find time to grasp, much less to remember, as they appear. Yet specialization becomes increasingly necessary for progress, and the effort to bridge between disciplines is correspondingly superficial.[12]

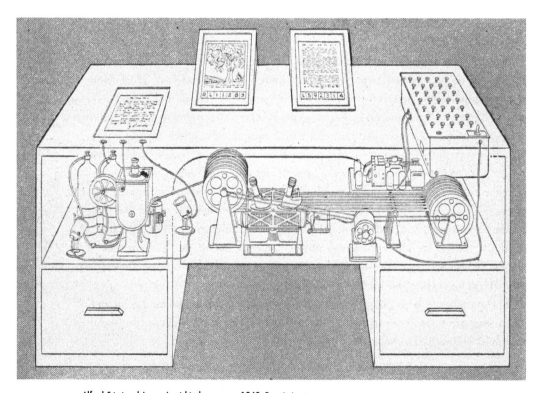

Alfred Crimi and James Lewicki, the memex, 1945. Permission to reprint granted from the estate of Mary and Alfred Crimi by Joan Adria D'Amico, executor.

The human capacity for remembering reaches an abrupt limit in the face of increasing disciplinary specialization, the expansion of information transfer, and rapid technological change. In this environment, the task of productive forgetting for the purpose of understanding and reporting on experience is ever more urgent.

In an important sense, what this forgetting is productive of is precisely the subjectivity of the individual. Bush theorizes a machine whose capacity to remember is potentially infinite and an individual whose burden of memory is productively contained. Freed from his enslavement to the undifferentiated mass of others' texts, data, and information, the subject is returned to himself and his own memories and thoughts, comfortable in the knowledge that this mass of information is still available should it prove important. His subjectivity is restored. Not only was the memex designed to operate via trails of thought, but it would also record those trails, thereby keeping a record of how the human subject navigated from idea to idea, topic to topic, image to image. Bush explains that the memex user "builds a trail of his interest through the maze of materials available to him. And his trails do not fade."[13] He describes various mechanisms by which the trails would be recorded, photographed, copied, and shared with others. This is something like the search record on a computer browser or an interactive hypertext story, in which the directional choices made by the user produce a unique history of moves or a unique narrative. Indeed, he calls the intrepid users of the memex "trailblazers," a term that heroizes the individual whom Bush imagines, the self-made thinker who is not lost within the jungle of information but who asserts his unique individuality on it.

What Bush hoped for his memex is precisely what legions of subsequent commentators have sought in computers: that they be made to perform uncannily like the human mind, which, according to Bush, operates by association. "With one item in its grasp, [the mind] snaps instantly to the next that is suggested by the association of thoughts, in accordance with some intricate web of trails carried by the cells of the brain. . . . the speed of action, the intricacy of trails, the detail of mental pictures, is awe-inspiring beyond all else in nature."[14] By 1965, Bush's romantic ideal was partly realized in Ted Nelson's proposal for hypertext, which emerged from a file structure he called ELF (Evolutionary List File).[15] Hypertext, as Nelson designed it, was meant to accommodate not only the mind's associations but also the fact that the mind itself is constantly changing. Above all it was meant to be customized to the individual, an outward reflection of his inner thought processes:

> Let me introduce the word "hypertext" to mean a body of written or pictorial material interconnected in such a complex way that it could not conveniently be presented or represented on paper. It may contain summaries, or maps of its contents and their interrelations; it may contain annotations, additions and footnotes from scholars who have examined it. Let me suggest that such an object and system, properly designed and administered, could have great potential for education, increasing the student's range of choices, his sense of freedom, his motivation, and his intellectual grasp.[16]

Nelson incorporated his ideas for hypertext into the design of a computer system he called Xanadu, a precursor of the personal computer that, like Bush's memex, would store and retrieve information. Of course today hypertext is the format in which almost all Internet information is presented and the chief mechanism by which it is searched. In Nelson's view, the operations performed by the computer are simply the outward manifestation of the user's own idiosyncratic thinking; the computer is a mirror in which he can see his own subjectivity as an independent mind.

As laudable a goal as preserving or restoring the individual's subjectivity might be, the role of such technologies in that task is complicated by two things: the ambivalence with which computers in particular have traditionally been designed to regard the human; and the role that computers have played in dismantling traditional notions of the subject. In this sense, in addition to theorizing what would later become the personal computer, Bush might be seen as establishing another important conceptual precedent with which scientists and science fiction writers would wrestle in various ways for the subsequent half century. His article betrays a fundamental contradiction in technology's relation to the human subject. On one hand, such technology has regarded the human mind as an exemplar of complex thought, reasoning, and emotion, an ideal to which computers should aspire. It is, for Bush, "awe-inspiring beyond all else in nature." Computer engineers, scientists, novelists, and film and television writers have thus sought to imagine and create computers that emulate as closely as possible the procedures of the human mind for remembering and forgetting (including the ever-elusive experiencing of emotion). On the other hand, such technology has regarded the human mind as pathetically limited, frail, and outmoded. Despite Bush's respect for human thought, the impetus for his article is the mind's severe limitations.

Again, those whose job it has been to think creatively about the potential for computer intelligence have also seen the computer as inherently superior to human thinking and therefore obligated to overcome it and bound to supersede it. Microsoft researchers Gordon Bell and Jim Gemmell have said, with regard to their digital life storage and retrieval project, MyLifeBits, "Human memory can be maddeningly elusive. We stumble upon its limitations every day."[17] Their project, using a powerful computer and what they call the SenseCam, records every Web page the user reads, every text message he receives, every song to which he listens, every television show he watches. It also records his location via GPS, details of his ambient environment, his heart rate, and a visual record of what he sees. Bell and Gemmell position this system as the direct heir of Bush's memex and argue that it surpasses human memory in terms of both the amount and the kind of data that are captured: "Digital memories can do more than simply assist the recollection of past events, conversations and projects. Portable sensors can take readings of things that are not even perceived by humans, such as oxygen levels in the blood or the amount of carbon dioxide in the air."[18]

So boastful have such claims become that, as a result, some scholars have looked far more skeptically on the role of computers in extending memory and supporting subjectivity. José van Dijck, for example, examines the rhetoric surrounding new technologies for recording and retrieving individual human memories, or, as they are commercially described, "bits of life."[19] He examines recent software programs such as Lifestreams, Memories for Life, and MyLifeBits in order to show the ways in which computers do more than simply passively record the photographs, graphic images, remembrances, video clips, music files, and audio messages that are poured into them. Rather than emulating human memory and mirroring individual subjectivities, that is, working in the service of the mind, such technologies, he argues, actively structure how human memory takes place, making the mind work in the service of the computer and potentially threatening the subject who remembers. He says simply, "Digitization is surreptitiously shaping our acts of cultural memory—the way we record, save and retrieve remembrances of our lives past."[20] He is interested in "how digital technologies, by changing the material basis of our mediated memories, (re)shape the nature of our recollections and the process of remembering."[21] Of course, human memory has always been shaped by technologies—writing, photography, drawing, and so forth; the computer is simply the latest such technology. Its particular effects on memory, however, are being actively and sometimes combatively debated today. As a result of these debates, we are left to ask: Is the computer simply a crude laborer well suited to routine tasks of computation, duplication, and storage, its undertaking of which affords the human being the luxury of higher-order thinking? Or is the computer a prosthetic device meant to help human beings overcome the debilitating handicap of memory loss? Does the computer contribute to or detract from the individual's memory and therefore, by direct implication, his subjectivity and capacity to bear witness to what he has experienced?

Ironically, the digital age to which Bush's essay seems to point has, to many observers, only deepened the memory crisis and made more anxious the ambivalence of technology toward the human, rather than ameliorating either one. To understand this, we will find it useful to consider a couple of key points about our present relation with and understanding of memory. Today we live in a culture in which, according to historian David Gross, we look more skeptically on the importance of memory than we did three hundred years ago. For evidence of this, Gross cites numerous examples from ancient to early modern European history in which remembering was not only revered as an important skill but was seen as essential to human subjectivity. "Despite the physical and mental changes that inevitably occur in the transition from childhood to maturity, or from maturity to old age," Gross explains,

> remembering, it was said, kept one mindful of the fact that one always remained the same person, and that the responsibilities and obligations incurred at one point in one's life also had to be honored at every other. If this were not so,

one's sense of self would be diffuse and chaotic, and it would be impossible to develop anything like a consistent moral character. In fact, without memory, it was argued, one would literally *be* nothing, have no identity, possess no real personhood.[22]

With the rise of capitalism, urbanism, new technologies, and the emphasis on innovation and newness they engender, along with the development of psychology, with its emphasis on the individual mind and the crippling effects of memory, remembering began to be viewed much more negatively.[23] Today, Gross argues, to be concerned with memory is to be seen as backward-looking and melancholic; it is to be seen as having been overcome by an excess of information that outweighs and compromises selfhood. Contemporary culture thus often treats memory as "burdensome and unhealthy" because of the common view that it "is not and cannot be as accurate as it was once assumed and thus can be relied upon neither for values, identity, nor any other aim or end in the same way that it had in the past."[24] No doubt the proliferation of computer technologies has contributed to our unease about memory.

Another irony is that, despite the suspicions that are now attached to memory (about its usefulness, its melancholic consequences, its severe limitations), we are at the same time obsessed with memory. This obsession is demonstrated in diverse cultural manifestations, such as the focus on and privileging of memory over history within recent historical scholarship (e.g., the work of Pierre Nora), the rapid expansion of memorials and museums, the proliferation of digital cameras and software for obtaining and managing personal memories (e.g., Gordon Bell's MyLifeBits project), and the growth in popular culture of campy nostalgic displays of the past as well as dystopic representations of how memory functions in the present (e.g., the film *The Eternal Sunshine of the Spotless Mind*). Andreas Huyssen argues, in his millennial analysis of Western culture, that all this memorializing is in part a response to the collapse of temporality produced by new technologies:

> Our obsessions with memory function as a reaction formation against the accelerating technical processes that are transforming our *Lebenswelt* (lifeworld) in quite distinct ways. Memory is no longer primarily a vital and energizing antidote to capitalist reification via the commodity form, a rejection of the iron cage homogeneity of an earlier culture industry and its consumer markets. It rather represents the attempt to slow down information processing, to resist the dissolution of time in the synchronicity of the archive, to recover a mode of contemplation outside the universe of simulation and fast-speed information and cable networks, to claim some anchoring space in a world of puzzling and often threatening heterogeneity, non-synchronicity, and information overload.[25]

Huyssen represents a significant point of view expressed by a variety of scholars in the late twentieth century, including Pierre Nora, Paul Virilio, Jean Baudrillard, and Gilles Deleuze. This view posits a radical historical break (i.e., modernity) before which information, knowledge, and time were presumably purer and more stable. From that perspective,

it is the crushing speed of new technologies along with their capacity to remember everything indiscriminately that leaves the human subject feeling overwhelmed and preoccupied with the problem of memory. Huyssen's rhetoric is pointed; the contemporary individual seeks something to slow down, to resist, to reject, to recover from, and to make claims against what is threatening, poisonous, and overloaded.

What happens to our sense of human subjectivity when we place memory in the hands of the computer? One of the things that occurs, of course, is the mythologization of the capacities of the computer-augmented human, so that he begins to look like Crimi's five-eyed memex user. This mythology thereby imagines a supersubject, a cyborg that is both human and fundamentally technological; one whose gaze is omniscient and complete; one whose memory is unfailing; one who blazes a trail. The exact opposite also occurs: the subject is commonly viewed, as it is by Huyssen, as overwhelmed by its own omniscience, unable meaningfully to understand what has been stored in the computer's RAM and ROM or what has been found by an Internet search engine. I am reminded of Ross McElwee's lament that it is extremely difficult to live one's own life and record one's own life at the same time. As Virilio warns, "Blindness is . . . very much at the heart of the coming 'vision machine.' "[26] Amelia Jones, whose project has been to understand the function of the subject and intersubjective engagement in performance and new media, has tried hard to resist these polemics, explaining instead that she explores new media bodies "for their capacity to activate rather than suppress the object or subject reproduced." She sees new media as tools for the examination of traditional Hegelian notions of subjectivity and for the creative (re)invention of the self. Moreover, she rejects "the tendency in discussions of new media or new communications technologies to insist . . . upon the obsolescence of the body."[27]

As the foregoing discussion attests, no matter whether it is viewed with hope or with deep suspicion, from the position of "true good" or total warfare, digital culture, because it is integral to questions such as subjectivity and memory, is a significant but largely unexamined issue within the ethics of witnessing. Not only is it entwined with the crisis of human memory (posed as either a solution to or a leading cause of that crisis), but also it has had a crucial influence on how we understand the subject. And subjectivity, as Kelly Oliver emphatically states, "is the process of witnessing, of addressing oneself to others, of responding to the address from others."[28] In the most basic terms of witnessing, in order for it to take place, a subject who sees and experiences the world needs to be present and then needs to remember and speak, to testify truthfully to his experience. In addition, someone must also listen, attend to that person's story and respond to it by acknowledging its reality.[29] What I would like to suggest in the remainder of this chapter is that within the vision machine of contemporary digital culture, the main components of that ethics—the subjectivity of the one who testifies, the vision with which he apprehends the world, the reality to which he swears, the capacity of his memory to conjure that reality, and the responsibility of the one who listens—are both radically and productively altered and in

some important ways severely compromised.[30] I will suggest both that new media technologies offer unprecedented opportunities to question the hegemony of authorized witness and to reimagine the self and, at the same time, that they have the problematic potential to relativize witness testimony and disperse the responsibility of attending to the witness.

In what follows, I undertake an analysis of specific scenes from a performance by the Japanese collective Dumb Type called *memorandum*. I use those scenes as a means to make and think through the implications of the following assertion: we cannot continue to discuss the ethics of witnessing as though memory has not been radically altered by computers, as though subjects have not been dispersed through information networks, as though vision has not been replaced by what Virilio calls the "vision machine,"[31] as though reality is a stable ontological category. The performance, the substance of which entwines memory, technology, and selfhood, reveals and forces the viewer to experience the contradictory nature of the contemporary witness: his simultaneous ability to witness everything and his inability to testify to the reality of anything. I will argue that *memorandum* provocatively asks, Where is the self located? and demonstrates that in contemporary culture the subject is split, not just within himself, as Lacan suggested years ago, but also between his prosthetic digital devices and his bodily self (or selves); between his camera eyes, which see everything, and his biological eyes, which are ailing and myopic; between the screens that surround him everywhere and the screen of his own mind. Further, I will claim that the contemporary subject and the witnessing he attempts to perform are constantly battered by the anxieties of forgetting and the burden of remembering, by the certitude of self-knowing and the dislocation of the self as it is fragmented, projected into machines, manufactured in digital memories, and networked with countless other selves, both real and imagined. That witness cannot, as Oliver hopes, "address himself to others and respond to the address from others" in quite the same way as he used to.[32]

memorandum

I do not remember *memorandum*. That is, my memory of the piece that Dumb Type toured internationally between 1999 and 2002 is fragmented, incomplete, and distilled for me into a feeling of having been entirely overwhelmed and undone by it. The performance, which is loud, fast moving, and presented in chunks and pieces with surprising visual, aural, and textual references, creates a condition of amnesia. As its authors describe it, "*memorandum* is a non-elegy to recall, an impossible investigation into the unstable neuro-philosophical events of memory itself."[33] Thus, my memory of the performance I saw in 2002 (at the Walker Art Center, in Minneapolis) has been supplemented, altered, and in some cases entirely replaced by descriptions I have read of it, such as that by Woodrow Hood and Cynthia Gendrich of a performance at the Museum of Contemporary Art in Chicago, and by the video recording I have seen of another version of the performance staged in 2000 in Osaka.[34] Ironically, then, to describe and explain this piece, which is

completely occupied with the problem of memory and technology, means having to rely on technologies of memory.

The performance begins with trying to remember simple stories. The lights brighten, and we see a stage, across which is hung a large scrim/projection screen, twelve meters, or nearly forty feet, wide. Words are projected on the scrim, unconnected, seemingly random words and punctuation marks that look as though they are all that remain from a block of text that has been censored or erased: "hungry," "soup," "only very little," "least," "minutes," "unmade," "?," "her," "after," "they." As we soon learn, these words are taken from the story of "Goldilocks and the Three Bears." Now the projected image shows people appearing to crawl from the bottom of the scrim to the top by using these words as handholds to hoist themselves up and footholds on which to perch momentarily, as though they are climbing a wall. In the dim light, it appears at first that this is entirely a video projection, but soon we realize that actual bodies are crawling across the black carpeted stage floor from left to right and that a closed-circuit digital video camera, which hangs down on a cable from above the stage, records their image, which in turn is then projected vertically onto the scrim. At the same time, a digital video of the text, which we now realize is changing before our eyes, is also projected and superimposed over the performance of the climbers. While the bodies continue to climb the text, more words are added to fill in the blank spaces. As the initial climbers exit on the other side of the stage, appearing on the scrim simply to rise above our field of vision at the top of the "page," the final climbers seem to become wedged in the now complete lines of text, around which they must contort themselves. We hear a childlike female voice speaking in English, reading the story, which is now printed on the screen:

> It's a simple story. The three of them were away. The door was open, and she was so very hungry. She went inside, and there was soup on the table. She ate only very little from the least bowl. Then she sat a while in the smallest of the three chairs or maybe rested a few minutes on the unmade bed. So why were they so angry with her? When they came home, they made so much noise they scared her and woke her up!

With that, the lights black out, and when they snap on again, we see the storyteller (Seiko Kato) standing in the center of the stage in front of the now blank screen, and she asks, "And then, how did it go after that?"

The storyteller leaves the stage, and a man, Takao Kawaguchi, takes her place. He sits on a chair in the middle of the stage under a pin spot and holds a pad of paper and a felt pen. He begins to write on the paper, and we can see what he is writing because it is projected on the screen behind him as he writes it. As in the last sequence, a closed-circuit video camera dangles above his head. "All work and no play make Jack a dull boy"; we watch the words emerge on the paper, one after another. Kawaguchi, scribbling as fast as he can with the pen, tries then to jot down the key plot points of "Jack and the

Beanstalk." He wears a sensitive body microphone that allows us to hear the squeaking of the pen and his hand against the paper. The words emerge over his head:

1. Jack likes the view from the top of the tree but misses home.
2. Upon his return, everybody has aged, much like Einstein's theory of time/speed-of-light travel.
3. In reaction to the betrayal of time, Jack chops down the tree with his golden axe.[35]

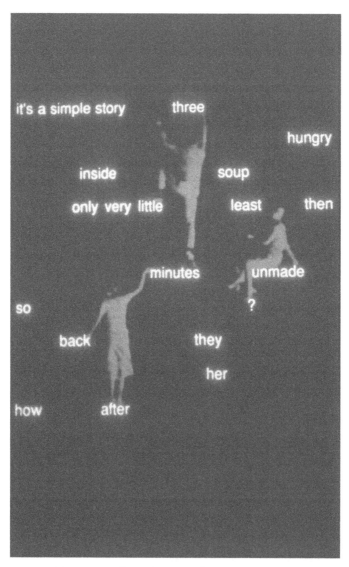

Dumb Type, *memorandum*, 1999–2002 (performance).
Copyright Dumb Type. Photograph by Kazuo Fukunaga.

Dumb Type, *memorandum*, 1999–2002 (performance).
Copyright Dumb Type.

Kawaguchi draws brackets and arrows between sections, circles certain passages with his pen, gets lost in his summary of the story, begins to scribble commentary in the margins, writes a maxim that Vannevar Bush might have coined: "Sometimes you have to forget to remember." The paper, now crowded with scribbled and nearly illegible text, signifies his confusion and frustration. He tears the paper violently from the pad, crumples it, and throws it down on the floor. The lights go black.

Dumb Type describes this performance as follows: "Who can say what memory was before photography existed? What will come to replace cumulative direct experience as new technologies continue to overtake the thresholds of cognizance, the speed of human recognition?"[36] Just as was the case in the nineteenth and early twentieth centuries in regard to the new technology of photography, so is the case in contemporary times in regard to digital culture: defining what memory was or how it was conceived to be before the advent of the computer has become increasingly difficult. These two sequences of *memordandum* are therefore meant to introduce us to the problem of remembering, the mnemonic technologies brought to bear on that problem, and the impact of such technologies on the subjectivity of the rememberer. I will take up each of these issues in turn.

In both of these scenes, a single individual tries unsuccessfully to remember a well-known fairy tale. In the first segment, a woman tells the story of Goldilocks, which is itself a tale about memory. The story's structure mimics the techniques of ancient mnemonic

devices, such as attempting to imagine a room in which objects are arranged in particu-lar ways, each object, each part of the room, functioning as a clue to remembering the information to which it is attached and for which it acts as a prompt. The teller of the story must also remember a sequence of facts, a series of numbered objects: the three bears, the three bowls, the three chairs, the three beds. In this regard, one might read the story as a metaphor for the functioning of the mind. The bears' house is like the closed room of the mind, a room in which memory arranges its objects and orders them hier-archically: kitchen, living room, bedroom; eating, resting, sleeping; large, medium, small; father, mother, baby. This mind is then disrupted and disarranged by an intruder, who licks the spoons, breaks the chairs, rumples the bed clothes. When the bears return, they must determine whether the current state of their home matches their memory of it. They ask, "Has the porridge been eaten? Has the chair been moved? Was the bed made when we left?" Goldilocks is a figure of forgetting or, rather, a figure for the ways in which forgetting is constitutive of remembering.

The tale of Jack, which is introduced in the second segment of the performance, is similarly a story about memory. Jack is a fool and a disloyal son who has trouble remem-bering his mother's instructions. Paying no attention to the past, his mind flits about in the present, distracted by whatever he encounters. His is a cautionary tale that instructs children in what David Gross describes as the virtue, piety, and ethics of memory.[37] In addition, in the performer's diagram of the story, Jack disrupts the linear progression of time by entering the liminal realm of the giant. During the period he spends with the giant, time does not move forward for Jack, though it does for those he has left at the foot of the beanstalk. When he returns from his journey, his family has aged, time has passed, but like an amnesiac he has no memory of it. He has betrayed time. And though he returns home with the giant's gold to lavish on his mother, he has also betrayed her by forgetting.

Dumb Type's performance cleverly introduces into all the remembering and forget-ting going on in these stories various mnemonic technologies: paper and printed text, the camera and the projection, digital code and the screen on which it is made visible. And with those technologies comes the question of the subjectivity of the rememberer.

The first memory technology we ought to consider is the handwritten or printed text, specifically as it appears here in relation to the individual who writes or speaks. When we first encounter the image of fragmented blocked-out text in the Goldilocks sequence, no actor is onstage, so the random words read as though they were the transcription of the similarly random thoughts of an unseen individual who is in the process of remember-ing something (memo random). The speaker's memory may be thought to navigate these words the way the climbers do, not from left to right and top to bottom in a linear narra-tive, but from bottom to top, wherever one word may be grasped from the point of view of another. Gradually, however, a distinction emerges between the individual memory and the text. The text is filled in, succumbs to the logic of printing, and arranges itself

in the orderly fashion of a narrative, thereby asserting its authority over memory, which it both prompts and safeguards. While this happens, we are no longer certain whether what we are seeing and hearing is the product of a single mind, a unique memory, or if the technology of printed text has meant the obliteration of the individual in relation to the story, even as she reads it aloud. This sequence thus captures a pivotal moment that is enacted again and again in our interactions with technologies (the pen, the printing press, the camera, and the computer), the moment when the distinction between the self and the machine, the private and the public, the individual and the collective, is blurred. It is at this moment, when the text is complete, that it disappears from the screen and the speaker appears onstage, as though speaking the story has brought her into being. She is quite literally the one who speaks (in fact, she is the only person who speaks in the entire performance), the subject who addresses herself to others. But her memory falters and she asks, "How did it go after that?" If we are able to answer, it is because of our shared technologies, because we have read the story thousands of times. Writing and printing tend, therefore, to stabilize and constrain memory, to turn it into a public discourse.

In addition to the printed word, the first sequences of *memorandum* deploy the technologies of the camera and closed-circuit image projection. As was the case in the first segment, in the segment on "Jack and the Beanstalk," what we see on the screen projected behind the sole actor reads as though it were a glimpse into his own mind in the act of remembering and trying to understand the story of Jack. In both instances, the closed-circuit camera functions as a metaphor for the mind's techniques of memory, which work on a closed-circuit where experiencing and recording take place simultaneously. Moreover, in both instances, we see the subjects of speech, or thought, or memory only through exterior technologies, only through paper and camera.

We can think of the projection of Kawaguchi's scribbled words as also a projection of his subjectivity, his own thought process. In that regard the screen acts as a giant version of the ones that Vannevar Bush designed for his memex: all instantly record via a photograph of written text and visualize via a projection of that text the user's trails of thought. Bush's description of the memex operator's behavior is remarkably similar to Kawaguchi's intertextual performance:

> He has dozens of possibly pertinent books and articles in his memex. First he runs through an encyclopedia, finds an interesting but sketchy article, leaves it projected. Next, in a history, he finds another pertinent item, and ties the two together. Thus he goes, building a trail of many items. Occasionally he inserts a comment of his own, either linking it into the main trail or joining it by a side trail to a particular item. . . . He inserts a page of longhand analysis of his own.[38]

Here we can imagine Kawaguchi as a researcher, one whose thoughts have led him to look up and read about Einstein's theory of relativity, which then leads him to think about

theories of time, which in turn leads him to the story of "Jack and the Beanstalk." Or we might follow another trail, one that begins with Jack and Jill, and then moves to Jack and the beanstalk, and then to Jack Sprat, and then to the Jack who has been made a dull boy by overwork. In response to this research, he inserts comments of his own and eventually an entire "page of longhand analysis." Unlike Bush's imagined scenario (see the memex diagram by Crimi and Lewicki), though, this scene is not clean; its actor demonstrates no mastery over the materials he has gathered; it does not proceed neatly from one reference to another. Although it begins with a list of numbered ideas, it devolves into scribbling, multidirectional arrows, text that is crossed out and written sideways. Bush's scenario doesn't allow for failure, dead ends, or disorder; rather, he sees it as the individual's ever-expanding colonization and appropriation of information. In the end, Kawaguchi tears up the record of his mind's trails, destroys it, and throws it to the ground in a defiant act of forgetting. This scene, in contrast to the one that precedes it, stages the personal, contingent, and fragmentary nature of memory in relation to the mnemonic technology of writing.

As these brief analyses suggest and many critics have noted, *memorandum* concerns itself with our current crisis of memory and the technological environment in which that crisis flourishes. Critic Yukiko Shikata explains, "Based on the premise of a shared quality between humans and computers, *memorandum* shows humans connected to machines as their own memories are cut up."[39] Hood and Gendrich similarly comment, "In dumb type's vision, memory is understood through technology, which helps us record, recall, and reflect on the events of our lives. Through our reliance on various technologies to help us remember (since human memory is not failsafe), we also allow technology itself to taint—or, less pejoratively, to shape—our memories. That is, we confuse the digital documentation of our lives with the memories themselves."[40] Amelia Jones argues that one result of this cutting up of memory, this memory crisis, is what she calls "the paradox of postmodern subjectivity," in which the subject is "both decentered and contingent . . . , and profoundly aware of itself in its identity as dissolved."[41] In this environment, the subject does not know whether her selfhood is produced out of the memory of real experiences, of fictional tales, or of digitally produced perceptions. Nor does she know where her self is located, whether in her body, recorded voice, photographic portrait, the lens of her camera, or the computer screen on which she writes. As Virilio writes, "If man's sphere of activity is effectively no longer limited by extension, duration, even the opacity of obstacles that block his path, where is he situated? That is, where is his presence in the world, his real presence situated? Tele-present, certainly, but where? From which place, from which position? Living-present, here and there at the same time: *where am I if I am everywhere?*"[42] "Real/reel—or in a dream," Jones writes, echoing Virilio. "That's the crux of contemporary life. Where/who am I?"[43] But unlike Virilio, Jones sees this sense of confusion as a productive crisis, one in which the individual can engage in acts of "self de- and re-construction."[44]

The selves performed in *memorandum,* the subject positions they create and occupy, the mechanisms by which they remember, and the memories they retain are similarly complicated and troubled. They are split and shifting, sometimes superimposed, sometimes completely at odds. There is the subject of the written text, the author, whose memories take the form of printed words. There is the subject who speaks, the actor, whose memories are stored in repeated speech. There is the subject who scribbles, the scholar, whose memories are revealed in trails of thought he builds and in the screens on which those trails are projected. There is the subject who photographs, the cyclops that dangles on its cord from the ceiling and makes pictures of bodies writhing on the floor and a man scribbling on some paper. There is the subject who attends, the audience member, who tries to comprehend and remember what she has seen in the darkened auditorium of her own mind. As is the case with the memex, it is very difficult in *memorandum* to disentangle these subjectivities from one another and from the technologies they employ.

The question of technology and its effects on memory and subjectivity is taken up in another of the performance's segments. In it, the experience of a crisis is much more vividly rendered than in the previous sections we've examined. As Hood and Gendrich characterize it, "We see bodies in crisis and stress, tossed and twisted, writhing in agony and sometimes, though rarely, ecstasy."[45] What brings these bodies to crisis is a seeming onslaught of visual, aural, and digital information. In this regard, the performers' own description is most instructive: "The safe and sheltering forest of memory is no more. Nostalgic reminiscences of happy days past, sweet dreams of future memories to come— all are poised without critical mass on the brink of never, swimming headlong down a horizon-less maze toward no vanishing point."[46] The maze or labyrinth that the performers have in mind is the labyrinth of time. In commenting on the performance, they quote Borges: "The next time I kill you . . . I promise you that labyrinth, consisting of a single line which is invisible and unceasing."[47]

The lights come up dimly, and we see only the projection screen. In this sequence, a series of very fast-changing images and digital video clips is projected onto the screen. Sometimes we see a single image that stretches the width of the stage, and at other times the screen is divided into four separate rear-projection videos that repeat one another and move in a pattern that is so fast, its logic so elusive, that it washes over us in a suffocating deluge of visual data. This is matched by composer Ryoji Ikeda's loud sound track, which hovers somewhere between digital music and sound: computer signals on a dial-up modem, television static, a pinging noise like that of a heart monitor, and Morse code signals. At first we see digital video of people moving in slow motion in a generic airport terminal; then the images come fast and furious: typewriter keys, telephone poles, a computer keyboard, a page from a phone book, columns of numbers, an urban street, a product logo, highway signs, a hub cap, streetlights, piano keys, a clock, window frames, bricks, wrought iron, a printed date, printed words, cars, handwriting, a chain-link fence, a highway overpass, license plates, waves rolling onto a beach, long grass waving in the

wind, snow on an untuned television screen. While all these images and sounds throb before us, performers enact simple movements silhouetted against the projection screen. They run at full speed from left to right across the stage, perform stylized dance movements, and turn slow somersaults. Sometimes they appear as dark silhouettes against the bright images on the screen; at other times they appear as translucent ghosts who move behind the screen, mimicking the actions of their fellow performers who jerk, bend, leap, and crawl before it. The sequence concludes with the stage emptied of performers and a single pulse of light that moves across the screen—a heart monitor flat-lining—from left to right accompanied by a digitized pinging sound.[48]

In this sequence the viewer is forced into a delirious experience that is both exhilarating and disorienting. In it we feel something of the crisis of temporality that Andreas Huyssen describes as having "marked the age of modernity with its celebration of the new as utopian, as radically and irreducibly other."[49] For Huyssen that crisis is inherently connected to the crisis of memory and destabilization of subjectivity. Temporality was threatened, in his view, when culture began to focus urgently on the future, collapsing all previous moments into now, pulling up the anchors of past events so that they are no longer fixed in time and place but wander freely to be endlessly consumed, duplicated, and relocated. As Huyssen explains it,

> Modernity's engine of the future, namely technological development, continues at its accelerated pace ushering us into a world of information networks that function entirely according to principles of synchronicity while providing us with multiple images and narratives of the non-synchronous. The paradox is that we still harbor high-tech fantasies for the future, but the very organization of this high-tech world threatens to make categories like past and future, experience and expectation, memory and anticipation themselves obsolete.[50]

As though it were informed by Huyssen's concerns, this segment of *memorandum* exhibits a temporal crisis. A memex in overdrive, it connects image to image, idea to idea, sound bite to sound bite, movement to movement, at such an accelerated pace that it is beyond comprehension. Were we able for a moment to bracket off the video projection from everything else that is going on here and make an inventory of the images that flash before us as we watch this scene (a task that is virtually impossible), we would have a list of what Huyssen calls "high-tech fantasies of the future": typewriter, telephone, adding machine, automobile, airplane, computer, printer, television. But all these technologies are presented in a synchronous way, removed from their historical contexts, from their different sites of production and influence. In this regard, I disagree slightly with Hood and Gendrich's claim that in this sequence "it all works as an aural/visual/physical metaphor for our memories—some confused and upsetting, others pleasant and easily recalled."[51] For me, these are not simply images that I recognize from my own memory (though obviously I am familiar with them); rather, they seem to be free floating, unattached to

any specific consciousness or subjectivity. The images of grass or waves on a beach, for example, are not "pleasant," because they are reduced to merely generic signs, pixilated simulations of nature projected to a techno beat. This sequence therefore seems to suggest two things: first, the ways in which our own memories have always been both produced and battered by the world in which we live, how they are—like the story of Goldilocks— both personal and public; and second, the ways in which the temporality required for memory to function has been radically changed within new media.

So far we have considered the role of memory, subjectivity, temporality, and technology in *memorandum*, but we need to go further to understand how Dumb Type specifically implicates these issues in acts of witnessing. In this regard it is useful to examine yet another sequence from the performance, one that concretizes the relation between memory and witnessing. As was the case with the first two sequences we discussed, this one involves the telling of a simple story, though in this instance not a fairy tale. It is the story of a man alone in a spare living room furnished only with a single chair, a telephone on a small end table, and a suitcase on the floor. The man picks up a cigarette lighter and plays with it; he takes things out of the suitcase, smokes a cigarette, and picks up the telephone receiver. A bear, whom we have already seen in an earlier sequence of the performance and whom we imagine may have strayed away from the story of Goldilocks, comes to the door. The man opens it, and the bear hands him an orange. The man turns away from the bear, and the bear suddenly, violently knocks him on the back of the head so that the man falls down, unconscious. The scene is complicated by our seeing not just one enactment of it but five different performances simultaneously. Real actors are onstage using real furniture and props, but behind them are four different digital video versions projected onto the screen. The live actor begins moving about the set, and a couple of beats after that the videographed actor follows him in the image on the left. The image to the right of that is a couple more beats further behind the live action. Given the delayed broadcast of the first two video segments, it is surprising that the bear first appears not live onstage but in the third image, as if to foretell what is going to happen. The fourth image takes place in slow motion. Finally, the real bear does appear onstage, and just as the video predicted, he offers the man the orange that we've already seen in the exchange enacted on-screen. In the version of this performance that took place in Osaka in 2000, as the bear raises his arm to strike, the lights black out and the audience is left to fill in what happens next. In the version that was performed in Chicago in 2002, the scene seems to conclude more fully, when the bear strikes the man and he falls to the floor. However, the lights black out and come back up quickly to reveal the man now standing unexpectedly over an unconscious bear.

This sequence engages the problem of witnessing in a number of ways. First, what we see onstage seems to demand our witnessing; it has the feel of a crime, an act of unexpected and inexplicable violence. As a result, we feel compelled to say what just happened, to report on the event we witnessed, but our ability to do so is already scripted

for us by the scene itself. The event's presentation fits the ways that trauma is commonly described: "everything seemed like it was in slow motion"; "it was surreal, like a movie"; "it's a scene I keep playing over and over in my head." Finally, though we may act as witnesses to this event, our memory falters. In one version of the performance, we do not actually see the violent act in real life at all. We are not eyewitnesses. We see the event only on video, but when the live actors come to that point in the story, the event ends abruptly and its conclusion takes place only in our memories. In the other version of the performance, we *do* see what we think is an act of violence, but a moment later we are forced to question our perceptions, since it is not the man who lies on the floor but the bear. Thus, our ability to speak the truth of the event or to respond to that event's reality for another is undermined, in part by the sheer proliferation of versions (both within and between these different performances) and in part by the visual technologies through which the event is presented to us. As Yukiko Shikata explains, "By showing different shots, time delays and reversals on multiple screens in parallel with real scenes, the artists put actuality in a transitory position, depicting the real as being constructed from multiple virtualities."[52] As a result, we experience the kind of memory crisis that I described earlier,

Dumb Type, *memorandum*, 1999–2002 (performance).
Copyright Dumb Type. Photograph by Kazuo Fukunaga.

because our perceptions of reality are put in doubt and because our own minds—even when confronted with experiences we are certain are real—have limited memory capacities. Too much is going on, too quickly, on too many temporal planes, for us to remember it all. And the very technology that is brought to bear on this problem, the photographic (or, in this case, videographic) image, does not alleviate but rather adds substantially to the problem. The event is not, therefore, contained as in the tidy photographic storehouse of the memex; it multiplies wildly.

It is possible to see these effects—the multiple virtualities, the destabilization of the witness, the introduction of doubt with regard to the actual, the hesitancy of testimony—as enormously useful and positive. To the degree that this scene helps to undermine the authoritative subject position of the witness and to question what constitutes reality, it helps to show the ways in which contemporary technologies foster the disintegration of an older paradigm of witnessing. That paradigm posits a single witness with a stable and self-identical subject position who sees a real event and reports on it truthfully. It does not ask, Who is given access to the position of the witness? What politics wins him a place there? It does not ask about the inherently interpenetrating nature of the putative real and its representation. Although sometimes that paradigm considers how different witnesses have completely different experiences of the same event, as, for example, in the story of Rashomon, it does so in order to comment on the paucity of human experience, the pettiness of human conflict, or to entertain moral relativism. Its purpose is not to see the event itself to be inherently multiple and shifting in an effort to question productively the social constructedness of the real. And while it often acknowledges that some experiences are so traumatic that the task of bearing witness to them is extremely difficult, it usually asks only how better to bear witness, not whether to do so at all. As we have seen, photographic and digital technologies completely renovate our understanding of subjectivity, of reality, of visual knowledge, of memory, and of witnessing so that this older paradigm is more and more difficult to maintain.

At the same time, however, as Vannevar Bush indicated years ago, a fundamental contradiction is at work in this technology, and the new paradigm of witnessing it ushers forth. Although it may productively undermine dominant conceptions of subjectivity and remembering (productively allow for the complete remaking of subjectivity), at the same time, even as it disintegrates the subject, it insists ever more forcefully on the ideal of *complete* memory: seeing, recording, and retrieving *everything*. It can substitute virtual truth for perceptual truth and subordinate the mental image to the vision machine. (Bell and Gemmell, for example, go so far as to claim that "a memory-impaired patient who reviewed SenseCam images every night was able to retain memories for more than two months.")[53] The voraciousness of new media memory is evidenced in *memorandum,* in the sequence with the bear, by our presentation not with just a single version of the event but with *every* version.

The problem with this is that camera technologies record and replay everything in a nonhierarchical retrieval system like the memex or Xanadu. These systems, after all, are not concerned with truth or even the politically contentious ways in which truth is normatively produced. They are solely concerned with remembering, so that truth means simply the act of having been recorded and stored. In Bush's discussion of the memex, he never asks from where the million pages of information will come, nor does he look skeptically on all those longhand notes that would be contributed by memex users. Indeed, today we see the effects of this on the Internet, where the search for information points to an undifferentiated mass of blogs, wikis, political Web sites, personal Web sites, newspaper and magazine articles, scholarly texts, commercial sites, government documents, and photographic images. In the absence of verifiable truth, we are susceptible to being overtaken by commercial rhetoric, political spin, and military disinformation campaigns, the purpose of which is not simply to tell lies but to obliterate the very principle of truth itself.[54]

Moreover, because these technologies throw subjectivity into doubt, they pose serious problems from the point of view of ethics. As we said before, if, as Oliver has written, "subjectivity is the process of witnessing, of addressing oneself to others, of responding to the address from others," what happens to witnessing in a world where subjectivity is not creatively questioned, not generatively reimagined, but altogether lost?[55] As Virilio warned a decade ago, "The specific negative aspect of these information superhighways is precisely this loss of orientation regarding alterity (the other), this disturbance in the relationship with the other and with the world. It is obvious that this loss of orientation, this non-situation, is going to usher in a deep crisis which will affect society and hence, democracy."[56] Therefore, while these technologies may laudably open up the question of how events are known, who describes them, how they are remembered and forgotten, at the same time, their single-minded pursuit of memory, their obliteration of truth, and their destabilization of the subject foreclose any discussion of the manipulation of reality, of the unequal access to witnessing, of the social and political consequences of relativizing memory, and of one's ethical responsibility to others.

Conclusion

I have tried in this chapter to think about the ambivalent and uneasy effects of contemporary technologies with regard to memory, subjectivity, and witnessing. Viewing these technologies neither as purely utopian solutions nor as some monolithic threat, I believe that, for good or ill, they are central to our self-conception in the twenty-first century; indeed, they are central to whether we can even think in terms of self-conception any longer, and therefore they are important though sometimes underestimated objects of analysis. This view is what has brought me to consider Dumb Type's performance and to find it so useful. As Hood and Gendrich explain, Dumb Type takes up a similarly cautious position:

Perhaps most obviously, the body and technology are equally important ele-
ments in dumb type's exploration of human consciousness and experience.
Here, technology is not simply a cold, mechanical component designed to cre-
ate dissonance between human beings and our mechanized society. . . . Instead,
technology emerges in dumb type's world as a tangible part of our emotional,
spiritual, rhythmic, physical experience; it is linked inextricably with who we
have become.[57]

The question of who we have become is the logical consequence of thinking about
subjectivity and memory, the human and technology, and so it is with that question that
I would like to conclude my analysis.

Consider the final sequence of *memorandum,* which serves as the conclusion of the
performance. In that sequence, we are treated to another rapid-fire display of digital
video images, jarring techno sounds, and bodies in motion. We see images of a clock,
train tracks, a cityscape, rapidly receding pavement as though seen from the back of a
moving car, animals, a crowd, rustling leaves, an escalator, a city street, a seascape, hands
moving, stairs, people in a landscape, the blurred roadside seen from a moving car, moun-
tains, text, the interior of a shopping mall, and the interior of a gate at an airport. As the
images appear and rapidly alternate to the staccato digitized rhythm of an assembly line,
they become more pixilated. Soon we see a series of numbers scroll steadily in a narrow
line that bisects the screen horizontally from right to left: 3.14159265358979323846. . . .
The video, which is now projected across the entire nearly forty-foot-wide screen, shows
a slow pan of unoccupied benches by the seaside. The image grows darker, but the bright
light of the numbers remains. We realize that the number is pi, 3.14159 . . . , calculated to
thousands of decimal places. As the number continues to scroll across the screen, we hear
a long digital tone, and then the numbers stop. A lone figure remains and moves offstage
to our right.

From a purely visual standpoint, this sequence of the performance rhymes with
the one I described earlier, in which similarly random images pulsate across the projec-
tion screen. That scene concluded with a bright white light that moved across the screen
horizontally from left to right—an image that is echoed here by the horizontal line of
numbers moving in the opposite direction. Conceptually, the two sequences also reveal
significant parallels. One instance is the heart monitor and its translation of death into
the image of a flat line of light. The other is the computer and its translation of the ratio
of the circumference of a circle to its diameter into an endless nonrepeating series of
numbers. Whereas the flat-line image seems to be a sobering reference to the human, to
mortality and finitude, the numbers provide a reference to the machine, to immortality
and infinitude. Despite their distinct qualities, however, these two references—the human
and the machine—are not presented as mutually exclusive or as hierarchically ordered.
That is a bygone luxury. The heart monitor, the EKG, the glucometer, the pacemaker,
the MRI are all machines by which we know the body, by which we recognize more fully

the fragile line between life and death. Although while watching these sequences and feeling overwhelmed by the excess of visual, aural, and textual information, one can easily assume that *memorandum* is about the victimization of human beings at the hands of machines, the performance also reveals those machines' own limitations in important ways. For example, as this row of numbers scrolls by more quickly than we can read it, we begin to see pi in almost mystical terms, an infinite number, the calculation of which has been one aim of computer technology, which has reckoned it to more than a billion decimal places. And yet, even those billion are nowhere near reaching its end, so pi has a way of putting into perspective and showing the limitations of even the computer's impressive memory skills.

Who have we become? The truest answer to that question is that I don't entirely know, but the reason I don't know is itself instructive, because not knowing ourselves as individuals, as distinct subjects, is a definitive feature of digital culture, of the vision machine. We are still fragile, mortal bodies even as we are enhanced, our lives extended, our thinking improved, our memories expanded by new technologies. But that same world productively dismantles our erroneous sense of fixed individuality, makes even provisional subjectivity a matter of invention, and invalidates almost completely the ontological question of who we are or who we have become. We live in a world that, to quote Baudrillard, murders the real every chance it gets, where information is too much and too fast, where we have lost the leisure of contemplation, where we are adrift in the heterogeneity of experience, where it's hard to tell the difference between reality and what we've seen on television.[58] We live in a world that has grown smaller and yet infinitely expanded, where technology simultaneously connects and isolates us. "Technology," as Dumb Type has written, "has in many ways created a network covering the globe, making the world smaller, and sending information tens of thousands of miles, from point A to point B, in just a few seconds. In reality, however, when we try to communicate, for example, the words 'I love you,' just these words, we are forced to realise the vast distances that lie between us."[59]

For Kelly Oliver, love is *the* ethical tool through which to undertake witnessing in such a way that it embraces differences between self and other. Love undermines the domination normally thought to come inevitably from imagining the world in such Hegelian binaries. She argues that "to love is to bear witness to the process of witnessing that gives us the power to be, together. And being together is the chaotic adventure of subjectivity."[60] But can we be together in this digital culture? Dispersed as we are across millions of screens, being together begins to look very much like the line of numbers in pi. We stand next to one another, six billion or more, but we remain separated by the vast distance of randomness and meaninglessness. Purely by chance and without recognizable pattern, one is here rather than there. Ultimately, it is to those vast distances, which threaten the ethics of communication and mutual commitment, just as much as to the problem of memory, that the question of witnessing must turn and that we must now ponder.

III. Biopower

6. This Being You Must Create
Transgenics, Witness, and Selfhood in the Work of Eduardo Kac and Christine Borland

Transgenic art, I propose, is a new art form based on the use of genetic engineering techniques to transfer synthetic genes to an organism or to transfer natural genetic material from one species to another, to create unique living beings. . . . I suggest that artists can contribute to increase global biodiversity by inventing new life forms.

—EDUARDO KAC, "Transgenic Art"

At length I wandered toward these mountains, and have ranged through their immense recesses, consumed by a burning passion which you alone can gratify. We may not part until you have promised to comply with my requisition. I am alone, and miserable; man will not associate with me; but one as deformed and horrible as myself would not deny herself to me. My companion must be of the same species, and have the same defects. This being you must create.

—FRANKENSTEIN'S MONSTER

This chapter is written by a monster in pursuit of monsters. Its voice is that of a transgenic cyborg, a hybrid who is disfigured within contemporary discourse on the body, reproductivity, genetics, identity, inheritance, and subjectivity. It seeks a being that, while similarly deformed, must still be created, one that, whether genetically engineered or crudely stitched, can be put to work in that place where biotechnology and identity politics meet.

In that regard, this chapter mimics the monster in Mary Shelley's famous novel *Frankenstein* (1818), who pleads with his creator to fashion a companion, a being of the same species that has the same defects. The creation that the monster demands is of a very interesting sort; he asks for a creature that is not better, not purer, not more eugenic, but one that is, like himself, degenerate. The impetus for that request is the unrelenting play of visibility and invisibility by which he is continually ensnared. He laments that he is invisible: "I look around, and I have no relation or friend upon earth. These amiable people to whom I go have never seen me, and know little of me."[1] And again, "When I looked around, I saw and heard of none like me" (99). At the same time, however, he

cannot escape the horrified stares of those for whom he is painfully, grotesquely visible: "Was I then a monster, a blot upon the earth, from which all men fled and whom all men disowned?" (99). For Frankenstein's monster, what is most troubling is that the seeing to which he is subject is itself a kind of blindness: "a fatal prejudice clouds their eyes, and where they ought to see a feeling and kind friend, they behold only a detestable monster" (111).

With that fatal prejudice, we enter into the realm of the politics of seeing to which we are all subject, though often unequally. That politics begins with the decision—whether based on cultural production, scientific practice, xenophobia, or public policy—to locate knowledge about an organism where it offers itself most to vision. It has far-reaching consequences in terms of how we conceive of identity, how we answer for ourselves the monster's question when he pleads, "I had never yet seen a being resembling me, or who claimed any intercourse with me. What was I? The question again recurred, to be answered only with groans" (100). Unable to bring meaning to the concept of identity, the wretched being is pushed to beg his creator for a duplicate, a mirror, in which to see himself. In this other he hopes to become both visible to himself, that is, to be seen for those *un*seen qualities of character as a "feeling and kind friend," and also invisible to a world that, because it is dependent on scopic knowledge, despises him. He seeks a witness to his invisibility. Like him, I hope to find that monster.

The Question of Witness

The monster's demand—"This being you must create"—is never met in Shelley's story (at least not in the form in which it was imagined by him); Victor Frankenstein would rather risk the murders of his friends and loved ones than produce such a being. But it seems to me that in the present era, in which genetics means precisely that "there is none exactly like me," the monster's request is worth considering. So the purpose of this chapter is to understand what might constitute a witness to our invisibility and what benefits might result from finding it.

In that regard, I want to explain what is meant by witness in this chapter. As I said in the Introduction, a great deal has been written on the subject of the witness in fields as diverse as feminist studies, art history, psychoanalysis, Holocaust studies, ethics, and historiography. Kelly Oliver's book *Witnessing* is just one example. While I have engaged with it to varying degrees throughout this book, I want to take it up here in greater detail, because it provides me with a model of witnessing that helps to clarify not only the terms of my project but also the dangers I see there. Oliver usefully explains that witness involves both seeing (in the sense of the eyewitness) and testifying to what is beyond seeing (the one who bears witness). She writes: "It is important to note that witnessing has both the juridical connotations of seeing with one's own eyes and the religious connotations of testifying to that which cannot be seen, in other words, bearing witness."[2] Because I am

interested in the problem of the visible and invisible, I am, like Oliver, captivated by the double meaning of *witness*. However, my attempt in this chapter to imagine a witness to the invisible begins with a concept of witness that differs in some ways from this one.

I feel constrained by Oliver's quick separation of law from religion and, by implication, fact from faith, real from imagined. (We could keep going with this list: science/art, information/meaning, text/interpretation.) Because I live in a nation where law and religion are often mutually constitutive (even now we debate hanging the Ten Commandments in the courthouse), I have a hard time accepting this division. It depends too much on the idea that in fact a concrete, material, and visible realm exists in distinction from the evanescent, spiritual, and invisible. Moreover, in a culture of visuality, that distinction dissolves even as it is maintained, because to bear witness to the invisible often means only to bear witness to something that is still visualizable. Like Oliver, Cathy Caruth discusses the concept of witnessing relative to the visible and the invisible, but her approach offers a degree of productive ambiguity on this point that is better suited to my purposes. It emphasizes the fact that the eyewitness to an event, especially a traumatic one, is often in a way blinded by his seeing of the event, unable to testify to it or make sense of it. Caruth, then, sees the division between witnessing (firsthand seeing) and bearing witness (seeing what is beyond seeing) as being far more fluid than Oliver does. For Caruth, witnessing an event often means turning away from it, blinding oneself to it in order to see it better.

In addition to the issue of our respective approaches to the dual definition of witness, another difference exists in terms of our starting points for thinking about identity. The majority of Oliver's book goes beyond the strictly visible by discussing the more nuanced political invisibility of race and gender, in order to examine the politics of recognition and the ethics of bearing witness. However, Oliver starts from the position that race exists as a literally visible detail of biology and thus begins with the question of when and under what circumstances race is politically visible or not. I want to address a different problem. I am concerned with how such visible biological "facts" as race are already, at the level of the genome, obscured by the complexities of visibility politics. How, for instance, is the gene asked to testify to identity categories such as race or cultural narratives such as purity, which are always already multiple, hybrid, and dangerous—in short, monstrous?

My conception of witness is informed by the the tendency toward slippage and overlap between what we can see and what we cannot, especially within contemporary technoscience. First of all, I contend that clear distinctions between the visible and the invisible, and by implication between law and religion, fact and faith, information and meaning, are rare. As a corollary to this principle of ambiguity, my conception of the witness recognizes that the realm to which we normally act as eyewitness, the seen, is ironically constituted by both literal and political invisibility. Moreover, this conception recognizes that the realm to which we normally bear witness, the unseen, is also constituted by both literal and political invisibility. Therefore, my claim is that the "witness to the invisible" is neither strictly an eyewitness nor a bearer of witness. In fact, the witness

to the invisible may not be defined by sight at all. Rather, this monstrous witness is often characterized by blindness. It acts as a mirror, a duplicate in which the complexities and contradictions of the invisible–visible hybrid may be examined. It is a useful monster operating within a politics of radical invisibility.

The necessity of such a monster is evident in the argument put forth by Evelyn Fox Keller, a philosopher of science, who, in her book *The Century of the Gene,* claims that the twentieth century's pursuit of the gene was fueled by a reductionist logic, whereby it was thought that the invisible could be smoothly made visible. Mapping the genome was a project that promised to give us a visual picture of life. Keller writes:

> For almost fifty years, we lulled ourselves into believing that, in discovering the molecular basis of genetic information, we had found the "secret of life"; we were confident that if we could only decode the message in DNA's sequence of nucleotides, we would understand the "program" that makes an organism what it is. And we marveled at how simple the answer seemed to be.

The literally invisible genome would become our representation; science would make visible our microscopic selves. All of that changed, however, once the genome sequence began to be transcribed, for at that moment the simple representational model by which the gene had been pursued was revealed to be hopelessly inadequate. Keller goes on: "But now, in the call for functional genomics, we can read at least a tacit acknowledgment of how large the gap between genetic 'information' and biological meaning really is."[3] Now, although literally more visible, the gene, as well as the biology for which it is a sign, remains culturally invisible and politically unstable. Here, as with Oliver's division between law and religion, the scientist is confronted with the problem of information and meaning, concrete data and the supposedly trickier and more faith-based realm of interpretation. The problem of the gene shows us that information and meaning are spliced together in profoundly complex ways, that the factual information (in history, law, and science) that the eyewitness testifies to having seen is not as immediately visible as one might think.

Like Keller, Brazilian-born artist Eduardo Kac, writing just before the turn of the twenty-first century, rejects representational economies and easy substitutions:

> More than make visible the invisible, art needs to raise our awareness of what firmly remains beyond our visual reach but which, nonetheless, affects us directly. Two of the most prominent technologies operating beyond vision are digital implants and genetic engineering, both poised to have profound consequences in art as well as in the social, medical, political, and economic life of the next century.[4]

Kac urges us here not only to direct our attention to particular technologies of invisibility but also, like Keller, to understand better both the distinctions between and entanglement

of "information" and "biological meaning." Because genomics is marked at the same time by the visible and by radical invisibility, it remains firmly beyond our visual reach. Though we may see the gene through the microscope, we can neither see it nor testify to it through our habits of thought. Donna Haraway helps to show the radically invisible nature of biological meaning when she attempts to define it by piling up long lists of its complex components, which include race, gender, sex, ethnicity, nationality, humanity, nature, pollution, hybridity, origins, lineage, legitimacy, and "the drama of inheritance of bodies, property, and stories."[5] We need a witness to that invisibility.

I have said that this chapter is a search to find useful monsters that are of the same species and have the same defects as the visible–invisible hybrid. That search takes the form of an examination of the story of *Frankenstein* as it relates to and is retold by two contemporary artists: Eduardo Kac and the Scottish sculptor and installation artist Christine Borland. My purpose is not to provide some new reading of Shelley's novel, which has already been excessively analyzed by the considerable likes of Sandra Gilbert, Susan Gubar, Eve Sedgwick, Claire Kahane, and Mary Poovey, just to name a few. Rather, I hope to use the novel as a site of interpretation itself, as a progenitor for interpretations of biological meaning informed by scopic epistemes. It is a parent text through which we can read and reconstruct the chain of stories about stories that constitute our biological selves. I begin with how, in Shelley's novel, having one's eyes opened is a dominant regenerative metaphor.

Eye Opening

The story of Frankenstein's monster is a potent and cautionary tale for contemporary technoscience. That story has to do not only with the ethics of scientific creation and regeneration, the possibilities and dangers of "inventing new life forms," but also with the ethics of visibility and the nature of witness. In Mary Shelley's novel, Victor Frankenstein produces a creature from the dismembered parts of dead bodies selected for their individual beauty. But as with many stories about scientific experimentation, the resulting product is malformed by hybridity. The chimerical creature thus produced is so hideous to look on that even its own creator covers his eyes; the creature's visage has a blinding effect.

> It was on a dreary night of November, that I beheld the accomplishment of my toils. With an anxiety that almost amounted to agony, I collected the instruments of life around me, that I might infuse a spark of being into the lifeless thing that lay at my feet. It was already one in the morning; the rain pattered dismally against the panes, and my candle was nearly burnt out, when by the glimmer of the half-extinguished light, I saw the dull yellow eye of the creature open; it breathed hard, and a convulsive motion agitated its limbs. How can I describe my emotions at this catastrophe, or how delineate the wretch whom with such infinite pains and care I had endeavoured to form? His limbs were in

> proportion, and I had selected his features as beautiful. Beautiful!—Great God! His yellow skin scarcely covered the work of muscles and arteries beneath; his hair was of a lustrous black, and flowing; his teeth of a pearly whiteness; but these luxuriances only formed a more horrid contrast with his watery eyes, that seemed almost of the same colour as the dun white sockets in which they were set, his shriveled complexion, and straight black lips. (40)

Shelley's description is sunk in melancholy darkness: the room is dimly lit, the candle about to go out, the black night presses dismally against the windows blurred with rain. The creature himself is characterized by indistinction formed of paradox. His eyes are the same sickly yellow color as his eye sockets. He is both young (with black hair and white teeth) and old (covered with shriveled skin). The dying man's last gasp is the monster's first breath; the convulsions of death bring him to life.

In the novel's dull half light, where the blinded reader must listen for echoes of its layered voices, the monster takes up the position of a disembodied eye. Driven into hiding by the violent and hysterical reactions of those whom he encounters, the monster retreats to an abandoned hovel annexed to a small cottage, of which he becomes a voyeur: "On examining my dwelling, I found that one of the windows of the cottage had formerly occupied a part of it, but the panes had been filled up with wood. In one of these was a small and almost imperceptible chink, through which the eye could just penetrate" (89). It is as this eye that the creature observes the De Lacy family, from whom he learns all the ways of civilized life: language and reading, manners, familial piety, romantic love, social standing, and high honor. More important for our purposes, the De Lacy family's story is one that is imbued with biological meaning as it concerns the conflict of noble birth and economic class, mixed marriage and national exile. Whereas the creature is defined by his monocular vision, the old patriarch of the family on whom he trains his gaze is blind.

In the old man the monster fancies a potential witness to his invisibility. He drafts a plan in which to expose himself to the blind father, who, by virtue of his blindness, would ultimately testify to the monster's true self, a self that cannot be perceived by vision. "I resolved many projects," reports the creature, "but that on which I finally fixed was, to enter the dwelling when the blind old man should be alone" (110). He hopes that he can win the father's affection and that the father will in turn bear witness to his invisible benevolent nature. The plan nearly works. On meeting the creature and hearing of his anxieties about an unnamed family (the old man's own) whom the creature fears will remain prejudiced against him, the old man pledges:

> If you will unreservedly confide to me the particulars of your tale, I perhaps may be of use in undeceiving them. I am blind, and cannot judge of your countenance, but there is something in your words which persuades me that you are sincere. I am poor, and an exile; but it will afford me true pleasure to be in any way serviceable to a human creature. (112)

And that of course spells the monster's undoing. He is not, after all, entirely a "human creature" but rather a strange hybrid. Shortly thereafter the other family members return and despite their horror manage to drum the monster from their cottage. It is a form of treatment to which he is never, despite its frequency, inured.

It seems important that the story is collected around such moments of seeing: the monster's life begins at the moment when his perpetually blurry eyes open; the tale's conflict begins at that instant when the creature whom Frankenstein has made looks back at him; the plot proceeds from one blinding flash of his ugly features to another; and the novel ends with the monster's death in invisibility. The final sentence reads: "He was soon borne away by the waves, and lost in darkness and distance" (192). The narrative unfolds in a place of seeing/not-seeing: the half light of the transhuman body. In that semi-darkness, the monster sees and yet is invisible. All of his effort and rage and murderous violence attempt to summon a witness to that invisibility, a witness that never comes in the form he imagines.

Blind Witness

There is no bride of Frankenstein's monster, but there is a witness of sorts in the form of the book's narrator and purported author, Robert Walton, in whose hand the story is supposedly written. As readers of Shelley's book (and its framing device), we are also readers of Walton's long letters to his sister. It is ultimately those letters, that text, that bear witness to the monster. Walton does not encounter the monster until the very end of the book, but that encounter is coupled with a moment of overt self-awareness about his role as writer. Walton scratches these words on the page: "I am interrupted. What do these sounds portend? It is midnight; the breeze blows fairly, and the watch on the deck scarcely stir. Again; there is a sound as of a human voice, but hoarser; it comes from the cabin where the remains of Frankenstein still lie. I must arise, and examine. Good night, my sister" (187). He writes that his writing is stopped. It is in that interstitial break that Walton's first encounter with the monster occurs:

> Never did I behold a vision so horrible as his face, of such loathsome, yet appalling hideousness. I shut my eyes involuntarily, and endeavoured to recollect what were my duties with regard to this destroyer. I called on him to stay. (188)

Walton does something that no other human being has been willing to do; he invites the monster to remain in his presence. Although like the others he is blinded by the monster's visage, he asks the creature to remain. (Mr. De Lacy, the blind father, does not expel the monster from his cottage, but neither does he directly invite him to stay.) This is in part because Walton has just been instructed by the dying words of Victor Frankenstein to continue the work of trying to destroy the creature, but one can also read the passage differently. What are Walton's duties with regard to the monster?

As a writer, Walton might be considered, in Derrida's terms, a "blind man." Derrida discusses a genealogy of blind writers, including Homer, Joyce, Milton, and Borges, his analysis of whom is enveloped in the metaphorical. Although these writers are literally blind, for Derrida the writer or draftsman is by definition blind because he must turn away from the thing about which he writes or the thing that he draws in order to write about it or draw it. "It is as if," he laments,

> just as I was about to draw, I no longer *saw* the thing. For it immediately flees, drops out of sight, and almost nothing remains; it disappears before my eyes, which, in truth, no longer perceive anything but the mocking arrogance of this disappearing apparition. . . . It blinds me while making me attend the pitiful spectacle. By *exposing me,* by *showing me up,* it takes me to task but also makes me bear witness.[6]

Just as Derrida describes, Walton too must leave his writing to see the creature about whom he writes, but in order to bear witness to that creature, he must turn away from seeing. Walton is thus a "blind man, a man of memory."[7] In the end it is he who creates the "being" of the same species and with the same defects for whom the monster so painfully longs. The novel *Frankenstein* is itself that monstrous creature.

Shelley's tale notoriously proceeds via a series of encased voices, each speaking the story of another: the creature relates the story of the innocent Swiss family whom he secretly observes to his creator, Victor Frankenstein; Frankenstein tells the story of the creature's encounter with the De Lacy family to his friend and rescuer Robert Walton; Walton transcribes the story of Frankenstein, the monster, and the De Lacys in long letters to his sister; and Mary Shelley writes Walton's story (and all those that are encased within it) in her novel. The structure of the novel is made even more complex by its elusive author: the manuscript was originally sent to publishers anonymously, and Mary Wollstonecraft Godwin's name (she had not yet married Percy Bysshe Shelley) does not appear on the title page of the first edition. And that name itself is also a doubling, a repetition of Mary Shelley's mother's name, Mary Wollstonecraft. Shelley's introduction for the 1831 edition sews together the two multiply framed narratives of the novel and her own biography. As Fred Botting explains:

> From the outset *Frankenstein*'s author is displaced. At the start the reader encounters a displacement of origins, an enmeshing of ends and beginnings: the writing preparatory to and about the novel and its origins is a beginning rewritten by a woman of a different name, Mary Wollstonecraft Shelley, to the young woman, Mary Wollstonecraft Godwin, who, the Introduction tells us, was inspired to write *Frankenstein.* The Introduction which describes events anterior and contributory to the inception of the text postdates it with an account that, for the reader, precedes the novel: the novel's origins whose date announces them to be posterior to that text are situated in advance of it. The reader is thus implicated in a chain of stories about stories s/he has yet to read, uncomfortably situated among the broken frames of *Frankenstein*'s textual body.[8]

The book's hypermediated narrative appears to Botting as a body—as broken and stitched together as the monster's own. That body, to the degree that it is a chain of stories that both demand and defy interpretation, offers us a model for thinking about the interpretation of biological meaning.

Frankenstein is a monster. It is a witness to the invisible that teaches us that biological meaning is always encased in stories, of which there is no single origin in genetic information, no stable center. Such meaning is inherently disposed to replication, repetition, and substitution, for which the name Mary Wollstonecraft Shelley is itself a perfect embodiment. As essentially narrative in nature, such meaning is paradoxically given to both stability and change, the importance of which for genetics is the subject of Keller's book. Such meaning is always already hybrid, monstrous, very often written or told in darkness, as it stands both for lack of knowledge and for stubborn refusals to see. Moreover, this witness to invisibility reminds us that bringing biological meaning to light, offering a clear interpretation of it (should such a thing ever be possible), dangerously presumes that visibility necessarily equates to knowledge, progress, and power. One need not look far to find examples of that danger. Think, for instance, about attempts to discover and make visible the so-called gay gene, which would presumably prove a biological basis for a supposed "mutation," or, at the opposite extreme, the current claims that race has no genetic legitimacy, which effectively consigns it to scientific invisibility. In this context, bearing witness to invisibility, to mystery, to what we cannot know, is a radical act.

The complexity of the novel's encasement and its emphasis on vision and blindness is deepened at the hands of Scottish artist Christine Borland. Her 1997 work *The Monster's Monologue* is an artist's book that combines a small printed facsimile of five chapters from Shelley's novel along with two CDs on which is recorded the voice of a thirteen-year-old boy, Ian Forrest, reading these chapters aloud. The section of the novel that Borland takes as her subject is that in which the monster describes his pitiful existence after having been given life by Frankenstein. The work was exhibited at the Walker Art Center as an installation in which one stood in a corner of a white gallery to listen to the quiet sound of the recorded reading. The boy's soft voice and Scottish accent combine to produce an unexpected embodiment of the monster, not only because Forrest's prepubescent voice is far from threatening, but also because his aural presence offers nothing at all for the "viewer" to look at, no horrific features from which to recoil. Borland's piece thus employs a strategy of "blinding," which brings the very nature of visibility into ironic focus.

The choice of this young boy as another frame for the story of *Frankenstein* resonates strongly with that passage he is asked to read. The monster's monologue, which ends with the demand "This being you must create," describes what is in essence the monster's childhood, his education as a transhuman. The monologue concerns that period in which, secretly nurtured by his unknowing adopted family, he learned to speak, to read, and to write. One of the most important of his childhood lessons, however, involves biological meaning: "Every conversation of the cottagers now opened new wonders to me . . .

the strange system of human society was explained to me. I heard of the division of prop-
erty, of immense wealth and squalid poverty; of rank, descent, and noble blood. . . .
I learned that the possessions most esteemed by your fellow-creatures were, high and
unsullied descent united with riches" (99). These biological meanings, in which the mon-
ster is trained and that include blood, legitimacy, ethnic purity, national identity, and
gender privilege, are brought to life by the child/monster Ian Forrest, in whom genetic
information is just now budding to produce what we cannot fully anticipate.

Forrest (and, by means of him, Borland) makes us witness to these invisibilities. We
become monsters in this piece. In his reading of the text, we hear ellipses, pauses, hard
swallowing, stumbles, and elisions that occur when one attempts to accommodate the
words of others in one's mouth. Just as Walton self-consciously displays his role as writer,
so Forrest with his youthful voice displays his role as reader. In uttering the printed words
the young reader performs the dizzying complexity of the transhuman, a monstrous aural
hybrid. This is perhaps clearest in that scene, read by Forrest, in which the monster plots,
after already having rescued one small child, to reveal himself to another in order once
again to try to fashion for himself a witness:

> Suddenly, as I gazed on him, an idea seized me, that this little creature was
> unprejudiced, and had lived too short a time to have imbibed a horror of defor-
> mity. If, therefore, I could seize him, and educate him as my companion and
> friend, I should not be so desolate in this peopled earth (119).

Of course, as before, the plan does not come to fruition. The monster grabs the boy and,
despite the child's screaming, attempts to reason with him, saying, "I do not intend to
hurt you; listen to me." In response the child cries, "Let me go," and boldly hurls at the
creature's malformed face the epithet "monster!" as though it were a sharp object. For-
rest reads Shelley writing Walton's letters transcribing Frankenstein's description of what
the monster told him about what the little boy had said. Forrest is both the monster who
pleads "listen to me" and the boy who cries out in terror. He becomes in this reading a
hybrid creature, to which we as listeners are blind witnesses. As such, we testify to the
monster's illegibility within biological meaning, his invisibility within reproductive (both
visual and biological) economies, and his illegitimacy as a descendant of man.

This interpretation of *The Monster's Monologue* as a commentary on biological mean-
ing gains validity and greater profundity when one considers that work in tandem with a
piece Borland created a year later, which reprises its basic structure. In 1998 she produced
an installation of handmade books for an exhibition in Zurich at the Museum für Gegen-
wartkunst. There she displayed a German edition of *The Monster's Monologue* but paired it
this time with books containing the diaries of the anatomist Hermann Voss, who, as Bor-
land explains, "achieved recognition during the '30s and '40s for his investigations, carried
out mostly on the exterminated bodies of Polish Resistance fighters."[9] Voss, a prominent

German scientist whose anatomy textbook was standard in Germany until the mid-1980s, was sent by the Reich Ministry of Science and Public Education to Poland in 1941 to serve as the director of the Anatomical Institute of the Reich University of Posen.[10] He continued his anatomical studies in Poland, where he also traded in the bones of freshly murdered Poles, a grisly commerce purified by the presumed hygienic epistemes of the scientific laboratories where they ended up.[11] His diary entries testify in a rather horrifying way to the urgency of comprehending biological meaning in our own time, but also to the ways in which meanings have been constructed and privileged in the past. He writes, for example, about the polluting effects of the "primitive" Poles, whose bloodline is being replicated and extended at a pace with which the Germans cannot compete:

> The Polish people are multiplying twice as fast as the Germans, and that is decisive! The much more primitive Slavic peoples will devour the German people, which do not multiply fast enough by far. 23 June 1935.[12]

And further, he offers a chilling interpretation of biology, its uses both as a science and as an essential fact of human existence. As a science, biology is objective and unemotional, keenly privileged to "see" into the bodies of those it examines. The empirical gaze on which it is based is equivalent to and overlaps with the law's eyewitness. But what empiricism finds in those bodies is what it has always already placed there, that is, a legible biological makeup whose meanings can be read as portentous:

> I think that one should look at the Polish question without emotion, purely biologically. We must exterminate them, otherwise they will exterminate us. And that is why I am glad of every Pole who is no longer alive. 2 June 1941.[13]

Voss testifies to the Poles' inferiority, the clandestine nature of the threat they pose, but he does so in terms of the visualizable. That is, the intangible realm of biological meaning is reduced to and naturalized through supposed facts of biological information. The way in which Voss considers the Poles to be human monsters demonstrates Foucault's assertion that their "field of appearance is a juridico-biological domain."[14] He appeals both to the laws of nature and biology that prove the Poles' inferiority and to the laws of the Third Reich, which permit their genocide. Like Ian Forrest from the earlier work, the viewers of this piece become self-conscious readers of texts that are centrally concerned with hybridity and purity, eugenics and scientific creation.

By reading Voss's diary, we engage what Borland refers to as "a monster's monologue of a different kind."[15] Thus, it seems that each of these monstrous texts is a mirror for the other, a replication of the same species. Each is witness to the other's invisibility and its murderous consequences. Voss's text displays a horrifying countenance precisely because its author makes claims on normativity that he presumes are justified by his

Aryan appearance. That appearance made it possible for him, years after the war, to render invisible his participation in genocide. So *The Monster's Monologue,* in which we are encouraged to consider that which remains outside the scopic, is a witness to Voss's text, the violent implications of which are found precisely where it places its faith in the visible.

The Invisible

The story of *Frankenstein* awakens us to the chain of stories through which we interpret biological meaning; its repetitions, multiple voices, lack of origins, and hybridity teach us to look for that meaning elsewhere than in the strictly visual. The story of a work called "GFP Bunny" (2000), by Eduardo Kac, is enframed by *Frankenstein*'s tale and revives its interpretative methods. The statement by Kac with which I began this chapter displays traits that his work inherits from Mary Shelley's. Kac designed his statement to have a dense ambiguity. He is sincere in his hope that transgenic artists will contribute to bio-diversity, that they will create new life forms. He is excited by the new materials and methods that are available to the contemporary artist and considers the debates involving scientific progress and bioethics to be of particular urgency for cultural production. He is also deeply concerned about the intractability of these debates, the willful ignorance of their participants, and their persistent invocation of biological, ethnic, gender, and ideological purity. At the same time, his statement is meant to elicit emotion, to stir fear and discussion by resonating with potent cultural images of the megalomaniacal scien-tist and the egotistical artist. The statement is perhaps most shocking, however, because of its banality: transgenic mutations have always appeared in "nature," and transgenic science has been around for a very long time, even though relatively few of us seem to have noticed. The difficulty is only in making people see the transgenic, something that remains invisible for a variety of reasons.

In "GFP Bunny," Kac collaborated with French scientists to create a white rabbit genetically engineered to contain a sequence of DNA, called green fluorescent protein, or GFP, from a flourescent jellyfish. The resulting animal, named Alba, appears normal in every respect unless illuminated with an ultraviolet blue light, with which she glows green. Alba, like Ian Forrest, is an unlikely monster; she was designed to be Kac's family pet. What is monstrous about her is that she is a transgenic hybrid, one that contains DNA from an entirely different species.

The controversy surrounding this work and the spate of articles that set out to ana-lyze it rely heavily on references to the Frankenstein story. In a 2001 *ARTnews* article, for example, Blake Eskin remarks, "The plan to alter the genetic code of animals made Kac, who has dark curly hair and favors tinted glasses, look like an intellectual heir of Dr. Frankenstein."[16] Mary Shelley's story is remarkably embedded in Eskin's narrative. He subjects Kac to the assignation of biological meaning by reading his physical appear-ance much as the villagers in Shelley's story read the monster's, or more generally how

Eduardo Kac and Louis-Marie Houdebine, *GFP Bunny (Alba)*,
2000. Transgenic albino rabbit. Photograph courtesy of
Eduardo Kac.

human appearance was interpreted in the nineteenth century. Somehow Kac's outward appearance makes visible his identity, his character, his true motivations. We rehearse again the lessons learned by the monster: that one of "the possessions most esteemed by our fellow-creatures is high and unsullied descent." Kac is presented to us by Eskin as a double, a repetition of Victor Frankenstein, one of his legitimate heirs. Kac himself has rejected this chain of references, saying, "I want to talk about transgenics as social sub-jects, and contextualize their existence for its own sake, to shift the discourse away from this cliché of Frankenstein and Dr. Moreau."[17] If his own biological meaning is disposed to duplication and substitution, and if it depends on a presumption that visibility equates to knowledge, how much more can this be said of Kac's "creature"?

Just as Kac is made a surrogate for Victor Frankenstein, Alba's biological meaning is very often described in terms that recall Frankenstein's monster. Like the monster, Alba is defined by darkness and invisibility; one cannot see her mutation without subjecting her to a particular kind of light. In this sense, the day-to-day ambient light in which she exists is a half light, the kind in which Victor Frankenstein's laboratory is shrouded. Also, as in the case of the monster, the opening of her eyes is a significant regenerative metaphor. The science fiction writer Robert Silverberg describes the chilling experience of seeing Alba emerge from half darkness into the ultraviolet light: "The rabbit's name is Alba. She is healthy. She eats, she breathes, she hops around; she is said to have a 'particularly mellow and sweet disposition.' But when the ultraviolet light is switched on, that science-fictiony green glow emanates from her paws and whiskers and—with particular intensity—from

her eyes."[18] Just as in the *Frankenstein* tale, the moment when this little monster's eyes open marks her birth and the birth of the conflicts she engenders. What we see in the green glow of Alba's eyes is the ethics of bearing witness to the invisibility (and the power that accrues to it) of the scientific laboratory, the artist's studio, and the private home.

Kac imbricates these three spheres in his descriptions of Alba, in which she represents simultaneously the burgeoning practices of technoscience, an artistic "creation," and a domesticated animal. Kac figures her, for example, as a duplicate, a repetition of and substitution for a long line of chimeras, scientifically, artistically, and culturally produced. He describes "the 'GFP Bunny' project" as "a complex social event that starts with the creation of a chimerical animal that does not exist in nature." Moreover, his Web site (in which an ongoing debate of the project continually takes place) is careful to trace Alba's lineage back to the biblical era, in which rabbits are mentioned in both Leviticus and Deuteronomy. He provides a detailed history of the domestication and selective breeding of rabbits, which has contributed in particular to the survival of albino rabbits.[19] The rabbit's historical and familial lineage serves at least a couple of functions. First, it parodically mimics the narratives through which humans claim social and biological legitimacy, such as those told in the Jewish and Christian traditions that link contemporary religious practitioners to David and ultimately to Adam. We hear once more the lesson that Frankenstein's monster learns about the importance of "rank, descent, and noble blood." Second, this lineage functions in the Foucauldian sense as a genealogy, which strategically lays bare the "discontinuous, illegitimate knowledges" that participate in producing history.[20] Such a genealogy helps Kac inspect the "discursive formations" that constitute and evaluate biological meaning, discourses that depend on origins and authenticity but in truth are decentered, marked by repetition, hybridity, and monstrousness.

He seeks to demonstrate that any notions of pure nature and natural descent, that any simple understandings of bioethics, medical progress, and ultimately of how we define ourselves as genetic organisms, are illusory. To do this he points out that, without "artificial" human intervention, starkly white rabbits such as Alba would not survive, since they are easy prey in "nature." Their inability to camouflage themselves, to become invisible to predators, makes them hopelessly vulnerable. Alba is thus a symbol of the very problems of the visible/invisible. In Donna Haraway's terms, she is a "transgressive border-cross[er]" who "pollutes lineages— . . . the lineage of nature itself—transforming nature into its binary opposite, culture."[21] This is because, as Kac explains, "humans have determined the evolution of rabbits for at least 1,400 years," even though most people are blind to this. As an artifact of culture, Alba physically embodies the powerful reach of science, art, the social, and the domestic, all of which play a part in manufacturing culturally engineered identities and then making them seem innocently natural. As a white rabbit, she stands for eugenics; she embodies purity, fecundity, domesticity, and reproduction. Moreover, she hints at the terrible history of that science; the rabbit's reputation for multiplying seems the perfect metaphor for the xenophobic fears that Hermann Voss so

chillingly described and that still lamentably persist in virulent forms. In his genealogy, Kac begins to realize one of his main goals for "GFP Bunny," which is the "examination of notions of normalcy, heterogeneity, purity, hybridity, and otherness."

Not only does "GFP Bunny" resonate with *Frankenstein* in terms of its emphasis on repetitions, multiple voices, lack of origins, and hybridity, but Kac's project also questions the dangerous assumption that visibility is equivalent to power and knowledge, an assumption that both undervalues the invisible, as a productive source for complicating how we understand identity, and underestimates its potential threat, which our faith in the visible makes possible in the first place. He accomplishes this, much in the way Borland does, through a strategy of radical invisibility, that is, a making visible of both literal and political invisibility. Unlike the work of selective breeding, the goal of which is to produce animals and plants that conform to a "standard form and structure," often a set of preferred visual characteristics, transgenic art offers, according to Kac, "a concept of aesthetics that emphasizes the social rather than the formal aspects of life and biodiversity." Alba was bred not to "appear" in any particular way but rather to cloak the appearance in her DNA of that sequence taken from the *Aequorea victoria* jellyfish. Kac explains the critical purpose of this invisibility:

> Alba is a healthy and gentle mammal. Contrary to popular notions of the alleged monstrosity of genetically engineered organisms, her body shape and coloration are exactly the same kind we ordinarily find in albino rabbits. Unaware that Alba is a glowing bunny, it is impossible for anyone to notice anything unusual about her. Therefore Alba undermines any ascription of alterity. It is precisely this productive ambiguity that sets her apart: being at once same and different.

Alba's mutation was designed to be both invisible (at the level of the gene) and visible by being literally "brought to light." She is the metaphorical embodiment of the confounding relation between "information" and "meaning." One form of her biological difference, her whiteness, is intensely visible and yet remains politically or culturally invisible to most viewers, who do not recognize whiteness as a mutation. Another form of her biological difference, her fluorescence, is invisible to the naked eye and yet becomes hypervisible to many of those who have heard about the project and are scandalized by it. In this way Alba seems to embody our contemporary state of threat: the invisibility in which disease, mutation, commercial manipulation, eugenics, and biological hybridity lie; the invisibility (the microscopic) in which science operates and the invisibility (public unawareness) by which it often succeeds.

Like Victor Frankenstein, we have caught only brief glimpses here of the monsters for which we are searching. Robert Walton is a blind witness to Frankenstein's monster; Mary Shelley's deformed novel *Frankenstein* is a creature that mirrors the deformities of the monster it brings into being; the viewers of Borland's work are blind witnesses to the

This Being You Must Create

visible/invisible half-breed; and *The Monster's Monologue* is itself a duplicate in which we can see the grotesque features of Hermann Voss's diaries. However, it is in Alba—pure and yet hybrid, natural and yet cultural, promising and yet dangerous—that I see the human monster most fully reflected. In terms of her biological meaning, Alba is "as deformed and horrible" as ourselves. As a text, she "has the same defects." She is for human beings a "companion of the same species," a species composed of unique living beings, each utterly unable to see itself.

7. The Shame of Biological Being
Microbiology and Theories of Subjectivity in a Project by Ann Hamilton and Ben Rubin

Perceived or imagined as blushing, reddening cheeks are imagined to announce their vulnerability and to offer themselves to the observer for reading; the prospect of the other's somatic legibility enables a fantasy of possession. (Your blushes are for me.)

—MARY ANN O'FARRELL, *Telling Complexions*

As I have already noted, Kelly Oliver writes that understanding subjectivity and subject positions is central to the ethics of witness. "To conceive of oneself as a subject," she remarks, "is to have the ability to address oneself in another, real or imaginary, actual or potential. Subjectivity is the result of, and depends on, the process of witnessing—address-ability and response-ability."[1] For Oliver, as we've said, the subject is defined by witness, because witnessing requires telling one's story, speaking from the place that "I" designates. To witness is to occupy a position from which one is able to address another, an other whose responsibility it is to respond.

Whereas her book is dedicated to understanding the philosophical ethics of witnessing, I am more concerned with its politics. In writing about that politics I have learned that very often some witnesses, some subjects, are not responded to, that they are prevented from addressing themselves to others. Conversely, other witnesses, other subjects, occupy the position of the "I" forcefully, hegemonically, telling not only their own stories, their own perceptions of the world, and what has meaning for them, but also what meaning is in itself. I contend that subjects of the latter sort often come to the subject position of witness clandestinely, invisibly. Their testimony, which marks them as subjects, is normalized, usually through claims on and technologies of objectivity, so that they are no subjects at all. For example, as I've attempted to show throughout this book, the authority of historical objectivity, the neutrality of the documentary camera, and the anonymity of the scientific gaze help to produce the subject-that-is-no-subject.

The invisibility and attendant political power of the witnessing subject is made more complicated, irrespective of what subject position testifies or is given credence, by the rapid changes in our contemporary understanding of the self—the one who stands in

the place of the subject—under the influence of computer networks, advances in micro-biology and genetics, economic globalization, rabid nationalism, and anxious cultural debates about memory, simulation, and the real. This living self is what I want to focus on now, the self that is subject to what Donna Haraway calls "technobiopower," which involves genetics, informatics, global economics, and humanism.[2] I will be concerned here with how we understand being and selfhood today through biological conceptions of liv-ing and through philosophical conceptions of subjectivity. But because the self, like the privileged subject, is an elusive thing, it seems necessary to find a mechanism by which to bring it to light. I would like to suggest that the blush, for a variety of reasons, is that mechanism. As I understand it here, the blush is something that allows us to see seeing, to understand better the privileges of witnessing, because it is a form of somatic commu-nication and, more important, interpretation. In particular, the blush allows us to see the seeing that takes place in biological conceptions of the self.

Blushing is a strange sort of experience in that it occurs in moments when the subject takes up another's perspective on the self, when one sees oneself as others do, and so one is simultaneously the subject and object of the gaze. A man blushes when he sees himself from another's position, not necessarily because from that position he judges himself or his actions negatively, but rather because he is made aware of both himself seeing and being seen. The blush, therefore, because it implies a shift in viewing positions (the imagi-native projection into the place of the subject, who looks and makes the one who blushes an object) can be a signal of a subject position that is otherwise difficult to detect. To the degree that we can say "your blush is meant for me," the blush, though it appears on *your* body, is a sign of *my* presence and *my* looking.

The blush is thus a very useful and powerful device, not just for its capacity to light up subjects, but also for its ability to compel us into a discussion about skin and bodies. The blush is a language that the skin speaks, and thus it has obvious connections to such things as race, identity politics, and subjectivity generally, as well as to biology and scientific con-ceptions of the self. Of course these two trajectories—the social and the scientific—are often interrelated, and obviously they entail crucial issues for any understanding of the politics of witnessing: who speaks and who is silenced, who claims authority and who does not need to claim authority because it is assumed. My concern in this chapter, however, is not with specific disputes that develop around claims to the subjectivity of witness. A huge number of scholarly volumes (Kelly Oliver's book prominent among them) are already devoted to that topic, books and articles that show how certain witnesses (usually racial, sexual, or economic others) have been deprived unjustly and deleteriously of subjectiv-ity. This chapter, by contrast, bears on the question of more subtle and insidious forms of disenfranchisement, the mechanisms by which science, in its presumed political neutrality, confers and revokes subjectivities. I am curious about scientific epistemes because science is often ignored in questions of subjectivity, except where it engages such things as race or

gender directly. I am interested in how, long before we come to questions of specific witnesses, particular identities, or individual injustices, science circumscribes how we imagine the self and, as a consequence, the subject. Strangely, despite its conventional associations with politics and morality, the concept through which I want to think about this is shame, though a very specific version of it (as I hope will become clear below). In addition, as I will argue further on, because the blush is the visual expression of shame, it conveys shame's subjectifying and desubjectifying effects.

As an example of the way in which the blush functions both as an object of scientific inquiry and as a mechanism for subjectivity production, I turn to Mary Ann O'Farrell's book on the role of the blush in nineteenth-century English literature, which explains that both that century's literature and its science presume that "blushes exist to be read." "Reddening cheeks," she continues, "offer themselves to the observer for reading; the prospect of the other's somatic legibility enables a fantasy of possession."[3] She discusses Charles Darwin's study of blushing in his book *The Expression of the Emotions in Man and Animals* (1872). Although my interest ultimately lies with much more recent history and more contemporary science, Darwin's book is a useful starting place to show how the blush relates to the question of witnessing, how it attends the privilege of the scientific witness, how it is a visual signal that is presumed to be in need of reading, how it works to reveal not only the one looked at but also the one looking. In 1867 Darwin distributed a questionnaire to colonial observers, missionaries, and British travelers in Africa, India, the western United States, Latin America, and Southeast Asia, asking that they use it to make a study of human expressions of emotion in racial others, or, as he refers to them, "the most distinct and savage races of man."[4] Each of these representatives is thus asked to be witness to Darwin's claim that such expressions are inherited biologically, are reinforced environmentally and behaviorally, and are thereby subject to natural selection, like other physiognomic traits.

O'Farrell notes that in a section called "Blushing in the Various Races of Man," Darwin presumes "the exclusivity of the group (he will call it simply 'us') whose responses set his norm."[5] Thus, his observers, his witnesses, occupy a powerful and unmarked subject position that allows them quite literally to read the faces of others. Indeed, his many witnesses report to find blushing of various shades in Indians, mulattoes, Maori, Tahitians, Latin Americans, Native Americans, and Africans. Not surprisingly the testimony he receives is filled with judgments that indicate how all that blushing is being read by these surrogate scientists. A very clear picture emerges, not necessarily about the races under examination, but about the colonial gaze that reads and interprets their skin, that grants or revokes their subjecthood. The dispatches from all over the empire frequently comment, for example, on the imperial conditions under which blushing arises: when the racial other is laughed at, humiliated, examined naked, rebuked for poor workmanship or laziness, yelled at, or accused of a crime.[6] Not surprisingly, these reports seem blind

to the oppression that is their mode of production. Although Darwin makes comments about the qualifications of his various reporters and the reliability of their testimony, their individual subjectivities are radically unmarked when they are gathered up under the neutral and unremarked "us." Swept into obscurity, this collective subject can comment more neutrally and thus more authoritatively on the ways in which blushing is a sign of the racial and moral inferiority of the colonized.

What this suggests is that, more than simply occupying the position of the subject and relegating the other to the position of the object of his inquiry, the scientist (or, in this case, the one who acts in his place) produces and controls what counts as subjectivity. In regard to the position of the subject, the presumption is that the blushing of the colonized is a sign of not only his individual shame or self-awareness but also the innate and scientifically observable qualities of his race. And so we can glean from these reports a rather routine catalog of racist stereotypes about the savage's innate immorality, stupidity, duplicity, filthiness, primitiveness, helplessness, and childlike innocence. Some witnesses argue that while blushing does occur in darker-skinned peoples, it reads only as an intensification of blackness and presumably of savagery, or it is simply obscured by "the dirty state of [aborigines'] skins." Others report that the capacity to blush either increases with the influence of British education, and therefore presumably the native's exposure to moral thinking, or that it decreases with age, presumably because the adult natives have grown estranged from the innocent morality that produces shame in native children. In addition to these examples of the scientist speaking from the position of the subject so as to objectify others, examples of the epistemological establishment of subjecthood itself also occur within Darwin's text. When no blushing is detected, some of Darwin's sources contend that racial others cannot be trusted because they "know not how to blush." Subjectivity, then, depends firmly on the individual's capacity to imagine himself as such, to see himself within a community of others, to see himself as someone who sees.[7]

Darwin's book on human expression is a particularly vivid case in which to examine the blush as a mechanism of subjectivity. It shows how the blush functions as the site for somatic interpretation and the ways in which it can illuminate the obscurities of the witness as subject. The blush is a visual signal for the particular kind of self-seeing that I described at the beginning of this chapter. This process occurs when, first of all, an individual feels shame because he imagines seeing himself the way others see him and, second, when an individual sees another person blush in shame and realizes that the blush is a product of her own, otherwise invisible, act of seeing that other. The crux of my concern here is that visual signal and how it lights the otherwise obscure question of subjectivity, which is central to understanding the witness. As a provocative example of the blush's visual play and of art's capacity to reveal the seeing it entails, I want to devote the rest of this chapter to a consideration of an untitled work of art by Ann Hamilton and Ben Rubin that, had it been realized, would have been quite literally made of light. The purpose of this discussion of blushing and this analysis of art is not to pile up more

examples of testimonial injustice, of the privileges of witnessing; rather, it is to understand how contemporary conceptions of subjectivity (particularly those influenced by biology) are changing the nature of witness.

Lighting Up

In 2001, through a carefully developed process involving a committee of diverse individuals including scientists, artists, and museum professionals, Ann Hamilton was awarded a commission to execute a public art project for the new Molecular and Cellular Biology Building at the University of Minnesota.[8] She worked on the commission intermittently for a period of four years to develop a concept, draw up a specific design, create a technological structure including a computer algorithm, and find a mode of fabrication and installation. In 2006, just before the contracts would have been issued for the piece's fabrication, the project was canceled by a single individual, Frank Cerra, senior vice president for Health Sciences, on the grounds that the project was not supported by the full selection committee. While it is tempting to answer that claim and question what I consider to be a censorious and short-sighted decision, such a pursuit would not productively advance the present study. Instead, because I believe the proposed project to have engaged beautifully and thought-provokingly with issues in contemporary biology, I want to contemplate it, even though it now exists solely in the imaginations of a few people. So powerful is this artwork that, from the moment I heard about it, even though it did (and still does) not exist in physical form, it has inspired me to think about a great many complex and interrelated questions. It is to that thinking that I now turn.

In November 2001, Ann Hamilton, describing her immersion in the bewildering metaphors and technical challenges of her public art project for the Molecular and Cellular Biology Building, lamented, "This building is giving me a hard time." She also noted the scientific concept with which she was preoccupied. "So," she continued, "my head is filled with fluorescence." A week later, she guessed more optimistically, "I think fluorescence will be our savior."[9] Indeed, the project she ultimately developed with her collaborator, multimedia artist Ben Rubin, involved installing sensors throughout the interior of the building, which were to collect sound data and which in turn were then to be configured through a computer algorithm and expressed on horizontal bands of colored lights on the exterior of the MCB Building. The floor plans from the building indicate with blue and red dots the proposed locations of the sensors. They were to have been placed in hallways, at entrances, in the auditorium, and in the main atrium. Hamilton and Rubin thus conceived of the building as an enormous cell or organism that communicates from interior to exterior through electrical impulses; the lambent light that was intended to play about the building's surface was designed to be a conversation in photometric code. The facade of the building thereby becomes a skin, a membrane lit up by and blushing with fluorescence.

The lighting up of the building refers not only to natural processes, such as inter-cellular communication and the behavior of biofluorescent animals, but also to the work of the microbiologist, who labors to bring the microscopic world into light. Advances in microbiology since the 1970s, such as X-ray crystallography and magnetic resonance spectroscopy, have made it possible to study cells and the organisms of which they are a part through practices of visual marking. Philosopher of science Evelyn Fox Keller offers this example:

> The gene for luciferin could be isolated from the firefly and attached to a gene normally found in the host, and, by way of the viral or plasmid vector [that is, a virus whose DNA is used as a vehicle to transport genetic information into cells that are being studied], the composite construct [is] incorporated into its normal position in the host genome. Now, whenever the host gene is activated, the firefly gene will also be activated, and its location in the cell will literally "light up." Here, a visual signaling device, able to reveal a level (and kind) of

Ann Hamilton and Ben Rubin, *Untitled,* 2005. Unfinished project for the Molecular and Cellular Biology Building, University of Minnesota, Minneapolis. Thin horizontal bands of primary colors were digitally added to a photograph of the building's facade. Photograph courtesy of Ann Hamilton.

Ann Hamilton and Ben Rubin, *Untitled,* 2005. Unfinished project
for the Molecular and Cellular Biology Building, University
of Minnesota, Minneapolis. Detail of plans for installation of
sensors. Photograph courtesy of Ann Hamilton.

detail which the microscope never could achieve, has been introduced into the
interior of the cell nucleus.[10]

Keller describes an almost inconceivable advancement in microbiological research made
possible by gene splicing, which is capable of producing a panoply of glowing chimerical
organisms. The task of lighting up fragments of cells, segments of DNA code, pieces of
RNA, or even entire parts of an organism's body is an effort to shine a light, like Lucifer,
the morning star, on the darkest corners of life, to bring the invisible into visibility. It is
interesting to consider this play of visibility in artistic terms, to study the ways in which

the MCB project stages a conversation between science and art on the topic of visual marking, the "lighting up" of both the subjects and the objects of looking. To see a cell or an organism lit up by luciferin is also to see the scientist in the act of looking.

That Hamilton and Rubin's project similarly involves illuminating the relative positions of observer and observed is evident in their official proposal for the microbiology building, which includes the following quotation from the best-selling book *Consilience*, by entomologist E. O. Wilson:

> Where humans detect electricity only indirectly by a tingling of skin or flash of light, the electric fishes of Africa and South America, a medley of freshwater eels, catfish, and elephant-nosed fishes, live in a galvanic world. They generate charged fields around their bodies with trunk muscle tissue that has been modified by evolution into organic batteries. The power is controlled by a neural switch. Each time the switch turns on the field, individual fish sense the resulting power with electroreceptors distributed over their bodies. Perturbations caused by nearby objects, which cast electric shadows over the receptors, allow them to judge size, shape, and movement. Thus continuously informed, the fish glide smoothly past obstacles in dark water, escape from enemies, and target prey. They also communicate with one another by means of coded electrical bursts. Zoologists, using generators and detectors, can join the conversation. They are able to talk as through a fish's skin.[11]

In Wilson's entrancing, almost surreal, description, the observing scientist and animal subject are engaged in conversation as silent as the ocean depths. As though trained in an elemental form of Morse code, they flash electrical impulses across an aqueous membrane, very much like the interior of the human eye. By directing attention to this passage, the artists suggest that, in their project, the lighting up of the building is a somatic communication, an exchange of electrical signals from one side of a watery pool to another. The people who inhabit the building and, by their activities, generate the illumination on its face cannot, however, see that face. In that regard, they "offer themselves to the observer for reading," and thus we might think of these electrical signals as a form of blushing. If we imagine the piece in these terms, if we note how motion (the shuffle of feet on linoleum hallways, doors closing, bodies on stairways) is converted into pulses of light that bleed across the building's face, then we must ask not only what is being communicated through this fluorescent suffusion but also to whom.

Shame

I would like to start to answer those questions by thinking about a different building, a different skin, a different kind of light, but a building, a skin, and a light that will lead us through the confusing territory of subjectivity and selfhood and eventually return us to Hamilton and Rubin's project. The destruction of the World Trade Center towers in

New York in 2001 is an event that has both insistently prompted and deeply shaken the task of witnessing, the process of memory. Eve Sedgwick uses the word *shame* to describe the uncanny experience of living in New York after September 11, specifically the habit of looking up in the place where the World Trade Center towers used to be and feeling a flush of embarrassment. "These flashes of shame didn't seem particularly related to pro- hibition or transgression," she writes. "Beyond that, though it was I who felt the shame, it wasn't especially myself I was ashamed of. It would be closer to say I was ashamed *for* the estranged and denuded skyline."[12] Here Sedgwick connects shame to the appearance of an architectural landscape, or more accurately a building's traumatic failure to appear within that landscape. In order to describe the experience of looking at this absence, she cites the definition of shame offered by the American psychologist Silvan Tomkins, who explains shame's sudden disorientation, which occurs when "one is suddenly looked at by one who is strange, or . . . one wishes to look at or commune with another person but suddenly cannot because he is strange, or one expected him to be familiar but he sud- denly appears unfamiliar, or one started to smile but found one was smiling at a stranger." Although Sedgwick admits that an urban vista isn't quite the same as a loved face, she says, "it isn't quite different, either: the despoiled view was a suddenly toothless face, say, or suddenly preoccupied, or suddenly dead."[13]

As Sedgwick points out, shame is not necessarily an emotion or affect produced by an awareness of one's own improper behavior; rather, she explains, it "attaches to and sharpens the sense of who one is, whereas guilt attaches to what one does."[14] In this sense, shame is an index of subjectivity, the lighting up, so to speak, of the self within the social. That shame is the performative expression of subjectivity is one of philosopher and criti- cal theorist Giorgio Agamben's key arguments in his book *Remnants of Auschwitz*. In a chilling example, Agamben describes a student, an Italian Jew, whose face, when he was picked at random to be killed by the SS, reddened in embarrassment, flushed as a mark of the shame of "being haphazardly chosen."[15] For Agamben, the flushed face is a sign that the self has become "witness to its own disorder, its own oblivion as a subject. This double movement," he continues, "which is both subjectification and desubjectification, is shame."[16] The Italian student, picked at random, interpellated by the German soldier's call, "Du komme hier," is at this moment both intensely himself (the specific one who is going to be killed) and, just as intensely, no one at all (one of any number who would die just as well). Agamben repeats this definition on the next page: "Shame is what is pro- duced in the absolute concomitance of subjectification and desubjectification, self-loss and self-possession, servitude and sovereignty."[17] This is similar to Sedgwick's assertion that there is a "double movement [that] shame makes: toward painful individuation, toward uncontrollable relationality."[18]

Although Agamben's example takes place half a world away from and more than half a century before Sedgwick's, the conclusions of the two writers with respect to shame are surprisingly resonant. They are, however, two sides of what Sedgwick calls the

"contagion of shame": "Shame," she writes, "living as it does, on and in the muscles and capillaries of the face—seems to be uniquely contagious from one person to another."[19] The contagion spreads when one feels empathy for another's estrangement. Sedgwick and the Jewish prisoner represent the two parts of that strange self-seeing I described earlier: the prisoner represents the victim of shame who sees himself from outside himself and blushes; Sedgwick represents the witness to victimization who sees her own act of looking reflected in another's humiliation, in another's blush, which itself is produced in response to her looking. The awareness of her own looking, in turn, provokes in her a sympathetic shame. What unites the two is perhaps their respective experiences of randomness; it is by chance that each is picked from a crowd.

It interests me that these writers, not only Agamben and Sedgwick, but also their forebears Emmanuel Levinas and Silvan Tomkins, make vivid their conclusions on subjectivity through a florid metaphor, the blush. To the degree that the blush is a physical, even a biological, signifier, we can think of shame as a condition of bodily representation, and yet what is being represented seems decidedly cultural, written across the face in the bright ink of selfhood. The flush by which the face is overtaken is an unexpected light, which signals the place where the "I" and the "not-I," the mind and the body, selfhood and biology, victim and witness flagrantly cross. It is analogous to the electrical impulse of the freshwater eel, the luciferin that causes a flicker in the firefly's tail, the light that soaks across the face of the microbiology building. The similarity between the blush and fluorescence is more than merely visual; they do more than look alike. We could say, on one hand, that they are each a product of biological existence and, on the other hand, that they attach themselves to and comment on the problem of subjectivity for biology. In both cases, coloration is a kind of talking through skin.

From the point of view of genetics and microbiology since World War II, shame is attached to biological being. This has to do not only with scientific advancements, including Schrödinger's theory of gene action, Watson and Crick's discovery of DNA, and the Human Genome Project, but also with the traumatic destabilization of the meaning of "life" and of selfhood in the post-Holocaust era. It is important to emphasize that "shame," as I use it here, the shame that attends biological being, is of the kind that Sedgwick and Agamben describe. I am in no way suggesting that contemporary scientists are themselves ashamed of biology or the body. The shame I'm talking about is not the result of embarrassment or guilt that betrays some improper behavior; it is, rather, a visual signifier for the simultaneous experience of subjectification and desubjectification. Put more simply, shame and the blush that expresses it are figures for the ways in which contemporary genetic biology sees the body contradictorily: as constituting an individual subject; as constituting a mute object of study (the precise nature of which new technologies are passionately dedicated to witness); and as constituting only a host for the metaphorical subjectivity ascribed to DNA.

Hamilton and Rubin's project for the microbiology building is, among other things, an enactment of that shame, an enactment that not only thinks self-reflexively about the work of the scientist and the current state of biology but also thinks self-consciously about multimedia art practices. The connection between these two points of reference lies in the bodies of those who were imagined to inhabit the building and contribute to its motion data and in the bodies of those passersby who would have looked up at and been struck by the strangeness of the building's face. Both categories of actors would be called into the installation randomly, and neither would know if it is her actions that are being recorded or if it is he who is being signaled by the lights. Like fish, they communicate with one another by means of coded electrical bursts. The conversation in which they are summoned to act is, just like that of the electric eel, about the murky environment in which they find themselves. It is as if the two were trying together to discern the shape of an unknown object in dark water, a shape called "life," which casts a long electric shadow. The work of art in which this conversation takes place is thus, in my view, a concerted attempt to bear witness to life as it is paradoxically understood in contemporary technoscience. It is an attempt to see witness. In this sense, we can interpret the building's fluorescent blush in much the same way as Agamben interprets the reddened face of the Italian Jew. "It is as if the flush on his cheeks momentarily betrayed a limit that was reached," he explains, "as if something like a new ethical material were touched upon in the living being. . . . But in any case that flush is like a mute apostrophe flying through time to reach us, to bear witness to him."[20]

Life Crisis

To the degree that Hamilton and Rubin's project can be said to constitute an investigation of "the ethical material in the living being," the task of understanding what exactly "living" is takes on enormous urgency. But that task is surprisingly difficult. Richard Doyle, a professor of English and commentator on the rhetoric of science, writes:

> What once formed the rough and jagged boundaries of a consensus on the
> object of biology has somehow been displaced, with the molecule overtaking
> or territorializing the organism and getting plugged into the computer. Perhaps
> this is only a recognition of a prior multiplicity—indeed, if we look closely. . . it
> seems that we never really knew what we were talking about when we were talk-
> ing about life.[21]

Doyle explains that this quandary is the product not only of changes in the biological sciences but of a great many new technological and theoretical developments in both the sciences and the humanities, developments that urge us to think of life and living in radically hybrid, definitively mobile, and stubbornly contingent terms. His question is one

that has reverberated loudly from the mid-twentieth century onward, one that has been heard in quite disparate places, including science, art, philosophy, ethics, computer and systems theory, politics, and anthropology.[22] Of these developments, there are two that we can place in dialogue: first, the redefinition of life that takes place in the discoveries of genetics and microbiology, and second, the Jewish Holocaust's utter devaluation of life. While real points of historical connection exist between the two (not the least of which are the biological experiments carried out by the Third Reich and Nazi scientists such as Hermann Voss), I view them here as large entities that float past each other in deep water.

The tense circling of these two contemporaneous forces is evident in Erwin Schrödinger's book *What Is Life?* which Schrödinger wrote in Ireland, where he lived in exile from Germany and Austria during World War II. Although Schrödinger's book does not directly discuss the war or his experience of it, it is nonetheless haunted by the war's role in bringing the definition of life into crisis. It is haunted by the specter of human destruction, as this epigraph by Spinoza, which appears in the book's preface, makes clear: "There is nothing over which a free man ponders less than death; his wisdom is, to meditate not on death but on life."[23] Schrödinger, a free man of science, attempts to enact that wisdom by locating within the chromosome a form of microscopic survival.

The complexities and challenges of Schrödinger's task—the search for survival in a time of genocide—are articulated by Agamben, who examines the mechanisms of World War II concentration camps to understand what "life" is, more specifically what human life is in the Holocaust world of physical and ideological violence. Agamben considers this world to have been dominated by lacunae in which hierarchies were overturned and categories destabilized, lacunae into which life itself seemed to fall. In his analysis is a set of densely entangled questions that the camps make vivid: how to define "life" in a world of the walking dead; how to define witnessing in a world where testifying to the genocide ironically means having escaped it and therefore not fully experiencing it; how to understand subjectivity when the subject is split—he exists only in representation, only in the "I," which displaces the subject even as it names him.

It is the interstitial figure of the "*Muselmann*" that captivates Agamben, that personifies these contradictions. The *Muselmänner* were the walking dead of the concentration camps, those who were so far gone down the dark hole of starvation and physical exhaustion that they could not think, speak clearly, or interact with others. Their name, which means Muslim, is said to derive from the involuntary muscle contractions that made them appear to bow repeatedly as though in abject prayer. And this is the first in a long list of characteristics that Agamben finds profoundly meaningful: the *Muselmänner* were Jews who were called Muslims, living beings who were no longer alive, human and nonhuman, subject and desubject, the complete witness who could no longer bear witness, those who could not be killed because they were already corpses. The *Muselmann* is a concretization of the desubjectified subject. In him, what falls to the bottom is selfhood, identity; what rises up is biology, what Agamben calls "the flow of vital functions" that are genetically

programmed to resist death. The stubborn heart keeps pumping even though what we recognize as human, as life, has already leaked away.

In his discussion of vital functions, Agamben borrows heavily from Terrence Des Pres, a professor of English and author of *The Survivor: An Anatomy of Life in the Death Camps.* Des Pres's book, which discusses at some length the problem of biology in the context of the Holocaust, was written in consultation with his friend and colleague E. O. Wilson (whom Hamilton quotes in the proposal for the MCB project). Des Pres writes:

> Stripped of everything but life, what can the survivor fall back upon except some biologically determined "talent" long suppressed by cultural deformation, a bank of knowledge embedded in the body's cells. The key to survival behavior may thus lie in the priority of biological being.[24]

It is this priority of biological being that prompts Agamben to claim that "the liberation of the camps takes place not under the sign of joy, but, curiously enough, under that of shame."[25] The source of that shame is not, as is conventionally argued, the survivor's guilt at having taken another's place among the living. As we've already noted, the difference between shame and guilt is significant. Shame, for Agamben as for Sedgwick, is tied not to what someone has done but rather to subjectivity. The shame of the liberation thus lies with the unknown and unbidden physical advantage stored somewhere in the body. This reduces survival to mere biology and the survivor from an individual subject to an organism within a biosphere.[26]

"Consider, on the one hand," Agamben writes,

> the continuous flow of vital functions: respiration, circulation, digestion, homeothermy (but also sensation, muscular movement, irritation, etc.) and, on the other hand, the flow of language and of the conscious "I," in which lived experiences are organized into an individual history.

Here Agamben is trying to understand the nature of subjectivity, whether it derives from biological functions or from language, from the blood that flows or the self who speaks. "Is there a point in which these two flows are unified," he continues,

> in which the "dreaming" of the vital functions is joined to the "waking" of personal consciousness? Where, and how, can a subject be introduced into the biological flow? Is it possible to say that at the point in which the speaker, saying "I," is produced as a subject, there is something like a coincidence between these two series, in which the speaking subject can truly assume his own biological functions as his own, in which the living being can identify himself with the speaking and thinking "I"?

Agamben's answer to this question is that, no, the breathing subject and the speaking–thinking subject are closely paralleled, but they are not one and the same. "In the cyclical

development of bodily processes as in the series of consciousness' intentional acts," he pointedly states, "nothing seems to consent to such a coincidence."

> Indeed, "I" signifies precisely the irreducible disjunction between vital functions and inner history, between the living being's becoming a speaking being and the speaking being's sensation of itself as living. It is certainly true that the two senses flow alongside one another in what one could call absolute intimacy. But is *intimacy* not precisely the name that we give to a promiscuity that also remains distant, to a promiscuity that never becomes identity?[27]

For Agamben, these two streams—the flow of biology, of the vital functions, and the flow of the speaking subject, of language—divide the human being.[28] "Is there," he asks, "a point in which these two flows are unified, in which the 'dreaming' of the vital functions is joined to the 'waking' of personal consciousness?" His answer to this dilemma is of a deconstructionist sort: he does not attempt to synthesize the opposing terms of the binary, nor does he reverse their hierarchical order by finding biology to be superior to the conscious "I." Rather, he focuses again and again on the gap, the promiscuity, between them. He concludes, "The remnants of Auschwitz—the witnesses—are neither the dead nor the survivors, neither the drowned nor the saved. They are what remains between them."[29]

The biological questions raised by the Holocaust seem to grow in direct proportion to those being asked at the same historical moment by genetics, in which, just as with the Holocaust survivor, shame is attached to biological being. Schrödinger, an Austrian physicist who had won the Nobel Prize for his work in quantum theory, published his small but enormously influential book in 1945. This work, in which he applies his expertise in physics to a discussion of gene function, is important to science because of the influence it has had on the future of genetics.[30] The book is notable because it proposes the idea, nearly a decade before Watson and Crick's discovery of DNA, that the chromosome acts like a "code-script":

> It is these chromosomes, or probably only an axial skeleton fibre of what we actually see under the microscope as the chromosome, that contain in some kind of code-script the entire pattern of the individual's future development and of its functioning in the mature state.[31]

As Richard Doyle points out, with this claim Schrödinger provides genetics with a seductive metaphor that ascribes to the gene a miniature sentience, a masculinist and almost divine power.[32] "The chromosome structures," Schrödinger continues, "are at the same time instrumental in bringing about the development they foreshadow. They are law-code and executive power—or, to use another simile, they are architect's plan and builder's craft—in one."[33] What would later be understood to be DNA is already, in this small book, figured both as a secret code and simultaneously as the muscular agent who reads

and executes the code's unequivocal designs. Not only was this metaphor appealing to subsequent researchers, journalists, and politicians, but it also had the powerful effect of turning life inside out. As Doyle explains, "Schrödinger mistakes or displaces the pattern of the organism by its 'code-script,' injecting the life of the organism into its description."[34] That is, the essence of life is no longer the organism—its physical appearance or behavior—but the gene, into which the larger organism is rhetorically injected. This is a shift, in biological terminology, from the phenotype to the genotype. It is also a move toward simulation, toward that historical condition of the hyperreal, in which, as Baudrillard notes, we are no longer real but merely copies of our DNA.[35] It is the gene that is given agency in Schrödinger's science, which means that, in Doyle's words, "the body, and life, have disappeared."[36]

So influential has Schrödinger's metaphor become that, according to Evelyn Fox Keller, "the attribution of agency, autonomy, and causal primacy to genes has become so familiar as to seem obvious, even self-evident."[37] In other words, genes have been accorded a kind of subjectivity in contemporary culture even as the self, as it was traditionally understood, has been desubjectified. That subjectivity has been an important topic for genetics, and that within it the self becomes "witness to its own disorder," is evident rather early on in the history of genomics, in Schrödinger's contemplation of the implications of his own theory. He writes:

> Each of us has the undisputable impression that the sum total of his own experience and memory forms a unit, quite distinct from that of any other person. He refers to it as "I." *What is this "I"?*[38]

His answer to this question is, in essence, an inversion of the subject–body binary:

> If you analyse it closely you will, I think, find that it is just a little bit more than a collection of single data (experiences and memories), namely the canvas *upon which* they are collected. And you will, on close introspection, find that, what you really mean by "I," is that ground-stuff upon which they are collected. . . . And even if a skilled hypnotist succeeded in blotting out entirely all your earlier reminiscences, you would not find that he had killed *you*. In no case is there a loss of personal existence to deplore. Nor will there ever be.[39]

Schrödinger considers that which is normally thought to define the human—memories and experiences, subjectivity itself—to be less significant than "the ground-stuff," the irreducible, transcendent, unmediated, secret yet potentially knowable code that exceeds any individual life.

Schrödinger's notion of life was originally influenced by his study of the Vedanta (a school of Hindu philosophy) and its description of a singular universal consciousness that transcends death. Since the discovery of DNA and the genetic revolution

that followed, his views have been adapted to fit what Doyle calls the "postvital," a primary feature of which is "positivist mysticism."[40] The postvital is, for Doyle, the period in which the body begins to be seen, not as having been imbued with some inexplicable life force, but as merely an effect of the molecule, of DNA.[41] The postvital is thus characterized by thinking the body without life and ascribing to DNA code mysterious and mystical properties. This theology is marked by a shift, which Doyle describes in the following way:

> The virtual construction of the modern notion of life relied on the notion that behind or beyond the practices, symptoms, and deaths of organisms lay a unity, a primitive, invisible force on the basis of which living beings *were*. For the postvital body, the overlooking or disappearance of the body displaces this "beyond" onto an ever denser and ever more complex genetic apparatus.[42]

It is to this unity, this primitive invisible force, that Schrödinger appeals when he says that wiping out subjectivity, obliterating memory, does not constitute death. Rather, and here again we see the Vedantic underpinnings of his theory, he argues that it is folly to suggest that souls are perishable, that they are annihilated with the body.[43] Schrödinger's view, therefore, even though it comes from the perspective of biology, ends up eliminating the body in favor of "code-script," a kind of language that communicates (just as the MCB project was meant to do) from the interior of the cell to the exterior, a language that survives death.[44]

The wholesale adoption of the code-script metaphor within genetics has paradoxically contributed to the discrediting of a "vital force" as the fundament of life. As Doyle explains, "In molecular biology, the end of the grand narrative of life, the 'death' of life is overcome through a new story of information, in which a sequence of 'bits' is strung together or animated into a coherent whole through the discourse of 'that is all there is,' a story of coding without mediation or bodies."[45] And thus, as Keller concludes, "it is the computer that dominates our imagination, and it has liberated us from that odd locution 'man has a body.' In its place we have an even odder set of locutions. Today, it might be more correct to say that the body—in the sense that word has now acquired—has man."[46] The effect of this information paradigm for the conception of genes and biology more generally is that my DNA is a literalization of my individual selfhood, of my distinct subjectivity (as though I could download my genomic sequence onto a disk and carry it around), and yet it is I who am called by my DNA, seemingly randomly, to live or to die. It is by chance that I am picked, for example, out of the group of nine children in my family, to have diabetes. Is diabetes something that I as a subject have, or am I simply the physical expression, the effect of that genetic mutation? This form of biological hailing simultaneously marks me as a subject and detaches me from subjectivity, makes blood rise shamefully in my face as a sign, according to Agamben, of the "disjunction between vital

functions and inner history, between the living being's becoming a speaking being and the speaking being's sensation of itself as living."

Conclusion

And with that flush of color, we are returned once again to the MCB project, to the building as a speaking skin that seems to offer itself to reading. In my capacity as an official reader of such artworks, I would suggest that the meaning of this piece may have lain in its depiction of, to borrow from Agamben once more, "a limit that was reached" some years ago in how we conceive of ourselves as biological and ethical beings. One might argue that the Molecular and Cellular Biology Building and the scientific work to which it is dedicated are positioned precisely at that limit where the vital and the postvital, the gene and the self, the subject and the desubject, the I and the not-I, meet. This project, even though unrealized, makes visible, lights up, and bears witness to that microscopic limit.

As important a task as this is, the work could potentially have performed another, perhaps more vital and far more difficult, function than that of social commentary. In a crucial way, my subject position as reader of that blush is productively destabilized by the project as a whole. To see the suffusion of light on the building's face as merely a visual effect, a signal in whose interpretation I am anonymously and authoritatively engaged, is to be in denial both about the actual nonexistence of the work and about how it would function if it did exist; it is to ignore the ways in which that light falls on me and makes my incomplete and yet privileged looking visible.

Although this work was never finished, and therefore how it would look is a matter of pure speculation, its appearance is only part of its larger structure as a complex network of hardware, software, and what Doyle calls "wetware" continually exchanging messages in "coded electrical bursts." Even without having been realized, the concept of the work alone no doubt plays with the discomfort into which viewers (even official viewers) of installation and performance art are routinely brought: within such works, they are called on, interpellated, and sometimes blush at the randomness by which they were chosen; their subjectivity seems to be granted and stripped away in the same gesture. These art forms, as they are practiced today, are looked at by the participant but also subject him to their power, make his looking momentarily visible. But this fact is very rarely commented on by critics and historians. In this regard, I think, as I search to make sense of the odd materials I've gathered here—from Darwin through the blush through the Jewish genocide to the postvital—that I may have given a bit too much attention to Agamben's story of shame (or at least that part of it that I highlighted) and not enough to Sedgwick's. His story focuses laudably on the victim of the unequal power relation between the one who looks and the one who is looked at, but he thereby stands again (much more sympathetically of course) in the place of the victimizer and makes the victim the object

of his gaze. Her story, by contrast, examines herself looking, considers the sympathetic shame in which the passerby is brought into the drama of another's desubjectification, another's blushing. It is this role, more than that of interpreter or reader, that I imagine for myself in front of this work. Just as Sedgwick's attention was commanded by the alien towering absence of the World Trade Center buildings, so mine is captured by a familiar and unremarkable building that is suddenly made strange when I imagine this artwork stretched across it. And it is that strangeness, produced so thoughtfully by Hamilton and Rubin, that forces me to blush.

Conclusion A Mysterious Picture of God

Adrian McElwee, son of independent documentary filmmaker Ross McElwee, displays a colorful painting to his father's camera in the film *Six O'Clock News* (1997) and announces unexpectedly, "This is a mysterious picture of God." In a voice-over his father observes, "God sort of looks like a movie camera here." Indeed, on the left side of the painting, a broad dark outline suggests the shape of a camera lens. Ross McElwee guesses that Adrian's exuberantly colorful image, the product of his then four-year-old imagination, unconsciously bears the effect of his being the son of two documentary filmmakers. It is no wonder that Adrian, surrounded since birth by film cameras, conflates the camera's seeming omniscience with God's.

What intrigues me about this scene is its complexity relative to the question of witness: in it several agents of witnessing seem to act contradictorily and at once. By having painted his picture, by having attempted to represent a camera, Adrian acts as an eyewitness to all the cameras in his life, mimetically rendering the appearance of the large black lens with surprising accuracy. At the same time that he records this objective reality, he also bears witness, through the abstraction of his gestural brush strokes, to an invisible deity, who is nonetheless real enough to Adrian that, later in the scene, he takes his picture over to the window so that God can see it. The shot also locates and records others in their performances of witnessing. When Adrian holds his painting up to the window, it is as though he catches God in the act of watching and looks back at him, in the same way that one might wave to a surveillance camera. At the same time, we are privy to this scene only because of *McElwee's* camera, the giant eye through which he watches his son and contemplates what he takes to be his own reflection in his son's painting. Finally, the film audience itself sits as anonymous and invisible witness to Adrian and Ross's interaction, to their differing views on what exactly is represented in Adrian's painting.

I conclude with this image because of its complexity in relation to the mechanisms of witnessing, that is, because it brightly illustrates the concerns on which I have focused in this book. Moreover, it serves as a visual reply to the image with which I began, the image of Colin Powell testifying before the United Nations Security Council and gesturing

[122]

Conclusion

toward his surveillance photographs. In the earlier instance, I noted how those photo-graphs were presented as though they were taken *by* God; in the later instance, we see a picture that is purportedly an image *of* God. In both cases, God's seeing is likened in dif-ferent ways to the work of the camera, though it is Adrian's image rather than Powell's that shows a greater ambiguity and complexity with regard to photography's presumed status as "document." We might recognize the painting (particularly an abstract painting) as a work of fiction, an artifact of the imagination, whereas the photograph is normally accorded a documentary status. But it is a painting of a camera displayed within the context of a film that, as a whole, inspects how we understand the real through represen-tation, how the six o'clock news is just as much a matter of fiction as fact. In this respect, the painting is part of Ross McElwee's larger body of work, which includes such films as *Time Indefinite* (1993) and more recently *Bright Leaves* (2003), wherein McElwee self-

Adrian McElwee, *Mysterious Picture of God*, in Ross McElwee, *Six O'Clock News*, 1997. Distributed by First Run Films, New York. Photograph courtesy of Ross McElwee.

reflexively questions the discursive nature of the documentary. What McElwee's work teaches us is that how we understand the work of the camera—as a technology of either surveillance or witness; as either truthful or imaginary; as either malevolent or beneficent—will depend on who we imagine to occupy the subject position of the witness. Finally, I want to draw my narrative to a close with this image because it is emblematic of contemporary culture in the United States, where we are surrounded by cameras and talk of God.

In this scene, we can see a rather elementary, indeed somewhat self-evident but nonetheless important, principle, that is, that representation is inherently a form of witness. To depict, to show, to speak on behalf of, is to stand as witness to something else, real or imagined, empirically knowable or accepted on faith. If this is true, then it must also be true that witnessing must share, as a consequence, in the internal contradictions by which representation is riven, contradictions that might be described as traumatic.[1] One such contradiction is that a representation, such as an image or a word, despite its intense desire (or rather the desire of the one who employs it) to bear witness to the referent to which it fervently gestures, is nonetheless the very opposite of that referent, nonetheless testifies to its very absence. As Isabelle Wallace puts it, specifically with regard to painting, "The image necessarily exists at a permanent remove from its referent and is, for all its mimetic capacity, nevertheless incapable of the referent's resurrection."[2] In short, representation (and, by implication, witnessing) is the opposite of the real, and yet, at the same time, contradictorily, representations *are* real and have very real effects. This is a very troubling problem, particularly since the act of witnessing, even more forcefully than the act of representing, makes very specific claims on reality. It is a problem that comes down to this: who represents, that is, who speaks in the name of, the real? Throughout this book, I have asked that question in a variety of ways and in relation to a variety of subjects: the historian; the domestic partner, husband or wife; the native; the photojournalist; the computer; the gene; the scientist; the organism lit up with blushing or fluorescence.

Thus, I have attempted to show that the witness is always marked by a certain vulnerability, by a constitutive contestation. We see this enacted in a very gentle way in the scene I have been discussing from *Six O'Clock News*. Ross McElwee looks rather skeptically on his son's revelation. His voice-over second-guesses his son, suggesting that the picture represents not so much God himself as a movie camera. But of course the contention surrounding the witness's claims on reality is normally far more acrimonious and moralizing, and often a great deal more is at stake. Colin Powell's spurious testimony about the reality of chemical weapons facilities in Iraq is one example, but we have examined many others. As was the case with Powell, the need to verify one's sworn assertions, one's representation of the real, often leads to the invocation of religious narratives and metaphors. It often requires either positioning the witness as an invisible, omniscient, and godlike subject or as that subject's official representative. Therefore, Adrian's innocent portrayal of God

cannot be seen as an accident within the context of a film that contemplates the rights of witness, since what I would call a theology of representation is immanent in the question of witnessing.

I want to examine *Six O'Clock News* in more detail as a way to enumerate and track the theological components and religious implications of a broader discussion about the legitimate witness. My purpose is to reveal the ways in which the theology of representation is at work, not only in the rhetoric of an avowedly Christian presidential administration, but also in the seemingly more secular discourses of representation. What I wish to show is that these discourses are imbued with moralizing judgments, which, however, usually go unnoticed as such. If theological discourse is immanent in representation generally and in the question of witnessing in particular, what is the fate of those discourses within contemporary U.S. culture, in which Christian fundamentalism dominates?

Six O'Clock News

Adrian's painting is part of the film's larger contemplation of both God's role in the seemingly random occurrence of human trauma and suffering, or, as McElwee describes it, "the invisible virus of fate that apparently controls everything by making everything out of control," and the filmic or televisual documentation of such occurrences. *Six O'Clock News* is a documentary about television's representations of disaster, its mediation between individual experiences of trauma and what we call news. During the course of the film, McElwee contrasts his own representations with television's by interviewing a series of people who have been brutally infected by the invisible virus of fate. He covers an alarming number of apocalyptic natural disasters, including Hurricane Hugo, Arizona floods, California wildfires, and the 1994 Los Angeles earthquake. In addition to these events, he includes examples of trauma as it is designed and inflicted by human beings rather than by nature: the brutal murder of Korean shop owner Gloria Im, the murder of a priest, a child abduction, another child run over by a car, a deadly house fire, shootings at an elementary school in Greenwood, South Carolina, and more fatal shootings at an abortion clinic in Boston. In this way, the film also inspects and draws parallels among the presumed crass sensationalism of television, the supposed virtuous objectivity of the documentary film, and the expected innocence of the home movie. As McElwee explains:

> I keep wondering about the "real world," the world of the six o'clock news.
> [For] the people in these stories, suddenly, due to a twist of fate, the six o'clock news becomes their home movie, a movie they never wanted made.

Here we see the profound sources of McElwee's anxiety: the real and threatening world as it enters his home though the television screen and from which he must protect his young son, and the "real" as it is conceived in relation to representation. Which is more threatening to the child: murders, fires and floods, or the reality-effect of the evening news?

Like McElwee's other films, *Six O'Clock News* is a long meditation on the relation between life as it is traumatically lived and mechanisms of recording, saving, and bearing witness to that life. Unlike his other films, however, this one also contemplates the implicit parallel between the documentary camera's ubiquitous surveillance and the omniscience of God as he is popularly conceived and between the utter strangeness of God and that of representation itself. In order to draw connections between these scopic regimes (between surveillance and omniscience, between God and representation), the scene that the film captures again and again is that in which one kind of seeing, one eye, confronts another. For example, he films TV news crews as they film him; he films a camera obscura as it captures images of the world outside; he films Adrian's painting, in which a small film camera appears to stare back at the camera perched on his shoulder. In this way, in addition to pondering God's mysteries, such as the capriciousness by which human suffering seems to be inflicted, the film also investigates the mysteriousness of representation, its analogousness to theological questions such as truth, origins, faith, and witness.

That analogy appears frequently in theories of representation as they have been proffered in the last forty years. Such theories routinely note how representation mysteriously both authenticates and estranges the real. The photograph, for example, serves as evidence of the real, what Barthes calls the "that-has-been," but, at the same time, it signifies the death, the absence, of the thing it captures. Similarly, the word, the name, testifies to its referent while simultaneously supplanting it. That aporia, this literature asserts, sets in motion a hermeneutics (in both the general and the theological senses) of representation, the interpretative uncovering of origins, of truths. Like the pursuit of the true meaning of God's word, the hermeneutics of representation requires a belief in extratextual information, something that exists outside the photograph or the name as a signpost on the correct interpretative path. This supplement Jacques Derrida shrewdly calls the "transcendental signifier" to highlight the theological underpinnings of our belief in what is outside the text. Derrida's analysis of the text works to discredit this godlike signifier, which is supposed to sit somehow outside what is written or pictured (just as God sits outside the world) to confer meaning on it. This, according to Derrida, is a con game in which the signifier works to assure us that the pure signified, the real, which language names, is still present in representation, a category that is nonetheless defined as reality's definitive opposite. Derrida exposes the con when he explains, "That which words like 'real mother' name, have always already escaped, have never existed; . . . what opens meaning and language is writing as the disappearance of natural presence."[3] Because we insist on believing in the natural presence, which both sits behind and grants value to representation, we fall for the con every time.

Roland Barthes approaches the question somewhat differently by historicizing our faith in the real, our investment in "concrete" reality, in the six o'clock news, and ascribing that obsession to the parallel developments of modernity, literary realism, objective history, and technologies of authentication. He writes, "It is logical that literary realism

should have been — give or take a few decades — contemporary with the regnum of 'objective' history, to which must be added the contemporary development of techniques, of works, and institutions based on the incessant need to authenticate the 'real.'"[4] Of course it is Jean Baudrillard who situates our obsession with reality as a direct consequence of our existence in an image-saturated culture of simulation, the direct effect of which is what he calls a nostalgia for the real.[5] All of this nostalgia for and need to authenticate the real suggest that the movement from the real to representation is inherently lapsarian; that is, it is marked by the Fall.

Mark Taylor has more thoroughly addressed the specific religious connotations of all this in his analysis of Herman Melville's novel *The Confidence-Man: His Masquerade*. The book is about a group of passengers who are on a ship navigating the Mississippi River and are suspicious of each other, and particularly their new mysterious shipmate, because they have been warned of a criminal at large, a confidence man. The story is full of allusions both to God and to representation; the mysterious shipmate is both Christlike (young, innocent, a lamb) and a con man (someone who misrepresents).[6] The story's tension, according to Taylor, is produced by the surprising similarity between the two. Just as Christ is a stand-in for his father, a representation of his father, whose task it is to win confidence, to win faith, the con man presents himself as other than he is, as a stand-in, a representation of an assumed identity.[7] In this, Taylor notes the primarily visual and representational nature of faith: faith is a matter of vision, so seeing is believing. He goes on to ask, however, "Is the search for faith based on vision, and vision based on faith a wild goose chase?"[8] So *The Confidence-Man* is filled with the search for signs of authenticity, transcendental signifiers, reassurances about the truth of representations.

Like Melville's book, *Six O'Clock News* abounds with unsettling examples of false images, misplaced faith, the search for signs, and the confusion of reality and representation. In one scene, which takes place at the Santa Monica pier, McElwee films a camera crew as it films an episode of the TV show *Baywatch*. Soon he is approached by a policeman who asks him to stay on the pier so as not to disrupt the work of the TV crew. He complies with this directive without question only to discover later that the policeman was not really a policeman, but rather an actor dressed in a policeman's costume. Ironically, although McElwee's main purpose for filming at the pier is to document, from the point of view of reality, Hollywood's production of fantasy, he is taken in by an actor. He is duped by a false figure of authority and the faith he has been trained to place in such figures. The police officer thus serves as a "figure," in the rhetorical sense, for faith, both that which image-saturated societies place in representation and that which Christian culture places in the Incarnation of God, which, in Taylor's view, is a confidence game "in which God appears to be other than what he is."[9]

In another scene, McElwee films Carolyn Noeding, one of a series of victims of natural disaster, as she sits on the couch in her trailer and watches herself on television being interviewed by a TV news crew about the tornado that ripped through the trailer

park where she lives. The most discomforting thing about this vertiginous *mise en abyme* of images is not their sheer proliferation but the shattering of our faith in their origins and ultimately their truth. What was, in McElwee's representation of it, an incomprehensible traumatic experience for Noeding becomes, in his subsequent filming of her watching herself on TV, a euphoric moment of self-recognition and minor fame. We are sent on the wild goose chase of representation, left disoriented about which of these versions of the past is truer, about the origin of the different representations we're shown. While it is obvious that none is really true, in an absolute sense, that even McElwee's version of events is a representation, we experience an odd feeling of betrayal as we compare the woman seated on her couch with her image on the TV screen. Like McElwee's encounter with the policeman/actor, our faith in signifiers of the real is shaken.

That disorientation is played out again in a scene in which McElwee films the TV news crew that has come to his Boston apartment to videotape an interview with him, their dueling cameras capturing different angles of the same event. His film shows that the news crew's shot of McElwee's first meeting with the TV journalist, which appeared in the broadcast of the story, was actually staged three separate times. They laugh nervously as they repeat, "Hi. It's nice to meet you," again and again. About the three versions and his own filming of them he asks, "Is one version more real than the other?" In other words, McElwee inspects these competing versions of the same event to measure their perfidy, the degree to which they violate faith, the extent to which each has fallen.

McElwee's question, which haunts his film and plays about the margins of this book, is central to theories of witness, for witnessing is fundamentally an act of making claims on the real (the eyewitness) or on that which is beyond the real (bearing witness). Is James Luna's performance of native culture more real than Kevin Costner's? Is Gilles Peress's photograph of the dead in Rwanda more real than Alfredo Jaar's sealed black box? Is a photograph saved in a computer database more real than my memory of what the photograph depicts? Is the gene more real than the life force? The test of such claims' legitimacy is in some ways a moral one, the touchstone of which is faithfulness to a presumed origin. Therefore, the distinction between TV news crew and documentary filmmaker, between actor and policeman, between representation and reality, bears the force of a moral judgment. By exploring these diverse examples, I have attempted to think critically about how those boundaries are drawn, the judgments that are made on the basis of those boundaries, and whether it is an actor, policeman, or some other authority who patrols them. The legitimacy of truth claims, as I have argued, hinges primarily on who is imagined to occupy the privileged subject position of the witness.

So I return once again to Adrian McElwee's "mysterious picture of God," which is for me a visual concretization of the problem of seeing our own seeing. In general, one can describe our seeing, the seeing that takes place in the United States of the twenty-first century, as involving a strange combination of technology and entertainment capitalism, including TV news crews and twenty-four-hour cable news channels, surveillance

cameras, reality television (including dramatic reenactments of real events), satellite photography, digital-image streaming, the electron microscope, the Hubble telescope, digital cameras, and picture phones. And the testimony that is produced by all the seeing we do seems to me often to be couched in theological metaphors, ones in which witnessing is invisible, authoritative, disembodied, omniscient, neutral, inevitable, judgmental and moralizing, and sometimes, as a result, punitive. In that context, then, as we have seen, contemporary art can productively throw into question the claims that are made on the real and at the same time maintain an ethical responsibility to reality. It can, in short, like Adrian's painting, help us to see witness.

Notes

Introduction

 1. The White House Web site, www.whitehouse.gov/news/releases/2003/02/print/ 20030205-1.html, accessed May 2007.

 2. Colin Powell, in an interview for ABC TV news, broadcast on September 9, 2005, www.abc.net.au/news/newsitems/200509/s1456650.htm, accessed July 27, 2007.

 3. www.whitehouse.gov/news/releases/2003/02/print/20030205-1.html.

 4. Ibid.

 5. Ibid.

 6. Suskind, "Without a Doubt," 51.

 7. Laub, "Bearing Witness, or the Vicissitudes of Listening," 59–63; Oliver, *Witnessing*, 1–2.

 8. Laub, "Bearing Witness, or the Vicissitudes of Listening," 59.

 9. Ibid.

 10. Ibid., 61.

 11. Ibid., 62.

 12. Oliver, *Witnessing*, 8. The key concern of Oliver's book is the philosophical analysis of identity and otherness, the limitations in critical theory of thinking about subjectivity, self–other relations, as inherently antagonistic. She writes: "I want to challenge what has become a fundamental tenet . . . in debates over multiculturalism—namely, that the social struggles manifested in critical race theory, queer theory, feminist theory, and various social movements are struggles for recognition. For instance, I would argue that testimonies from the aftermath of the Holocaust and slavery do not merely articulate a demand to be recognized or to be seen. Further, they bear witness to a pathos beyond recognition and to something other than the horror of their objectification" (8).

 13. Ibid.

 14. "The performance of witnessing," she writes, "is transformative because it reestablishes the dialogue through which representation and thereby meaning are possible, and because this representation allows the victim to reassert his own subjective agency and humanity into an experience in which it was annihilated or reduced to guilt and self-abuse." Ibid., 93.

 15. Saltzman and Rosenberg, eds., *Trauma and Visuality in Modernity*, xii. It is important to note here, as my colleague Jani Scandura has pointed out, that in addition to visual and textual forms of witness there is the sonic, for example, Colin Powell's audio tapes.

1. A Promise Always Disappearing

1. Blocker, *Where Is Ana Mendieta?* 133.
2. Blocker, *What the Body Cost.*
3. Abramović et al., *Marina Abramović.*
4. Nancy, "Shattered Love," 257.
5. Phelan, *Unmarked,* 146.
6. Deleuze, *Difference and Repetition,* 10.
7. Nancy, "Shattered Love," 264.
8. Deleuze, *Difference and Repetition,* 262.
9. Blocker, *What the Body Cost.*
10. Nancy, "Shattered Love," 263.
11. Ibid.
12. Butler, *Subjects of Desire,* 1.
13. Ibid., 3.
14. Nancy, "Shattered Love," 246.
15. Carr, "A Great Wall," 40.
16. Ibid., 42–43.
17. Abramović and Ulay, "Catalogue," in *The Lovers,* 189.
18. Carr, "A Great Wall," 30.
19. Nancy, "Shattered Love," 261.
20. Carr, "A Great Wall," 29.
21. Ibid., for this and the following series of quotations, which come from pages 26, 28 (two), 32, and 42–43, respectively.
22. de Certeau, *The Writing of History.*
23. Carr, "A Great Wall," 30.
24. Ibid., 27.
25. Ibid., 44.
26. Ibid., 36.
27. Deleuze, *Difference and Repetition,* 17.

2. Peoples of Memory

1. Nora, "Between Memory and History: *Les Lieux de Mémoire,*" 7, 13; my emphasis.
2. Ibid., 8.
3. Deloria, *Red Earth, White Lies.*
4. Sobchack, "The Insistent Fringe," 5.
5. Roach, *Cities of the Dead,* 6.
6. Nora, ed., *Realms of Memory,* ix.
7. Weintraub, *Art on the Edge and Over,* 100.
8. James Luna, quoted in Durland, "Call Me in '93," 39.
9. Foucault, *Discipline and Punish,* 186.
10. Baudrillard, *Simulations,* 116, 117.
11. Ibid., 52.
12. Michaelsen, "Resketching Anglo-Amerindian Identity Politics," 228.
13. Ibid., 241.
14. Roach, *Cities of the Dead,* 33.
15. Shooman, "Celebrity-Friends Reminisce about 'Dino.'"

16. Graham, "Dean Martin/Entertainment as Theater," 363, 362.

17. Joe Roach writes that "forgetting, like miscegenation, is an opportunistic tactic of whiteness." Roach, *Cities of the Dead*, 6.

18. Durland, "Call Me in '93," 39.

3. Binding to Another's Wound

1. Agamben, *Remnants of Auschwitz*, 120.

2. Ibid., 164.

3. Austin, *How to Do Things with Words*, 12.

4. Ibid., 6.

5. Ibid., 8.

6. Butler, *Bodies That Matter*, 224.

7. Ibid., 225.

8. Parker and Sedgwick, "Introduction," in *Performativity and Performance*, 11.

9. Mavor, *Becoming*, 109.

10. Caruth, *Unclaimed Experience*, 18.

11. Ibid., 8.

12. Austin, *How to Do Things with Words*, 13.

13. Parker and Sedgwick, "Introduction," 10–11.

14. Ibid., 10.

15. Quoted in Felman and Laub, eds., *Testimony*, 43.

16. Spector, *Felix Gonzalez-Torres*, 143.

17. Watney, "In Purgatory," 39; my emphasis.

18. The heterological nature of this history is further complicated by the change that Gonzalez-Torres made in a limited-edition screen print of the billboard, in which he altered the date from 1895 to 1891, thus referring to the year of a famous photograph of Wilde. About this change, Susan Tallman writes, "The change of date marks a shift of emphasis from public exposure to private pleasure, reflecting the intimate satisfactions of the print rather than the distant public power of the billboard." Tallman, "Felix Gonzalez-Torres," 66.

19. Leys, *Trauma*, 9.

20. George, "You Can Take It with You," 70.

21. Caruth, *Unclaimed Experience*, 4.

22. Leys engages in a strong critique of Caruth, particularly in chapter 8 of her book *Trauma*, 266–97.

23. Caruth, *Unclaimed Experience*, 24.

24. Ibid., 11.

25. Ibid., 7.

26. Barthes, *Camera Lucida*, 65.

27. Agamben, *Remnants of Auschwitz*, 63.

28. This image is reminiscent of another work by Gonzalez-Torres, his *Untitled (Paris)*, from 1989, a black-and-white photograph that depicts the shadows of two people standing on a footbridge, cast onto the grass below.

29. Caruth, *Unclaimed Experience*, 4.

30. Ibid., 8.

31. George, "You Can Take It with You," 70.

32. Watney, "In Purgatory," 44.

33. Feinberg, *Queer and Loathing*, 255.

34. Ibid., 257.

35. Spector, *Felix Gonzalez-Torres*, 154.

36. Felix Gonzalez-Torres, quoted ibid., 154–56.

37. Gonzalez-Torres, "Interview with Tim Rollins, 1993," 13; my emphasis.

38. Tallman, "The Ethos of the Edition," 14.

39. Since originally writing this chapter, I have actually cut up Gonzalez-Torres's print and used it to make a book as a wedding gift for my friends Amy and John.

40. Rosen, "'Untitled' (The Neverending Portrait)," 52–53.

41. Caruth, *Unclaimed Experience*, 111.

4. A Cemetery of Images

1. Gourevitch, *We Wish to Inform You That Tomorrow We Will Be Killed with Our Families*, 15; my emphasis.

2. Ibid., 16.

3. *Oxford English Dictionary*, online, s.v. "imagine." While Kelly Oliver's is an enormously useful book on the ethics of witnessing, my own approach differs from hers in a couple of ways. First, Oliver, via Julia Kristeva, argues that imagination is essential to our ability to understand and represent the world, to know and survive trauma. Imaginative interpretation is, by this definition, transformative. While I totally agree with the idea of imagination as ethically liberating, I am a little more suspicious of this idea than Oliver is, and I wonder to what extent the imagination itself is subject to received knowledge, epistemic patterns, internalized images. Second, Oliver reports that for Kristeva the need for imaginative transformation is acute because our psyches have been diminished by the two-dimensional images of our culture. "Both drugs and media images," Oliver asserts, "provide only false or artificial selves that only temporarily smooth over the surface of an otherwise empty psyche" (*Witnessing*, 72–73). Whereas in the former of Oliver's points I am more suspicious, in the latter I am more hopeful. My reading of Gourevitch's experiences suggests that "pictures of the dead," pictures that are presumably the stock-in-trade of the media, are necessary for imagining and therefore testifying to the experiences of the dead.

4. Dori Laub discusses this phenomenon in terms of "listening" rather than seeing: "The listener, therefore, has to be at the same time a witness to the trauma witness and a witness to himself." Laub, "Bearing Witness, or the Vicissitudes of Listening," 58.

5. Gourevitch, *We Wish to Inform You That Tomorrow We Will Be Killed with Our Families*, 17.

6. Ibid., 196.

7. The literature on this topic is of course enormous. It includes critiques of photography by post-structuralists such as Roland Barthes. (In his essay "Shock-Photos," for example, he writes that "the photograph does not disorganize us," *The Eiffel Tower*, 72.) Marxists including Baudrillard and Adorno, and Situationists such as Guy Debord also look critically at photography. It has also been defended by social reformers such as Jacob Riis and art historians such as Rosalyn Deutsche, who writes in support of Krzysztof Wodiczko's work. See, for example, Squiers, ed., *The Critical Image*; Bolton, ed., *The Contest of Meaning*; and Taylor, *Body Horror*.

8. For a thorough history of the conflict, see Des Forges, *Leave None to Tell the Story*.

9. Gourevitch, *We Wish to Inform You That Tomorrow We Will Be Killed with Our Families*, 152.

10. Jaar, "Violence," 57.

11. Hartt, "Real Pictures," 9.

12. Levi-Strauss, "A Sea of Griefs Is Not a Proscenium," 38.

13. Ibid., 43.

14. Jaar, *Let There Be Light*, unpaginated.

15. The quoted phrase is from Levi-Strauss, "A Sea of Griefs Is Not a Proscenium," 41.

16. Taylor, *Body Horror*, 17.

17. Ben Okri, "A Prayer for the Living," quoted in Jaar, unpaginated.

18. Jaar, "Violence," 57.

19. Max Kozloff explains that Peress is "continually observant of the degrees to which religious indoctrination and political propaganda fuse in the consciousness of besieged groups. The photographs are made to witness the toll upon a community of exactly that kind of consciousness—of minds under siege." Kozloff, "Gilles Peress and the Politics of Space," 8. The relation between the Rwandan genocide and religious doctrine is suggested by what is called the "Hamitic hypothesis," which was invented by Europeans and claimed that the Tutsis were descendants of a Caucasoid race from northeastern Africa and, therefore, as descendants of David, were superior to the darker, more Negroid Hutus. See both Gourevitch, *We Wish to Inform You That Tomorrow We Will Be Killed with Our Families*, 47–56; and Des Forges, *Leave None to Tell the Story*, 36–38.

20. Kismaric, "Gilles Peress," 33.

5. Machine Memory

1. Bush, "As We May Think," 37.

2. Ibid., 47.

3. Nyce and Kahn, "Innovation, Pragmaticism, and Technological Continuity: Vannevar Bush's Memex," 215.

4. Bush, "As We May Think," 45.

5. Nyce and Kahn, "Innovation, Pragmaticism, and Technological Continuity: Vannevar Bush's Memex," 214. Nyce and Kahn explain that "for Bush, memex was not some kind of visionary device. In his own words what he had done 'was see a public need . . . and scurry about to find a way of meeting it.' Having identified the problem, Bush, like the engineer he was, surveyed the existing technology, borrowed from it, particularly from the analytic devices of the time . . . and came up with a solution" (214).

6. Bush, "As We May Think," 39.

7. Virilio, "The Vision Machine," in *The Virilio Reader*, 134–35.

8. Bush, "As We May Think," 44.

9. Engelbart, "Augmenting Human Intellect"; and Nelson, "A File Structure for the Complex, the Changing, and the Indeterminate."

10. Bush, "As We May Think," 44.

11. Ibid., 47.

12. Ibid., 37.

13. Ibid., 46.

14. Ibid., 44.

15. Nelson, "A File Structure for the Complex, the Changing, and the Indeterminate," 134–45.

16. Ibid., 144.

17. Bell and Gemmell, "A Digital Life," 58.

18. Ibid.

19. van Dijck, "From Shoebox to Performative Agent."

20. Ibid., 312.

21. Ibid., 313.

22. Gross, *Lost Time*, 2.

23. Ibid., 30.

24. Ibid., 3.

25. Huyssen, *Twilight Memories*, 7.

26. Virilio, "The Vision Machine," 147.

27. Jones, *Self/Image*, 138.

28. Oliver, *Witnessing*, 223.

29. Ibid., 108.

30. In part, this amounts to arguing that subjectivity has its own history, as Michel Foucault has demonstrated, and that the contemporary subject, therefore, cannot be entirely separated from the digital technologies by which he is now everywhere surrounded. Foucault, "About the Beginning of the Hermeneutics of the Self."

31. Virilio, *The Vision Machine*.

32. Oliver, *Witnessing*, 223.

33. Performance program, Walker Art Center and Guthrie Theater, March 21–24, 2002.

34. For a more complete description of *memorandum*, see Hood and Gendrich, "Memories of the Future." For information on the Dumb Type collective, see: Durland, "The Future Is Now"; Mézil, "Le japon décadent de Dumb Type"; Neave, "Meditations on Space and Time"; Shikata, "White-out"; and Trippi, "Dumb Type/Smart Noise." See also the Dumb Type Web site: http://dumbtype.com.

35. Hood and Gendrich, "Memories of the Future," 11.

36. Performance program, Walker Art Center and Guthrie Theater.

37. Gross, *Lost Time*, 26–30.

38. Bush, "As We May Think," 46.

39. Shikata, "White-out," 45.

40. Hood and Gendrich, "Memories of the Future," 9.

41. Jones, *Self/Image*, 130.

42. Virilio, "Polar Inertia," in *The Virilio Reader*, 128–29.

43. Jones, *Self/Image*, 131.

44. Ibid., 132.

45. Hood and Gendrich, "Memories of the Future," 9.

46. Performance program, Walker Art Center and Guthrie Theater.

47. Borges, "Death and Compass" (1942), quoted in performance program, Walker Art Center and Guthrie Theater.

48. This heart monitor image was an important one for Dumb Type's founder, Teiji Furuhashi, who describes his grandmother's death from cancer in a phone conversation with Laura Trippi. He explains that he did not know for sure his grandmother was dead until the technology of the heart monitor displayed her death in visual terms. "I couldn't distinguish what was the border between life and death. I had to rely on the technology to know she died." Laura Trippi, "Dumb Type/Smart Noise," 33.

49. Huyssen, *Twilight Memories*, 6.

50. Ibid., 9.

51. Hood and Gendrich, "Memories of the Future," 12.

52. Shikata, "White-out," 45.

53. Bell and Gemmell, "A Digital Life," 63.

54. Virilio, "The Vision Machine," 141. It is important to note that Virilio's view is the opposite of Jean Baudrillard's. In Baudrillard's analysis, cyber culture produces a condition in which everything is reduced to truth and we have lost the fundamental illusions on which traditional life has been based. With this excess of truth comes the loss of metaphor, of what Baudrillard calls "natural language." Baudrillard, *The Vital Illusion*.

55. Oliver, *Witnessing*, 223.

56. Virilio, "Speed and Information: Cyberspace Alarm!" in *The Virilio Reader*, 5; originally published in *Le monde diplomatique*, August 1995.

57. Hood and Gendrich, "Memories of the Future," 19.

58. Baudrillard, *The Vital Illusion*.

59. Quoted in Neave, "Meditations on Space and Time," 86.

60. Oliver, *Witnessing*, 224.

6. This Being You Must Create

1. Shelley, *Frankenstein*, 111. All further citations to this source are shown parenthetically in the text.

2. Oliver, *Witnessing*, 16.

3. Keller, *The Century of the Gene*, 7–8.

4. Kac, "Transgenic Art," n.p.

5. Haraway, *Modest_Witness@Second_Millennium.FemaleMan©_Meets_OncoMouse™*, 213.

6. Derrida, *Memoirs of the Blind*, 36.

7. Ibid., 35.

8. Botting, *Making Monstrous*, 2.

9. Borland, "Memorial for Anonymous," 21.

10. Aly, Chroust, and Pross, *Cleansing the Fatherland*, 104–5.

11. Ibid., 100.

12. Ibid., 105.

13. Ibid., 105–6.

14. Foucault, "The Abnormals," 51.

15. Borland, "Memorial for Anonymous," 21.

16. Eskin, "Building the Bioluminescent Bunny," 118.

17. Kac, quoted in Allmendinger, "One Small Hop for Alba, One Large Hop for Mankind," 62; subsequent pages available online at www.nyartsmagazine.com.

18. Silverberg, "The Case of the Phosphorescent Rabbit."

19. This information and all subsequent statements by Kac are taken from his Web site.

20. Foucault, *Power/Knowledge*, 83–84.

21. Haraway, *Modest_Witness@Second_Millennium.FemaleMan©_Meets_OncoMouse™*, 60.

7. The Shame of Biological Being

1. Oliver, *Witnessing*, 17.

2. Haraway, *Modest_Witness@Second_Millennium.FemaleMan©_Meets_OncoMouse™*, 12.

3. O'Farrell, *Telling Complexions*, 84.

4. Darwin, *The Expression of the Emotions in Man and Animals*, 17.

5. O'Farrell, *Telling Complexions*, 83.

6. Darwin, *The Expression of the Emotions in Man and Animals*, 315–20.

7. Ibid., 318–20. This view of the subject was already firmly established within both scientific discourse and common parlance long before Darwin's study. Indeed, Thomas Jefferson rather famously expressed this view, with regard to the difference between blacks and whites, as a matter of conventional wisdom in the eighteenth century: "The first difference which strikes us is that of colour. Whether the black of the negro resides in the reticular membrane between the skin and scarf-skin, or in the scarf-skin itself; whether it proceeds from the colour of the blood, the colour of the bile, or from that of some other secretion, the difference is fixed in nature, and is as real as if its seat and cause were better known to us. And is this difference of no importance? Is it not the foundation of a greater or less share of beauty in the two races? Are not the fine mixtures of red and white, the expressions of every passion by greater or less suffusions of colour in the one, preferable to that eternal monotony, which reigns in the countenances, that immovable veil of black which covers all the emotions of the other race?" Here Jefferson regards the monochromatic quality of African-American faces as evidence of their lack of beauty but also their lack of awareness of themselves as subjects. Jefferson, *Notes on the State of Virginia*, 138–39.

8. The building was completed in 2002.

9. Personal e-mail correspondence with Shelly Willis, Public Art on Campus coordinator, University of Minnesota.

10. Keller, "The Finishing Touch," 42.

11. Wilson, *Consilience*, 47.

12. Sedgwick, *Touching Feeling*, 36.

13. Ibid., 35.

14. Ibid., 37.

15. Agamben, *Remnants of Auschwitz*, 104. Agamben takes the story from Robert Antelme, *The Human Race*, trans. Jeffrey Haight and Annie Mahler (Marlboro, VT: Marlboro Press, 1992), 231–32.

16. Ibid., 106.

17. Ibid., 107.

18. Sedgwick, *Touching Feeling*, 37.

19. Ibid., 64.

20. Agamben, *Remnants of Auschwitz*, 104.

21. Doyle, *On Beyond Living*, 1.

22. Given the mandate issued by Peter Bürger, following Artaud, that the future of the avant-garde lies in its sublation of art into life, and given the strange politics that have developed as a result (about which I have written at length elsewhere), it would seem that art, too, has had a difficult time with understanding life.

23. Spinoza, quoted in Schrödinger, *What Is Life?* viii.

24. Des Pres, *The Survivor*, 193.

25. Agamben, *Remnants of Auschwitz*, 87.

26. Des Pres, *The Survivor*, 192.

27. Agamben, *Remnants of Auschwitz*, 124–25.

28. Ibid., 128 and 133–34.

29. Ibid., 164.

30. It is important to note that the significance of Schrödinger's contribution has been much debated since its publication. For more on that debate, see Murphy and O'Neill, eds., *What Is Life?*

31. Schrödinger, *What Is Life?* 20.

32. Doyle, *On Beyond Living*, 29.

33. Schrödinger, *What Is Life?* 21.
34. Doyle, *On Beyond Living,* 28.
35. Baudrillard, *Simulations,* 52.
36. Doyle, *On Beyond Living,* 33.
37. Keller, *Refiguring Life,* 8–9.
38. Schrödinger, *What Is Life?* 90.
39. Ibid., 90–91.
40. Doyle, *On Beyond Living,* 49. See also Moore, *A Life of Erwin Schrödinger,* 125–26.
41. Ibid., 8–9.
42. Ibid., 17.
43. Schrödinger, *What Is Life?* 90.
44. At the same time, Schrödinger's view has fostered the ascendancy of the postvital, one of the concerns of which is, for example, the distinction between intelligent and nonintelligent systems, between those entities that are capable of self-organization and those that are not. The result is the establishment early on of genetic code-script in the specific terms of nascent computer technology. This can be seen in the claims of contemporary geneticist D. H. Adams, who writes: "DNA possesses unique characteristics even within the small group of potential substances enabling it not only—as a computer analogue—to store exceptionally large amounts of 'information' but to translate and implement this by operating as an artificial intelligence system" (quoted in Doyle, *On Beyond Living,* 36). In the tradition established by Schrödinger, Adams views the body as a container of and a thing contained by genetic information, as a cybernetic feedback system, in Vannevar Bush's famous terms. It is now rather common to think of DNA as an individualized computer program, a software, that all the body's cells possess and utilize even as those cells carry out very different biological functions.
45. Doyle, *On Beyond Living,* 22.
46. Keller, *Refiguring Life,* 118.

Conclusion

1. Wallace, "Trauma as Representation," 4. Wallace argues explicitly that representation is a form of trauma. The two are also more implicitly connected in a great deal of Freudian-inspired psychoanalytic theory, which considers the body as a site of representation of trauma (i.e., hysterical symptoms as representations of psychic disturbance) and which contemplates the ways in which representation (e.g., narration, dreams, role play) can help a victim "work through" a traumatic experience.
2. Ibid., 13.
3. Derrida, *Of Grammatology,* 159.
4. Barthes, "The Reality Effect," 146.
5. "When the real is no longer what it used to be, nostalgia assumes its full meaning. There is a proliferation of myths of origin and signs of reality; of second-hand truth, objectivity and authenticity." Buadrillard, *Simulations,* 12.
6. Taylor, *About Religion,* 10.
7. Ibid., 24.
8. Ibid.
9. Ibid.

Bibliography

Abramović, Marina, and Ulay. *The Lovers*. Amsterdam: Stedelijk Museum, 1989.

Ackerman, Jennifer. *Chance in the House of Fate: A Natural History of Heredity*. New York: Houghton Mifflin Company, 2001.

Adorno, Teodor. *Critical Models: Interventions and Catchwords*. Translated by Henry W. Pickford. New York: Columbia University Press, 1998.

———. *The Culture Industry: Selected Essays on Mass Culture*. Edited by J. M. Bernstein. London: Routledge, 1991.

Agamben, Giorgio. *Remnants of Auschwitz: The Witness and the Archive*. Translated by Daniel Heller-Roazen. New York: Zone Books, 2002.

Allmendinger, Ulli. "One Small Hop for Alba, One Large Hop for Mankind." *New York Arts Magazine*, June 2001, 62.

Aly, G., P. Chroust, and C. Pross. *Cleansing the Fatherland: Nazi Medicine and Racial Hygiene*. Translated by Belinda Cooper. Baltimore, Md.: Johns Hopkins University Press, 1994.

Apel, Dora. *Memory Effects: The Holocaust and the Art of Secondary Witnessing*. New Brunswick, N.J.: Rutgers University Press, 2002.

Augé, Marc. *Oblivion*. Translated by Marjolijn de Jager. Minneapolis: University of Minnesota Press, 2004.

Austin, J. L. *How to Do Things with Words*. Edited by J. O. Urmson and Marina Sbisà. Oxford: Clarendon Press, 1975.

Bal, Mieke, Jonathan Crewe, and Leo Spitzer, eds. *Acts of Memory: Cultural Recall in the Present*. Hanover, N.H.: University Press of New England, 1999.

Barnes, Lucinda, et al., eds. *Between Artists: Twelve Contemporary American Artists Interview Twelve Contemporary American Artists*. Los Angeles: A.R.T. Press, 1996.

Barthes, Roland. *Camera Lucida: Reflections on Photography*. Translated by Richard Howard. New York: Hill and Wang, 1981.

———. *The Eiffel Tower and Other Mythologies*. Translated by Richard Howard. New York: Hill and Wang, 1979.

———. *Image, Music, Text*. Translated by Stephen Heath. New York: Hill and Wang, 1977.

———. "The Reality Effect." In *The Rustle of Language*, 71–73. Translated by Richard Howard. New York: Hill and Wang, 1986.

Baudrillard, Jean. *Simulations*. New York: Semiotext(e), 1983.

———. *The Vital Illusion*. New York: Columbia University Press, 2000.

Bell, Gordon, and Jim Gemmell. "A Digital Life." *Scientific American* 296, no. 3 (March 2007): 58–65.

Blanchot, Maurice. *The Writing of the Disaster.* Translated by Ann Smock. Lincoln: University of Nebraska Press, 1995.

Blocker, Jane. *What the Body Cost: Desire, History and Performance.* Minneapolis: University of Minnesota Press, 2004.

———. *Where Is Ana Mendieta? Identity, Performativity, and Exile.* Durham, N.C.: Duke University Press, 1999.

Bolton, Richard, ed. *The Contest of Meaning: Critical Histories of Photography.* Cambridge, Mass.: MIT Press, 1989.

Borges, Jorge Luis. "The Witness." In *Collected Fictions.* Translated by Andrew Hurley. New York: Viking Press, 1998.

Borland, Christine. "Memorial for Anonymous: An Interview with Christine Borland." With Anne Barclay Morgan. *Sculpture Magazine* 18, no. 8 (1999): 16–23.

Botting, Fred. *Making Monstrous: Frankenstein, Criticism, Theory.* Manchester: Manchester University Press, 1991.

Britton, Sheilah, and Dan Collins, eds. *The Eighth Day: The Transgenic Art of Eduardo Kac.* Tempe: Institute for Studies in the Arts, Herberger College of Fine Arts, Arizona State University, 2003.

Bush, Vannevar. "As We May Think." In *The New Media Reader,* ed. Noah Wardrip-Fruin and Nick Montfort, 37–47; illustrations by Alfred Crimi. Cambridge, Mass.: MIT Press, 2003. Reprinted originally from *Atlantic Monthly* 176 (July 1945): 101–8; and later from *Life,* vol. 19, September 1945, 112–14ff.

Butler, Judith. *Bodies That Matter: On the Discursive Limits of Sex.* New York: Routledge, 1993.

———. *Subjects of Desire: Hegelian Reflections in Twentieth-Century France.* New York: Columbia University Press, 1987.

Carr, Cynthia. *On Edge: Performance at the End of the Twentieth Century.* Hanover, N.H.: Wesleyan University Press; Hanover, N.H.: University Press of New England, 1993.

Caruth, Cathy. *Unclaimed Experience: Trauma, Narrative, and History.* Baltimore, Md.: Johns Hopkins University Press, 1996.

Coffey, Mary Katherine. "Histories That Haunt: A Conversation with Ann Hamilton." *Art Journal* 60, no. 3 (Fall 2001): 10–23.

Crimp, Douglas. *Melancholia and Moralism: Essays on AIDS and Queer Politics.* Cambridge, Mass.: MIT Press, 2002.

Darwin, Charles. *The Expression of the Emotions in Man and Animals.* Chicago: University of Chicago Press, 1965.

de Certeau, Michel. *The Writing of History.* Translated by Tom Conley. New York: Columbia University Press, 1988.

Deleuze, Gilles. *Difference and Repetition.* Translated by Paul Patton. New York: Columbia University Press, 1994.

Deloria, Vine. *Red Earth, White Lies: Native Americans and the Myth of Scientific Fact.* New York: Scribner, 1995.

Derrida, Jacques. *Archive Fever: A Freudian Impression.* Translated by Eric Prenowitz. Chicago: University of Chicago Press, 1995.

———. *Memoirs of the Blind: The Self-Portrait and Other Ruins.* Translated by Pascale-Anne Brault and Michael Naas. Chicago: University of Chicago Press, 1993.

———. *Of Grammatology.* Translated by Gayatri Chakravorty Spivak. Baltimore, Md.: Johns Hopkins University Press, 1976.

Des Forges, Alison. *Leave None to Tell the Story: Genocide in Rwanda.* New York: Human Rights Watch, 1999.

Des Pres, Terrence. *The Survivor: An Anatomy of Life in the Death Camps.* New York: Oxford University Press, 1976.

DiNucci, Darcy. "Uncertain Paths to Understanding." *Print* 50, no. 6 (November–December 1996): 72–79.

Doyle, Richard. *On Beyond Living: Rhetorical Transformations of the Life Sciences.* Stanford: Stanford University Press, 1997.

Durden, Mark. "Witnessing Atrocity." *Creative Camera* 361 (December 1999): 22–27.

Durland, Steven. "Call Me in '93: An Interview with James Luna." *High Performance* 14, no. 4 (Winter 1991): 34–49.

———. "The Future Is Now: Kyoto's Dumb Type." *High Performance* 13, no. 2 (Summer 1990): 32–37.

Engelbart, Douglas. "Augmenting Human Intellect: A Conceptual Framework." In *The New Media Reader,* ed. Noah Wardrip-Fruin and Nick Montfort, 95–108. Cambridge, Mass.: MIT Press, 2003. Reprinted from Summary Report AFOSR-3223, under Contract AF49(638)-1024, SRI Project 3578 for Air Force Office of Scientific Research (Menlo Park, Calif.: Stanford Research Institute, October 1962).

Eskin, Blake. "Building the Bioluminescent Bunny." *Artnews* 100, no. 11 (2001): 118–19.

Feinberg, David B. *Queer and Loathing: Rants and Raves of a Raging AIDS Clone.* New York: Viking, 1994.

Felman, Shoshana, and Dori Laub, eds. *Testimony: Crises of Witnessing in Literature, Psychoanalysis, and History.* New York: Routledge, 1992.

Foucault, Michel. "The Abnormals." In his *Ethics, Subjectivity and Truth,* vol. 1, *Essential Works of Foucault, 1954–1984.* Translated by Robert Hurley et al. Edited by Paul Rabinow. New York: New Press, 1991.

———. "About the Beginnings of the Hermeneutics of the Self," *Political Theory* 21, no. 2 (May 1993): 198–227.

———. *Discipline and Punish: The Birth of the Prison.* Translated by Alan Sheridan. New York: Vintage Books, 1979.

———. *Power/Knowledge: Selected Interviews and Other Writings, 1972–1977.* Edited by Colin Gordon. Translated by Colin Gordon et al. Brighton: Harvester; New York: Pantheon Books, 1980.

———. *"Society Must Be Defended": Lectures at the Collège de France, 1975–76.* Translated by David Macey. New York: Picador, 2003.

Fruin, Noah Wardrip, and Nick Montfort, eds. *The New Media Reader.* Cambridge, Mass.: MIT Press, 2003.

Gaessler, Dominique. "La guerre: Nouse laissera-t-elle en paix?" (War: When will she leave us in peace?). *Photographies Magazine* 64 (January–February 1995): 44–45.

Gamow, George, and Martynas Yčas. *Mr. Tompkins inside Himself: Adventures in the New Biology.* New York: Viking Press, 1967.

George, Carl M. "You Can Take It with You: The Public Life of Felix Gonzalez-Torres." *POZ Magazine* (December 1998): 68–71.

Gere, Charlie. *Digital Culture.* London: Reaktion Books, 2002.

Gonzalez-Torres, Felix. "Interview with Tim Rollins, 1993." In *Between Artists: Twelve Contemporary American Artists Interview Twelve Contemporary American Artists,* ed. Lucinda Barnes et al., 5–31. Los Angeles: A.R.T. Press, 1996.

Gourevitch, Philip. *We Wish to Inform You That Tomorrow We Will Be Killed with Our Families: Stories from Rwanda.* New York: Farrar, Straus and Giroux, 1998.

Graham, Dan. "Dean Martin/Entertainment as Theater." In *Blasted Allegories: An Anthology of Writings by Contemporary American Artists,* ed. Brian Wallis, 362–70. Cambridge, Mass.: MIT Press, 1987.

Gross, David. *Lost Time: On Remembering and Forgetting in Late Modern Culture.* Amherst: University of Massachusetts Press, 2000.

Grundberg, Andy. *Crisis of the Real: Writings on Photography since 1974.* New York: Aperture, 1999.

Hadria, Michele Cohen. "Alfredo Jaar: Éblouissement de l'obvie/The Dazzle of the Obvious." *Art Press* 261 (October 2000): 42–43.

Hamilton, Ann. *Ann Hamilton: kaph.* Houston: Contemporary Arts Museum, 1998.

———. *Ann Hamilton: Present–Past, 1984–1997.* Lyon: Musée d'art contemporain; Milan: Skira, 1998.

———. *Ann Hamilton, tropos.* New York: Dia Center for the Arts, 1994.

Haraway, Donna. *Modest_Witness@Second_Millennium.FemaleMan©_Meets_OncoMouse™: Feminism and Technoscience.* London: Routledge, 1997.

Harrt, David. "Real Pictures: An Installation by Alfredo Jaar." *Dialogue* 18, no. 3 (May–June 1995): 8–9.

Heartney, Eleanor. "Between Horror and Hope." *Art in America* 87, no. 11 (November 1999): 75, 77, 79.

Hirsch, Faye. "The More Photography Proliferates . . . the More It Becomes Simply Images." *Art on Paper* 3, no. 3 (January–February 1999): 26–28.

Hood, Woodrow, and Cynthia Gendrich. "Memories of the Future: Technology and the Body in dumb type's *memorandum.*" *Performing Arts Journal* 73 (2003): 7–20.

Huyssen, Andreas. *Twilight Memories: Marking Time in a Culture of Amnesia.* London: Routledge, 1995.

Jaar, Alfredo. *Let There Be Light: The Rwanda Project, 1994–1998.* Barcelona: Actar, 1998.

———. "Violence: Representations of Violence—Violence of Representations." Rubén Gallo, interviewer. *TRANS* 1–2, no. 3–4 (1997): 52–61.

———. "Wir haben unsere Sehfahigkeit verloren: Ein Gesprach mit Alfredo Jaar" (We have lost our ability to see: A conversation with Alfredo Jaar). Geneva J. Anderson interviewer. *Neue Bildende Kunst* 4 (August–September 1997): 44–47.

Jackson, Michael. *The Politics of Storytelling: Violence, Transgression and Intersubjectivity.* Copenhagen: Museum Tusculanum Press, 2002.

Jefferson, Thomas. *Notes on the State of Virginia.* Edited by William Peden. New York: W. W. Norton, 1954.

Jones, Amelia. *Self/Image: Technology, Representation and the Contemporary Subject.* New York: Routledge, 2006.

Kac, Eduardo. "Transgenic Art." *Leonardo Electronic Almanac* 6, no. 11 (1998): n.p. Web site http://mitpress.mit.edu/e-journals/LEA/.

———. "GFP Bunny." Web site www.ekac.org/gfpbunny.html, 2000.

Keller, Evelyn Fox. *The Century of the Gene.* Cambridge, Mass.: Harvard University Press, 2000.

———. "The Finishing Touch." In *The Practice of Cultural Analysis: Exposing Interdisciplinary Interpretation,* ed. Mieke Bal, 29–43. Stanford: Stanford University Press, 1999.

———. *Refiguring Life: Metaphors of Twentieth Century Biology.* New York: Columbia University Press, 1995.

Kismaric, Carole. "Gilles Peress." *Bomb* 59 (Spring 1997): 28–35.

Kozloff, Max. "Gilles Peress and the Politics of Space." *Parkett* 15 (February 1988): 6–25.

———. "Gilles Peress: Cajamarca, Peru, 1991." *Artforum* 32, no. 1 (September 1993): 134–35, 196, 204.

LaCapra, Dominick. *Writing History, Writing Trauma.* Baltimore, Md.: Johns Hopkins University Press, 2001.

Laub, Dori. "Bearing Witness, or the Vicissitudes of Listening." In *Testimony: Crises of Witnessing in Literature, Psychoanalysis, and History,* by Shoshana Felman and Dori Laub, 59–63. New York: Routledge, 1992.

Levi-Strauss, David. *Between the Eyes: Essays on Photography and Politics.* New York: Aperture, 2003.

———. "A Sea of Griefs Is Not a Proscenium: On the Rwanda Projects of Alfredo Jaar." *Nka: Journal of Contemporary African Art* 9 (Fall–Winter 1998): 38–43.

Leys, Ruth. *Trauma: A Genealogy.* Chicago: University of Chicago Press, 2000.

Marsman, Eddie. "Gilles Peress: 'Mijn foto's zijn anti-fotografie'" (Gilles Peress: "My photograps are anti-photography"). *Foto* 51, no. 1–2 (January–February 1996): 102–7.

Mavor, Carol. *Becoming: The Photographs of Clementina, Viscountess Hawarden.* Durham, N.C.: Duke University Press, 1999.

Mézil, Eric. "Le japon décadent de Dumb Type." *L'Oeil* 536 (Mai 2002): 70–73.

Michaelson, Scott. "Resketching Anglo-Amerindian Identity Politics." In *Border Theory: The Limits of Cultural Politics,* ed. Scott Michaelsen and David E. Johnson, 221–52. Minneapolis: University of Minnesota Press, 1997.

Miller, Nancy K., and Jason Tougaw. *Extremities: Trauma, Testimony, Community.* Urbana: University of Illinois Press, 2002.

Moore, Walter. *A Life of Erwin Schrödinger.* Cambridge: Cambridge University Press, 1994.

Müller, Silke. "Fotografie ist eine Frage des Uberlebens" (Photography is a question of survival). *Das Kunstmagazin* 11 (November 2000): 82–93.

Murphy, Michael P., and Luke A. J. O'Neill, eds. *What Is Life? The Next Fifty Years: Speculations on the Future of Biology.* Cambridge: Cambridge University Press, 1995.

Nancy, Jean-Luc. "Shattered Love." In his *A Finite Thinking.* Edited by Simon Sparks. Stanford: Stanford University Press, 2003.

Neave, Dorinda. "Meditations on Space and Time: The Performance Art of Japan's Dumb Type." *Art Journal* 60, no. 1 (Spring 2001): 84–95.

Nelson, Theodor. "A File Structure for the Complex, the Changing, and the Indeterminate." In *The New Media Reader,* ed. Noah Wardrip-Fruin and Nick Montfort, 134–45. Cambridge, Mass.: MIT Press, 2003. Reprinted from *Association for Computing Machinery: Proceedings of the 20th National Conference,* ed. Lewis Winner, 84–100 (New York: Association for Computing Machinery, 1965).

Nora, Pierre. "Between Memory and History: *Les Lieux de Mémoire.*" *Representations* 26 (Spring 1989): 7–25.

———, ed. *Realms of Memory: Rethinking the French Past: Traditions.* Vol. 2. Translated by Arthur Goldhammer. New York: Columbia University Press, 1997.

Nyce, James M., and Paul Kahn. "Innovation, Pragmaticism, and Technological Continuity: Vannevar Bush's Memex." *Journal of the American Society for Information Science* 40, no. 3 (May 1989): 214–20.

O'Farrell, Mary Ann. *Telling Complexions: The Nineteenth-Century English Novel and the Blush.* Durham, N.C.: Duke University Press, 1997.

Oliver, Kelly. *Witnessing: Beyond Recognition.* Minneapolis: University of Minnesota Press, 2001.

Parker, Andrew, and Eve Kosofsky Sedgwick, eds. *Performativity and Performance.* New York: Routledge, 1995.

Peress, Gilles. "Gilles Peress." Carole Kismaric, interviewer. *Bomb* 59 (Spring 1997): 28–35.

———. *The Silence.* New York: Scalo Publishers, 1995.

Phelan, Peggy. *Unmarked: The Politics of Performance.* London: Routledge, 1993.

Radstone, Susannah, ed. *Memory and Methodology.* Oxford: Berg, 2000.

Ritchin, Fred. "The Photography of Conflict." *Aperture* 97 (1984): 22–27.

Roach, Joseph. *Cities of the Dead: Circum-Atlantic Performance.* New York: Columbia University Press, 1996.

Rosen, Andrea. "'Untitled' (The Neverending Portrait)." In *Felix Gonzalez-Torres.* Stuttgart: Cantz Verlag, 1997.

Rothberg, Michael. *Traumatic Realism: The Demands of Holocaust Representation.* Minneapolis: University of Minnesota Press, 2000.

Saltzman, Lisa, and Eric Rosenberg, eds. *Trauma and Visuality in Modernity.* Hanover, N.H.: Dartmouth College Press; Hanover: University Press of New England, 2006.

Schrödinger, Erwin. *What Is Life? The Physical Aspect of the Living Cell.* Cambridge: Cambridge University Press; New York: Macmillan, 1945.

Sedgwick, Eve Kosofsky. *Touching Feeling: Affect, Pedagogy, Performativity.* Durham, N.C.: Duke University Press, 2003.

Sedgwick, Eve Kosofsky, and Adam Frank. *Shame and Its Sisters: A Silvan Tomkins Reader.* Durham, N.C.: Duke University Press, 1995.

Shelley, Mary. *Frankenstein.* London: Everyman's Library, 1818; reprint, 1994.

Shikata, Yukiko. "White-out: Dumb Type's Image Machine." *Art Asia Pacific* 27 (2000): 40–45.

Shooman, Annie. "Celebrity-Friends Reminisce about 'Dino.'" Dean Martin page, www.plweb.at/dino/mart05.htm, December 26, 1995; and Mercury News (database online).

Silverberg, Robert. "The Case of the Phosphorescent Rabbit." *Asimov's Science Fiction* 25, no. 9 (2001): 5.

Simon, Joan. *Ann Hamilton.* New York: Harry N. Abrams, 2002.

Sobchack, Vivian. "The Insistent Fringe: Moving Images and Historical Consciousness." *History and Theory: Studies in the Philosophy of History* 36, no. 4 (December 1997): 4–20.

Sontag, Susan. *Regarding the Pain of Others.* New York: Farrar, Straus and Giroux, 2003.

Spector, Nancy. *Felix Gonzalez-Torres.* New York: Guggenheim Museum, 1995.

Squiers, Carol, ed. *The Critical Image: Essays on Contemporary Photography.* Seattle: Bay Press, 1990.

Stiles, Kristine. "Shaved Heads and Marked Bodies: Representations from Cultures of Trauma." In *Talking Gender: Public Images, Personal Journeys, and Political Critiques,* ed. Nancy Hewitt, Jean O'Barr, and Nancy Rosebaugh, 36–64. Chapel Hill: University of North Carolina Press, 1996.

Suskind, Ron. "Without a Doubt." *New York Times Magazine,* October 17, 2004, 46–51.

Tallman, Susan. "The Ethos of the Edition: The Stacks of Felix-Gonzalez-Torres." *Arts Magazine* 66, no. 1 (September 1991): 13–14.

———. "Felix Gonzalez-Torres: Social Works." *Parkett* 39 (March 1994): 64–66.

Taylor, John. *Body Horror: Photojournalism, Catastrophe and War.* New York: New York University Press, 1998.

Taylor, Mark C. *About Religion: Economies of Faith in Virtual Culture.* Chicago: University of Chicago Press, 1999.

Trippi, Laura. "Dumb Type/Smart Noise." *World Art* 2 (1996): 28–33.

van Dijck, José. "From Shoebox to Performative Agent: The Computer as Personal Memory Machine." *New Media and Society* 7, no. 3 (2005): 311–32.

Virilio, Paul. *The Virilio Reader.* Edited by James Der Derian. London: Blackwell, 1998.

————. *The Vision Machine.* Translated by Julie Rose. Bloomington: Indiana University Press, 1994.

Wallace, Isabelle. "Trauma as Representation: A Meditation on Manet and Johns." In *Trauma and Visuality in Modernity*, ed. Lisa Saltzman and Eric Rosenberg, 3–27. Hanover, N.H.: Dartmouth College Press; Hanover: University Press of New England, 2006.

Wardrip-Fruin, Noah, and Nick Montfort, eds. *The New Media Reader.* Cambridge, Mass.: MIT Press, 2003.

Watney, Simon. "In Purgatory: The Work of Felix Gonzalez-Torres." *Parkett* 39 (March 1994): 38–45.

Weintraub, Linda. *Art on the Edge and Over: Searching for Art's Meaning in Contemporary Society, 1970s–1990s.* Litchfield, Conn.: Art Insights, 1996.

White House Web site. www.whitehouse.gov/news/releases/2003/02/print/20030205-1.html.

Wilson, E. O. *Consilience: The Unity of Knowledge.* New York: Knopf; distributed by Random House, 1998.

Zaya, Antonio. "The Concealment of Reality: Reflections Provoked by Alfredo Jaar's Rwanda Project." *Art Nexus* 30 (November 1998–January 1999): 36–37.

Zelizer, Barbie. *Remembering to Forget: Holocaust Memory through the Camera's Eye.* Chicago: University of Chicago Press, 1998.

Bibliography

Index

Muslims, 114
mutation, 95, 98, 99, 101, 118
MyLifeBits, 66, 67, 68

Nancy, Jean-Luc, 4–6, 9
native, 13, 14, 16, 24, 25, 106; body, 14; culture, 127; envy, 15; memory, 14, 22, 25, 26. *See also* Indian
Native America, 21
Native American, 15, 16, 22. *See also* Indian; native
nature, 4, 65, 79, 91, 97, 98, 100, 124, 136n7
natural selection, 105
Nelson, Ted, 63, 65–66
new media, 69, 70, 79, 81
Noeding, Carolyn, 126–27
Nora, Pierre, 13–14, 15, 61, 68
nostalgia, 126, 137n5
Nyarubuye, 51, 52

observer, 10, 32, 103, 105, 110
O'Farrell, Mary Ann, 103, 105
Okri, Ben, 56
Oliver, Kelly, xvii–xx, 69, 70, 82, 84, 88–90, 103, 129n12, 132n3
organism, 87, 88, 90, 100, 101, 107, 108, 109, 110, 113, 115, 117, 118
origins, xvii, xix, 98, 100, 125, 127; myths of, xxiii

painting, xviii, 121, 122, 123, 124
Parker, Andrew, 32, 33–34
Peress, Gilles, xxii, xxiii, 53, 54–55, 57–60, 127, 133n19; *The Silence*, 57, 58, 59, 60
performance art, 3, 4, 5, 7, 8, 10, 11, 25, 119
performative, the, 29, 30–31, 32, 33
Phelan, Peggy, 4
phenotype, 117
philosophy, xvii, 5–6, 9
photograph, xiv, xx, 30, 32, 35, 41, 51, 52, 54, 55–60, 75, 122, 125, 127, 132n7, 133n19; documentary, xiv, xviii, xxi, 52, 53–54
photography, xxiii, 32, 61, 67, 73, 122, 128, 132n7
photojournalism, xx, 52, 55, 56
physics, 116

pi, 83, 84
picture, xiv, xv, xvi, 27, 28, 41, 51, 53–56, 62, 63, 65, 90, 121, 122, 123, 127, 132n3
Plato, 5
Poland, 97
Poles, 97
Poovey, Mary, 91
postvital, 118, 119, 137n44
Powell, Colin, xiii–xvii, xx, xxi, xxiii, 53, 121–22, 123, 129n15; illustration of, xiv
primitive, 13
primitivism, 13
psychoanalysis, xvii, 37
purity, 13, 89, 97, 98, 100, 101

quantum theory, 116
Queegqueg, 14, 16, 28
queer, 32, 33, 36

rabbit, 98, 99, 100, 101
race, 89, 106, 136n7
racial other, 105, 106
Rapid Selector, 61
Rashomon, 81
real, xvi, 32, 37, 80, 81, 122, 123, 124, 125–28, 137n5
realism, xviii, 55, 125
reality, xvi, xvii, xix, 21, 27, 32, 39, 52, 54, 56, 58, 69, 70, 80, 81, 82, 121, 123, 125–28, 137n5
recognition, xix, 9, 73, 89, 113, 127, 129n12
religion, xxiii, 3, 89, 90; Bush administration and, xvi
religious fundamentalism, xxii, 124
remembering, 13, 61, 65, 66, 67–68, 70, 73, 74, 75, 81, 82
repetition, 4, 5, 6, 10, 11, 32, 33, 34, 36, 37, 48
representation, xvii, xviii, xix, xx, xxi, xxii, 4, 5, 6, 11, 16, 22, 25, 36, 68, 81, 90, 112, 114, 122, 123–26, 127, 129n14, 137n1; beyond recognition, xix; discourse of, xvii; theology of, 124; visual, xxii
representing, 123
RNA, 109
Roach, Joseph, 14, 25
Rosenberg, Eric, xx

Ulay (Uwe Laysiepen), 6, 8, 9, 10; *The Lovers*, 6–11

United Nations, 56; Commission of Experts, 53; Genocide Convention, 53; Human Rights Mission, 52; Security Council, xiii, xiv, xvi, xvii, 53, 121; weapons inspectors, xv, xvi

United States, xiii, xxii, 34, 53, 56, 123, 127; Bureau of Indian Affairs, 26

University of Minnesota, 107, 108, 109

van Dijck, José, 67

Vedanta, 117

Video Archive for Holocaust Testimonies, xvii

Virilio, Paul, 63, 68, 69, 70, 76, 82, 135n54

visibility, xxii, xxiii, 87, 89, 91, 95, 99, 101, 109

visible, 89, 90, 91, 98, 101

visible-invisible hybrid, 90, 91, 100, 102

vision, 32, 63, 70, 88, 92, 95, 126

vision machine, 69, 70, 81, 84

visual, xx, 98; politics of, xx, xxi

visual culture, xxii

visuality, 89; ethics of, xx

visual marking, 108, 110

Voss, Hermann, 96–98, 100, 102, 114

Walker Art Center, 45, 70, 95

Wallace, Isabelle, 123, 137n1

Walton, Robert, 93, 94, 96, 101

Watney, Simon, 35, 43

Watson, James, 112, 116

wedding, 29, 30, 31, 32, 33, 34, 40, 41, 42, 47, 48

wetware, 119

White House, 43

white identity, 22

whites, 14, 16, 21, 22

wildness, 16, 17, 22, 23, 24

Wild One, The, 23–24

Wilson, E. O., 110, 115

witness: act of, xvii, xix, xx, xxiii, 37, 43, 51, 79, 80; art historical, 44; authorization of, 30, 32, 33, 34, 35, 70; bearing, 34, 67, 81, 88, 89, 92, 95, 100, 113, 119, 121, 123, 127, 129n12; blind, 96, 101; concept of, xxii, 29, 30, 32, 33, 34, 37, 53, 60, 88–91, 107, 113, 121, 123, 128; ethics of, xxiii, 69, 70, 89, 100, 103, 132n3; history and, 3, 33, 52; illegitimate, xvi; imagining, 51, 52, 53, 55, 57, 58, 60; invisible, xiii, xv, xvi, xviii, xx, 53, 121, 123; legitimate, xvi, xxiii, 124; official, xxii, 9, 30; process of, 48; queer, 36; religion and, xvi; representation and, xvi, xvii; rights of, xiii, 43, 124; scientific, 105; as subject position, xv, xvi, xx, xxiii, 13, 103; technology of, 53, 60; testimony of, 70; theories of, xxii, 32, 127; traumatic nature of, 37; visible, xv

Wollstonecraft, Mary, 94

World Trade Center, 110–11, 120

World War II, 112, 114

wound, 30, 39, 42

Wounded Knee, 26

Xanadu, 66, 82

Zaire, 55, 57

Zelizer, Barbie, xx